robert VENOSA

illuminatus

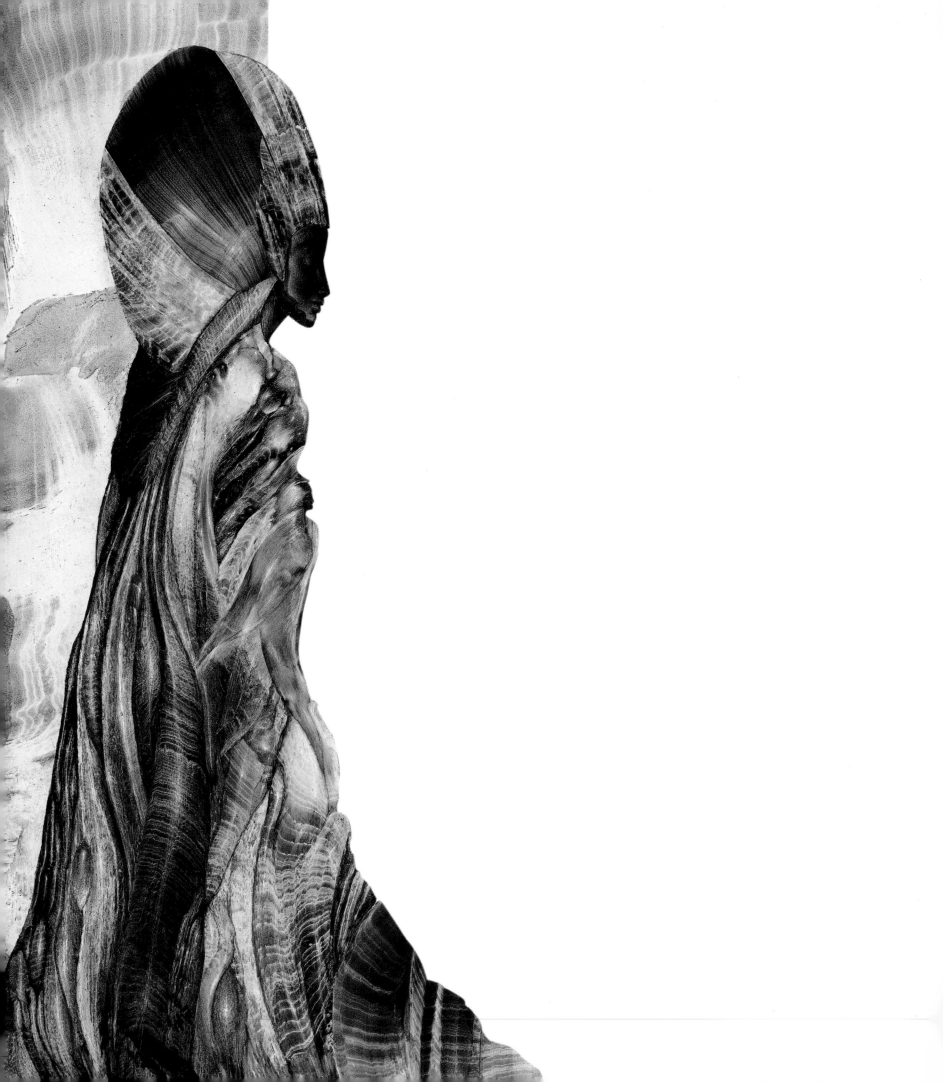

robert VENOSA
illuminatus

robert venosa

INTERFACE

for
Martina

contents

If the most exciting artmaking one can hope to encounter is an exploration of the furthest reaches of the imagination — then Robert Venosa must surely rank among the luminaries of our era. His painting is both evocative and archetypal, a fascinating exploration of essentially mysterious realms of being.

To some extent Venosa's imagery is a legacy of the late 1960s and early 1970s, when psychedelic sacraments led many of us for the first time to the mythic domains and buried treasures of the mind. We learned quickly that there was a remarkable world within, and we opened ourselves — sometimes recklessly, no doubt, but very much in a spirit of adventure — to both its sacred qualities and its terrors. Venosa paints the astral imagery of inner space and acknowledges the polarities of both light and shadow. But Venosa's aspiration, one senses, is towards transcendence — towards the liberation of the spirit. His crystalline goddesses, effulgent landscapes and liquid skies strike a deep chord because they seem to resonate with our yearning for dreams, visions and sacred knowledge. And Venosa's painting also reveals an astonishing affinity with sensory textures and translucent forms — his imagery literally enfolds you with its magical power.

Venosa is not alone in pointing us towards these visionary heights. In the twentieth century one can find other examples of outstanding creative geniuses who have literally redefined the boundaries of perception. Having helped unleash the revolutionary surrealist impulse, Max Ernst found deeply spiritual qualities within the Sedona landscape and towards the end of his life moved increasingly towards a realm of sublime transcendence. Salvador Dali explored visionary worlds where time seemed suddenly suspended, and where dream-images assumed the status of an alternate reality. René Magritte took us through the cracks of the visible world — into a fantasy domain where boulders could float in the heavens, where apples, lions and candles could be fashioned from stone, and where clouds and blue sky could assume the form of a majestic bird. And Ernst Fuchs — the great master of Viennese fantasy art — has produced numerous paintings where archetypal forces engage each other in a spirit of mythic encounter. All of these artists, and many more besides, are Venosa's creative forebears — visionaries who have helped define the sacred landscape. But it seems to me that Venosa has his own unique style. His paintings are immediately recognizable — they speak to us in a special way. And they are taking us somewhere that we had, perchance, forgotten: to a domain inhabited by spirits, gods and elementals. A cosmic terrain which lives on in the language of our dreams ...

It is the revelatory quality in Venosa's painting that I find so intriguing. His world is a world of mysteries and secrets — but we have the sense that in some elusive way the artist is sharing these secrets with us, even if we are unable to fully grasp the portents he is presenting.

I remember the first time I came across Robert Venosa's work — with the publication of his first book, *Manas Manna*, in 1978. In these paintings it seemed to me that the alchemy of the soul had been revealed for all to see. Here mythic beings graced ancient rock forms and crystal surfaces, merging into light and flame. One particular image from *Manas Manna* which is featured here as well — *Morontia Sentinel*, 1975 — has stayed with me for years as one of the most powerful magical paintings I have ever seen. I think its potency has something to do with the fact that these wise and dignified beings have emerged from the earth. The earth — as the shamans always remind us — is alive, and it is sacred. These creatures are magical guardians. It is they who watch and guard the planet. They epitomise the path of spirit that opens for those who can walk between the worlds. And in troubled times they are a beacon for us all.

As a co-founder of Craftsman House, and in my ongoing role as Publishing Director, I have seen the work of many fine artists. However, I think Robert Venosa is inspirational. His unique, tactile imagery will seem to flow forth from these pages as they open before you.

Nevill Drury

Sydney

From the point of view of the historical analysis of art as the millennium attains completion, the presence and legacy of modernism casts an enormous shadow over the intellectual territory through which our recent thousand-year peregrination has wandered. This is not simply because our own historical nearness to the twenty-first century makes it appear inflated in importance. There is a definitive and profound difference between the enterprise of art before and after modernism. The journey from the proto-Gothic and late Byzantine world to postmodern Fantastic Realism is the story of individual artists and their very private flirtation, and then obsession, with personal freedom.

While the idea is given wide lip-service that artists are the antennae, the advance guard, of the community's journey into ever more novel cultural forms, in many times and places this idea has been left unrealized. What is actualized is the notion of artists as repositories of form, keepers of the canons of design and detail, and too often, as willing instruments of political propaganda. In spite of this tendency the ideal of freedom has been the special province of artists as a community for many centuries. Today the heavy industrial scale of the counterculture with its therapies, lifestyle market share and thriving cults of ignorance, often makes it difficult to remember that its roots are in the earlier, gentler lifestyle that named itself Bohemian. The artist as madman, or madman/genius, the mingling of genius with madness, all the delicate social posturing which went on around the artist — an outclass status and yet an intimate relationship with courtly life and refinement — these dichotomies show us clearly that the ambiguity that attached itself to the ancestral artistic ideal, the shaman, has not entirely been expunged from the associations which surround his late descendants.

It would seem that the Ouroboric process of return is reached with the finale of modernism. And what is that finale? I believe that it is the conscious realization that the artist and shaman are one. The artist is heir to all the visionary landscapes and potentially curative power that was the province of the shaman. In the early twentieth century Freud and Jung mapped and legitimized the *terra incognita* of the human unconscious. What the Romantics had sensed and the Victorians denied, early psychoanalysis triumphantly confirmed: that the haunted wilderness of the "primitive mind" had not been exorcized from the psyche of western culture by scientific reductionism. That in fact, the fables of science and materialism have not penetrated deeply at all into the substructures of the human psyche in even the most urbane and sophisticated individuals.

Where others had seen only degenerative and localized pathologies, Freud and Jung discerned, especially in Jung's case, a coherent and unexplored territory common to all human beings, literally a new dimension into which culture was making its way. As always, the artists were sent ahead, advance scouts, canaries in the mine, at times sacrifices to the chthonic gods of the newly encountered collective unconscious.

It is in this context that I view the work of Robert Venosa. His work and life fuses and concentrates the techniques and insights that all contemporary artists receive from western civilization as their legacy: fidelity to the image as it is encountered, awareness of historical context and a command of physical materials that is married to the extra-cultural and often vertiginous sense of ambiguity that is the intellectual hallmark of print-generated literacy. His possession of these qualities in large measure would in themselves constitute a sufficient talent to propel his work to the forefront of new painting. But Venosa brings more than this to his passion, he brings a deep appreciation of the surreal, and a delightful sureness of hand in its depiction. Not that Venosa is a simple surrealist. In spite of his close relationship to his mentor Ernst Fuchs, and in spite of the enthusiasm that Dali has shown for Venosa's work, at the end of the day Venosa is far more intellectually dangerous than surrealism can hope to be today.

Dangerous? Can an artist be dangerous? Certainly. One has only to recall Goya's depiction of the horrors of war or Velasquez's savage but unstated parodies of his clueless aristocratic subjects, or Picasso's *Guernica*, to confront the danger, radical and revolutionary, that can often adhere to great art. So let the world in its ignorance proclaim Venosa neo-Surrealist or Fantastic Realist, but the cognoscenti see and feel far more than time-tested revolutionary formulas in his work. The cognoscenti recognize a fellow traveler in the realms that are only to be encountered through radical and intentional alteration of brain chemistry.

Let us say it softly but with perfect clarity. *Venosa is psychedelic.* This most radical and yet paradoxically traditional position places Venosa's work at the very center of the great issues that confound and convulse our civilization.

We are terrified of the mind, although perhaps not when we approach it from the therapist's couch and with the psychoanalytic vocabulary of treatable pathology. And perhaps not when we use the tools of traditional Surrealism, automatic writing, synchronistic juxtaposition and mutation of literary motifs to explore its associational architecture. We are terrified when we meet the mind alone and unarmed, when the cant that surrealism and psychoanalysis provide is at last silenced. And it is this quality that links Venosa to shamanism and to the unbroken tradition of natural magic and consciousness alteration that reaches unbroken back to the dimmest human beginnings. To submit oneself to the muse, without caveat or precondition, is the agenda of the arts, yet how many artists can step beyond their own fears and uncertainty to actually do this?

Venosa is one such artist. He has been there and knows the territory that he paints, not as a dilettante in search of a subject but as a pilgrim in a strange and personally vital landscape through which he has wandered, ever amazed, ever keen to remember and render the details — that William Blake called the "minute particulars" — most faithfully.

This newly discovered domain, the collective imagination, has worked its siren call into the souls of those who would become the defining voices of modernism. Alfred Jarry, Wassily Kandinsky, Marcel Duchamp, Max Ernst. Built upon this patriarchal timber the house of modernism has risen, defined and strong. Venosa is heir to all of these often contradictory impulses that have shaped modernism; the tension between abstraction and image, the tension between Realism and metamorphosis, the tension between the existential abyss and psychedelic affirmation.

But it is not to any of the great moderns that I would compare Venosa. His paintings may participate, indeed, do participate, in the summation of modernism. But to me Venosa seems most prefigured in a great pre-modern, one who gave summation to the aesthetic agenda of the nineteenth century — the Symbolist Gustave Moreau (1826–1898). Moreau had a preference for mystically intense images that evoked long-dead civilizations and mythologies. Treated with an extraordinary sensuousness, his jewel-like paint-encrusted canvases hover at the fractal boundary between realism and abstraction. In the

ambience of the *fin de siècle* of the nineteenth century he was summoned to the portrayal of an apotheosis of the Spirit.

This is a perfect description of Venosa's work, where he too exhibits a delight in the pagan and the exotic. Like Moreau, Venosa works under the shadow cast by the century-long unfoldment of a particular aesthetic. In the case of Moreau that canon is Romanticism. In Venosa's case it is the more crowded and less focused cacophony of twentieth-century art to which he attempts summation. But Venosa is able to give us the millennial recorso of this theme, a *fin de Mille*.

Venosa's paintings are a Viconian crescendo of organic and flame-like surfaces that support a human landscape that is beyond historical identification, that is in fact a idealized mnemonic reflection of being as possibility. These paintings are rich and moving to look upon. The figures, often dwarfed by the titanic but undefined environments around them, are ourselves: as we have seen ourselves in dream, in psychedelic states, and in idealized recollection. It is pure affirmation but without a denial of ambiguity. Venosa's paintings say that the course of evolution is ambiguous, profligate with the stuff of life and mind, but also triumphant. Out of the tumult comes beauty, anchored hope, even understanding. If there is a too-muchness it is the too-muchness of creative overflow, a revelation of the appetite of paint to become information for the observing mind, to affirm, to heal, to change and mutate before our startled lives. This work does all that and points deeper — into future time, when we shall scale the canyon walls of the individual mind and emerge at last into a power to make beauty so irresistibly intense that it will stop time in its tracks. This too is promised in the deepest Venosa images. Like Hieronymus Bosch (1450–1516), who simultaneously gave summation to the passing of the medieval world and anticipated the grotesqueness of the Industrial Revolution, Venosa gives summation to the strivings of one epoch even as he opens the door to a future that affirms the transcendental proposition that true humanness is not only possible, but is now, at long last, upon us.

Terence McKenna

Opihahali, Hawaii

Angelic joy shades tears that form the translucent world of dimensions beyond the ones that we know of and that we call reality.

Of course we see these tears of joy which stream from the angelic eyes by these observations of the King of Light which fills their eyes of visions. They are the mirrors of His light. Robert Venosa's work may show to us this space of glory in the manner of icons that the artist has composed in the sense of a metaphoric image language.

During the first steps towards the visionary world, Venosa was my student and, very swiftly, he embraced, and enhanced, the world of the old masters' craftsmanship. Patient and adventurous, he quickly learned to handle the ancient tools to express a more precise imagery containing the message of this translucent sphere that the inner eye perceives when meditating on the cosmic aspects of the letter of Jacob.

Out of the analogy of water drops and precious stones, Venosa comes to create a world that is the result of the sidereal fire — the stars appearing in the freeze of the Void. The enigma of light and darkness enlightens his paintings and, therewith, our eyes, so we can see and follow what he sees.

There is a tremendous beauty to these glowing tears that the celestial light evokes, as if pain was the source of their offspring. This is what the angelic world has in common with all the creatures to whom reflecting and perceiving eyes have been granted: look into the source of light and tears will flow. May this vision lead up to more and more aspects of the never-ending contemplation of the light divine of which we and everything are made.

What moves me in a work of art is never really the work of human hands but the intimation of the best that is yet to come, of which the Creator allows us a glimpse now and then, using the artist as an intermediary. So it is not ordinary pictures that enter the realm of the timeless, but a special authenticity of imagery born of the visionary experience. Those artists, such as Venosa, who gain access to visionary states, captivate us through their eternal imagery to fall under a spell of that reality. Yet this highly individual phenomenon of visionary perception would have to remain a secret of the one graced with that special gift. Sharing it with those who have had no direct experience of it in a language, a vocabulary and syntax of imagery makes it comprehensible to all. The greatest of these artists are masters of a timeless, alchemistic art — stemming from traditions going back thousands of years and climbing the steepest summits of a

restless present. They sense a reality more substantive than the "truth", and so draw us under the spell of the eternal image revealing some visitation or dream.

The past and future are visions that the creative spirit, in its awareness of eternity, blends into the present. Thus the artist, in contemplation, creates both history and eternity. A work of art is simply a monument to the temporal within eternity. Art alone can confer and transmit to other ages an enduring validity of what is trapped within its own era. Only the spirit of the artist can capture what is ephemeral and ineffable, otherwise it is doomed to be forever lost to us.

Art is the nourishment of the complete human being; it is the condition of our existence, the medium in which our lives are suspended, and since art knows no exhaustion, it is the medium of an eternal life, an inexhaustible life. For it is in art, like that of Robert Venosa's, that the creative force expresses its inexhaustibility.

Ernst Fuchs

Monte Carlo

Recently an art-history university student brought to my attention a chapter in the book, *Del Arte Objetual Al Arte de Concepto*, by Simon Marchán Fiz, in which the artists Hausner, Fuchs, Brauer, Klarwein, Atwell, Abrams, et al, have been classified as part of a clearly defined "post-Pop" movement which can be separated into three similar and interrelated currents, sometimes symbiotically overlapping: Fantastic Realism (or Visionary), psychedelic, and hyper- or photo-realism. All of these affirmed themselves during the late 1960s with the decline of Pop art. Robert Venosa, as well as Alex Grey, Robert Williams, Bill Martin, Manuel Ocampo, and the *Juxtapoz* and *Zap* magazine crazies from California, could also have been included in this list of new marginal geniuses had it not been for the fact that the above-mentioned book was written in the early 1970s at a time when these young artists were just starting to project their visions onto canvas.

Another minor detail the author failed to mention was that us older clowns on the list have been painting in the same vein as we do now — during the Abstract Expressionist 1950s and its fundamentalist and repressively dogmatic attitudes — right through the 1960s, 1970s, 1980s, 1990s, and still going *ssstttrrong*.

According to this text, our connection to Pop art was our appropriation of some of the Pop elements — whether formal or narrative — such as the banal, the popular and its vulgar "kitsch". We were supposedly fascinated with the exotic and would flirt with religious and mystic symbolism as a reaction to the art market's linear ongoing dialogue and its verbal packaging and the megabucks involved.

In those days "they" called us naive illustrators, reactionary academics painting imagery with an antiquated language (or technique), and any art gallery that respected itself wouldn't touch us with a ten-foot malstick. Yet respected art critics include us in *their* textbooks. So something *was* contributed by us to art history after all!

Here I must correct myself: the linear, two-dimensional unfolding dialogue in twentieth-century *western* art, which deals with "palpable" reality, textural reality, everyday reality, pragmatic interaction, construction of futures, accumulation of wealth, "dollars and sense", photo-reality, political reality, numbers reality, scientific reality, cosmic reality ... and here the borders of reality start to get blurry again, and fear of the unknown seeps in surreptitiously. Words such as "visionary", "fantasy", "mysticism" and "multi-dimensional realities" were considered suspect or downright taboo. Only during the psychedelic 1960s and through the consequent search into oriental cultures for answers to such phenomena as quanta and relativity in science, were we "neo-mystics" led to create the imagery that could trigger some sort of holistic understanding of the ongoing miracle of awareness that we are experiencing. Before we trusted only the irreducible to be real. We know that

reality is what contradicts itself most. Following any train of thought to its bitter end we invariably end up as lap doGs on God's lap.

The mystic rebellion in the art world emerged in the post-war period when the atom of matter was smashed forever and converted into pure wrath-of-God energy, destroying man's rigid, prideful single-mindedness, and making us see the light — or, more precisely, to make us see that *everything* is light.

Which brings us to the conclusion that, if everything is light, and matter is illusion, then the banal and the trite are equally beautiful in the accepted paradigm of beauty, and a Brillo-pad box, if presented in an unexpected context, can be as magic as the Venus de Milo taking a shower in your bathroom. Nothing is anything by itself, only when juxtaposed to something else.

Venosa, searching for the brighter light, learned the tempera and oil glazing technique — used by Albrecht Dürer and Jan Van Eyck — from yours truly in New York and Professor Ernst Fuchs in Vienna, and opted to perfect it in a state of mind of jewel-like clarity. He uses photorealism on some of his canvases only to lure us through its "reality" into his own inner world of swirling and seraphic energies. A sensual dance of reptilian dimensions surfing upon the delights of perfect organic harmony, between one instant and another. The harmony of cellular growth to the rhythm of the golden mean interacting with diabolical symmetry where expansion and entropy forever gain over the powers of retention and memory.

His are forms from the future days when the artist will be the genetic manipulator of new living organisms, whether vegetable or animal, with results as astounding and as extraordinary as we and our cabbages are today, or even more so ...

Mati Klarwein

Deia, Mallorca

It has been more than twenty years since I first became aware of Robert Venosa's work. His paintings have always radiated a fresh, pearl-like aura, reflecting that refined yet archaic Mediterranean world where we first met (Bob was living in Cadaqués, Spain — home to Salvador Dali and a number of other noted artists).

Then, as now, his art has reflected a crystalline fantasy, however the change I see is that his world has expanded significantly. Gigantic semi-precious stone veins formed from white lines produce convex as well as concave highlights, spreading across a frozen world like a gigantic net. Again and again these lines compress into regal heads in all dimensions. This scenery, formed as if by accident, seems to be the two-dimensional original pattern for three-dimensional, crystalline, and semi-precious stone worlds, and seems a mere detail of infinite parallel worlds that could very possibly materialize all of a sudden by just a small alteration of its sphere. The biggest thrill would be to touch this imaginary cool, smooth surface. This superior superficiality contains at the same time the horror that one experiences when comprehending its infinite expansion and vastness. Like the cosmos itself! I don't know of any other art that would better suit its creator.

His large painting of *Ayahuasca Dream*, 1996, where the color yellow dominates, reminds me of a room made of amber where the random flow of the resin has frozen in time. Grandeur seems to dominate this royal scenery. A preponderance of female heads, always without emotion, aesthetically adorned with crowns and gigantic headdresses, in various dimensions, rise in terrace form, endlessly. Reality seems to have been excluded. The only possible comparison is with Ernst Fuchs and his timeless artificiality. The thing that always interests me in viewing such work is the mania that seems to be present with most artists. Namely the accentuation and the strengthening of once-recognized faces, as if they had to prove the existence of their fantasies.

It has been a while since I have confronted Bob's work. The latest large-format canvases are overwhelming. They became more monochrome, so one finds oneself in a world of white resolving into the darkest color shadings. I would be delighted to experience one of these images in three-dimensional form and to touch these ethereal figures and faces with my hands. One is under the impression that the images have always existed — timeless, as in all transcendent art.

Perhaps all this sounds cloyingly positive, as if his art did not originate from any negative space at all. However, the transparent spheres he paints could be a macro- as well as micro-cosmos, which at the same

time encapsulates and struggles with a fear of these cosmic dimensions, where man is nothing — less than a dust particle. Whoever gets ensnared in Venosa's paintings — images where there is no up nor down, no in nor out — swims or floats in an otherworldly space where no object will remind you of the human existence. It is a sparkling realm of translucent, seraphic faces and fleshless celestial bodies, as if the artist were attempting a purity in both form and expression that he could not find in this reality. Here no malady can occur, at least not in the usual sense of the word. All imagined imperfections are detached from the human entity. Under his unique microscope, the worst epidemics can manifest as a splendor of godlike purity. An inspired being like Venosa has to paint inspiring visions. One expects that from him.

H.R. Giger

Zurich

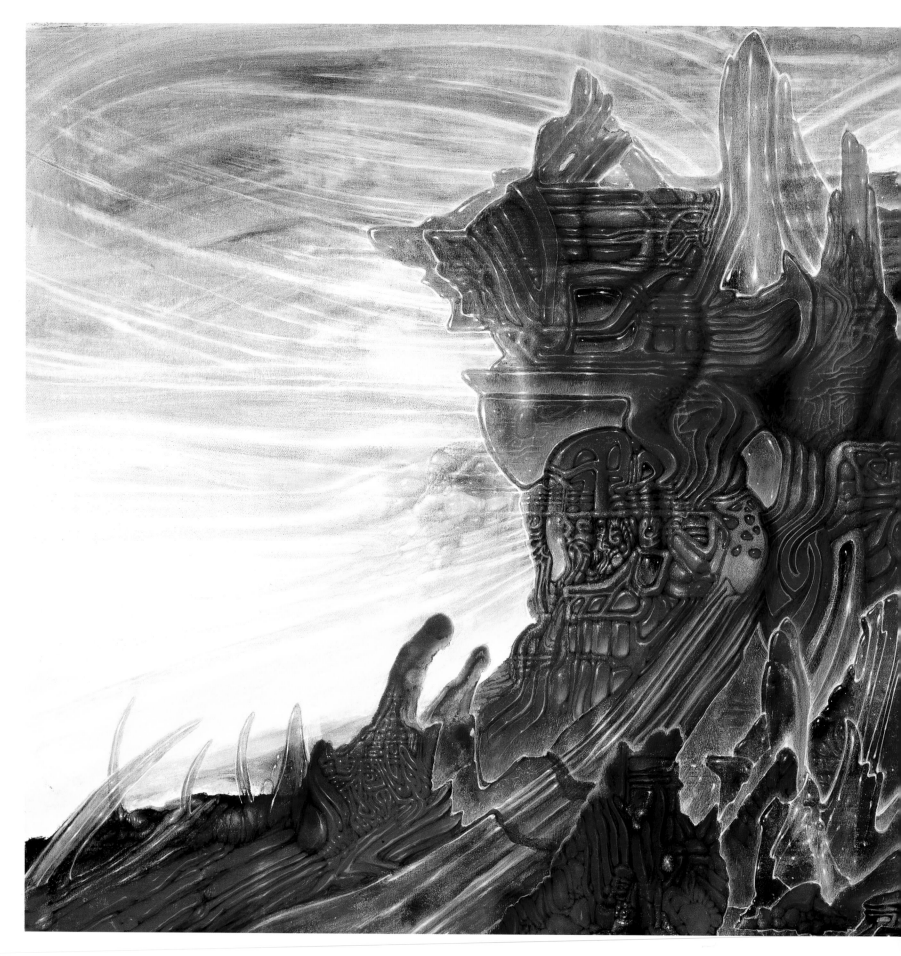

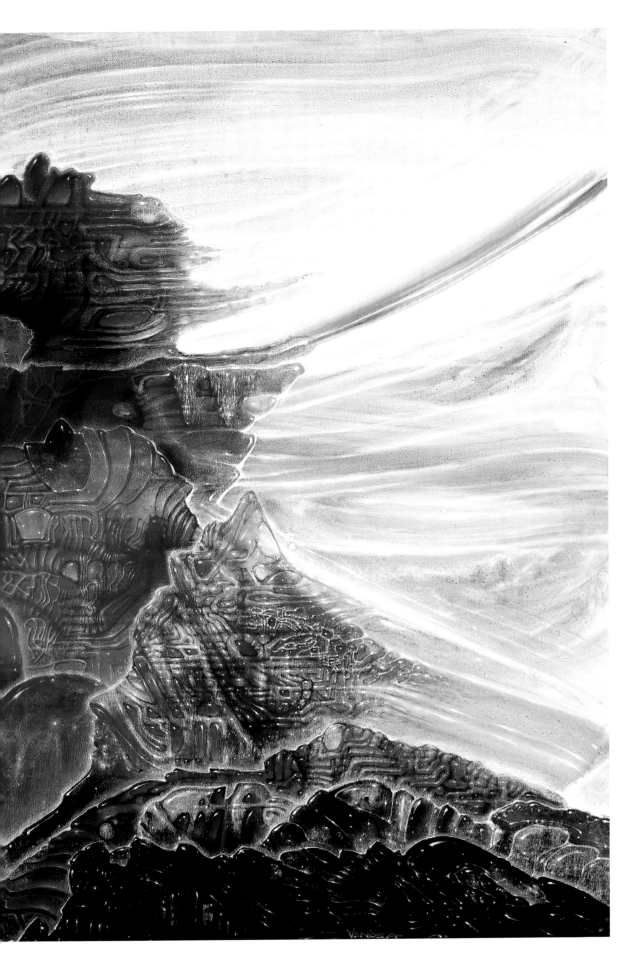

OOTHOON'S PALACE
1998, OIL ON CANVAS, 92 X 152 CM.
PRIVATE COLLECTION

Venosa's vision is simultaneously organic and yet evocative of a crystalline universe. A domain of fractures that is accelerated, erotic and often concerned with women conceived as truly physical forces. These goddesses are mysterious mnemonic attractors and complex vectors that always point towards the unresolved conundrum of the future.

SCHEHERAZADE
1997, OIL ON CANVAS, 44 X 55 CM.
PRIVATE COLLECTION

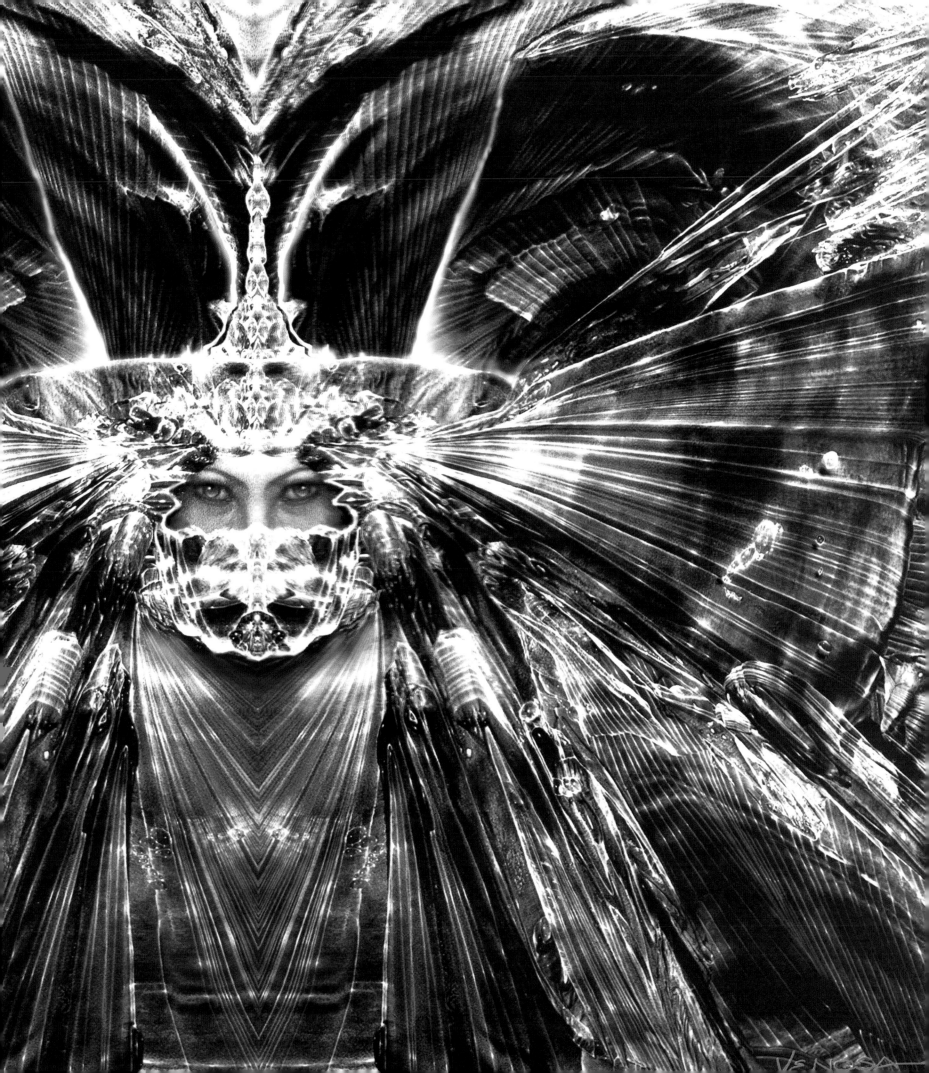

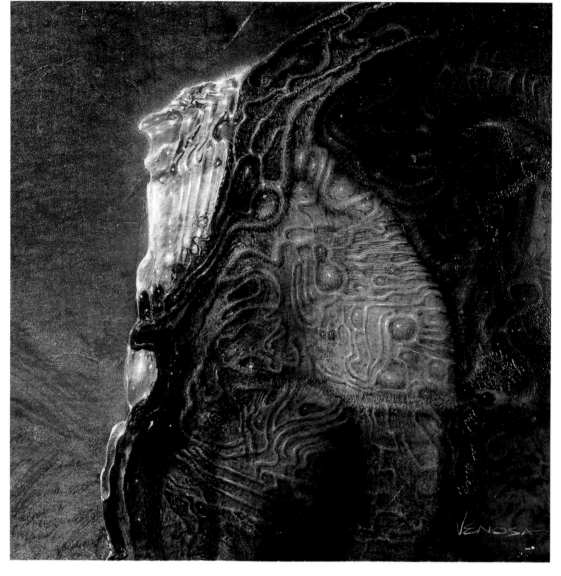

GREYSCAPE
1981, OIL ON CANVAS, 22 X 22 CM.
COLLECTION: MARK TRATOS, LAS VEGAS

MINDSCAPE
1980, OIL ON CANVAS, 25 X 23 CM.
COLLECTION: ADRIAN TANN, TAOS, NEW MEXICO

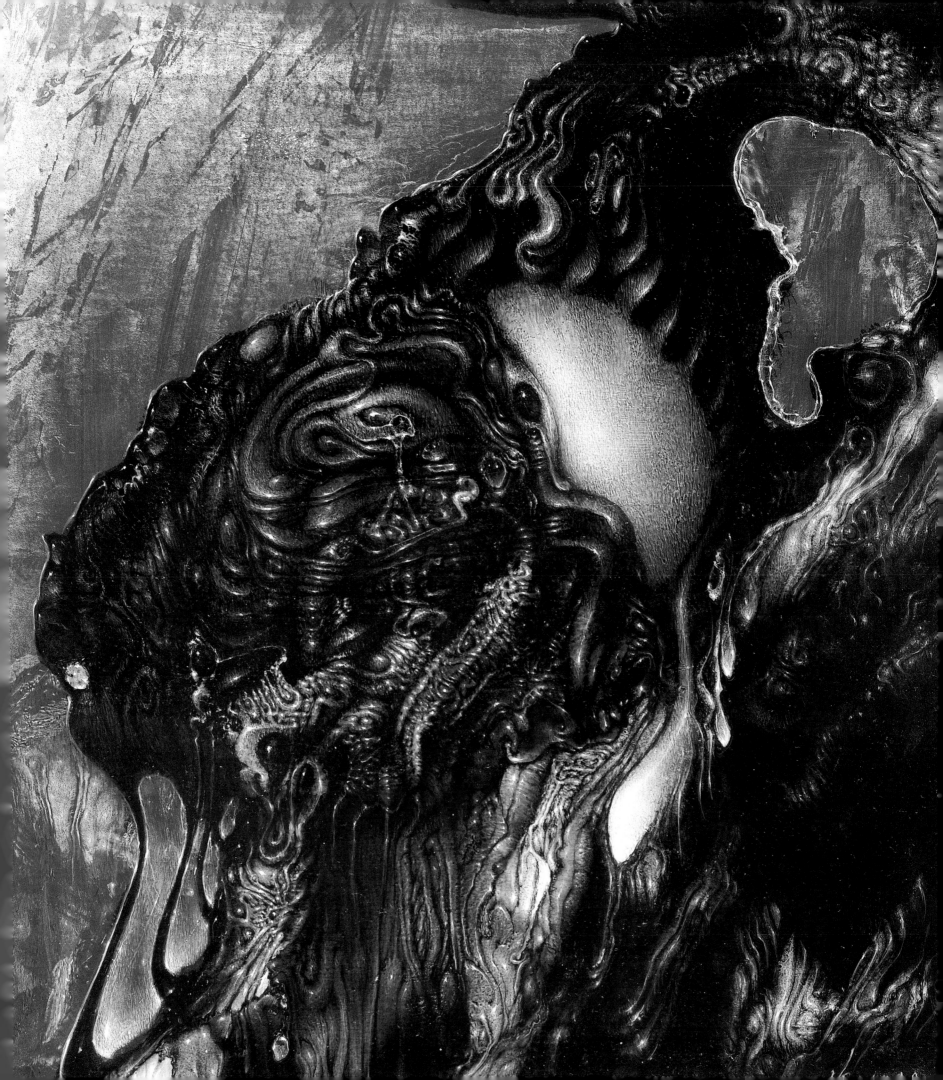

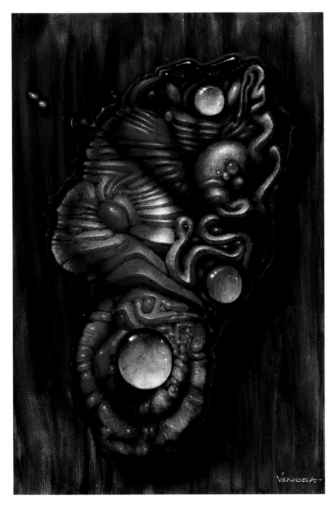

AMORPHOUSIA
1997, OIL ON CANVAS, 46 X 30 CM.
PRIVATE COLLECTION

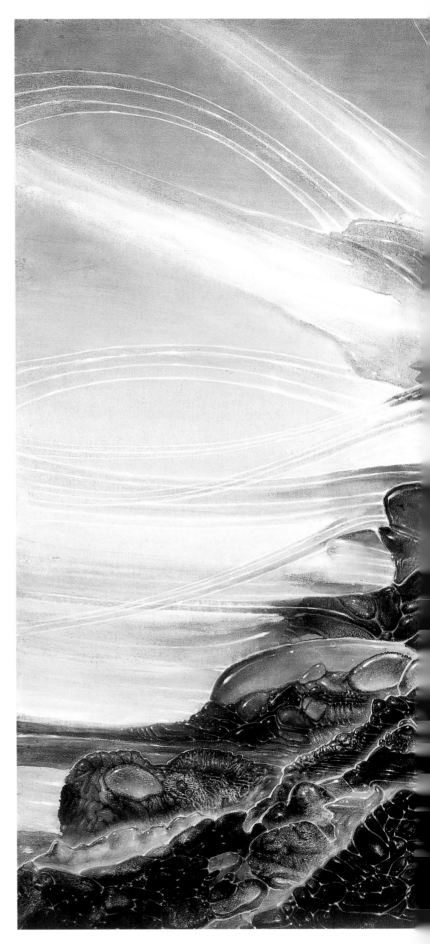

SANCTUM CAELESTIS
1999, OIL ON CANVAS, 89 X 130 CM.
PRIVATE COLLECTION

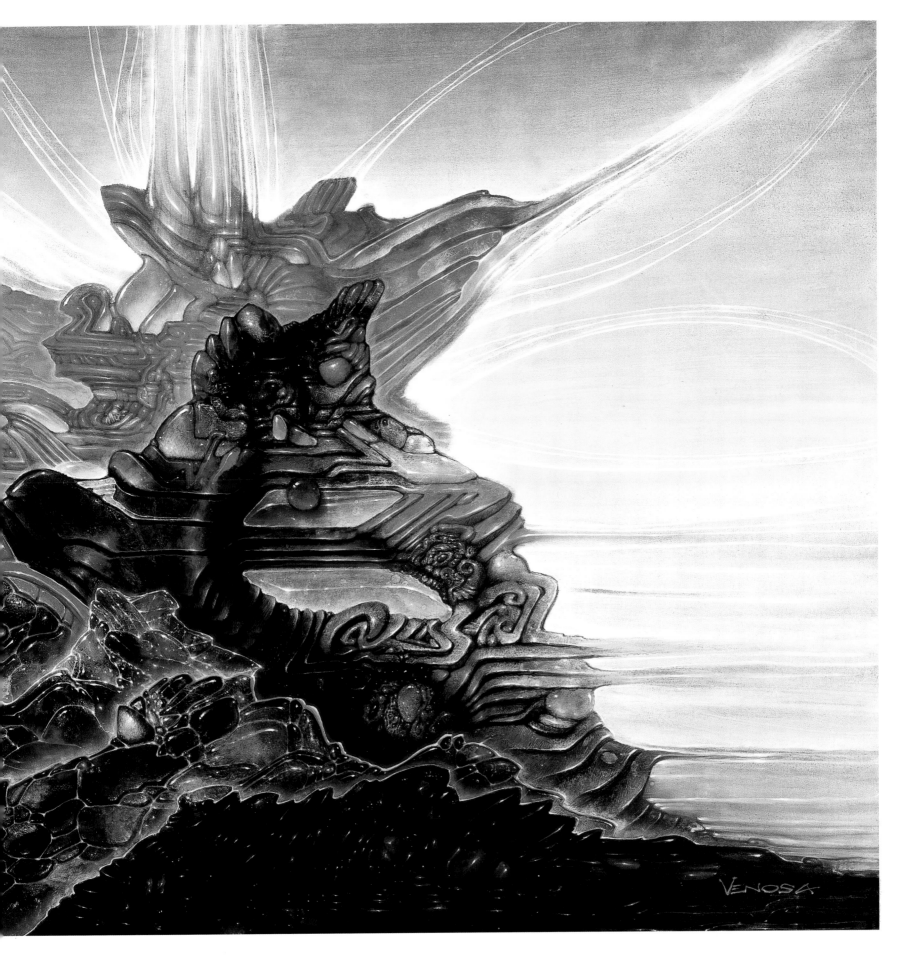

The ayahuasca worlds provide a subject matter resonant with the artist's own taste. Jungle sunlight, trapped by the mysterious labyrinth of photosynthesis, is spectacularly released as a plethora of radiant beings. An adoration, a conjuration, seems to be going on in the negredo-like alembic swirl of the dark foreground, but it is dwarfed by the nobility of the ancestral figures that move silently above the scene and imbue the tableau with an eerie mythic dignity.

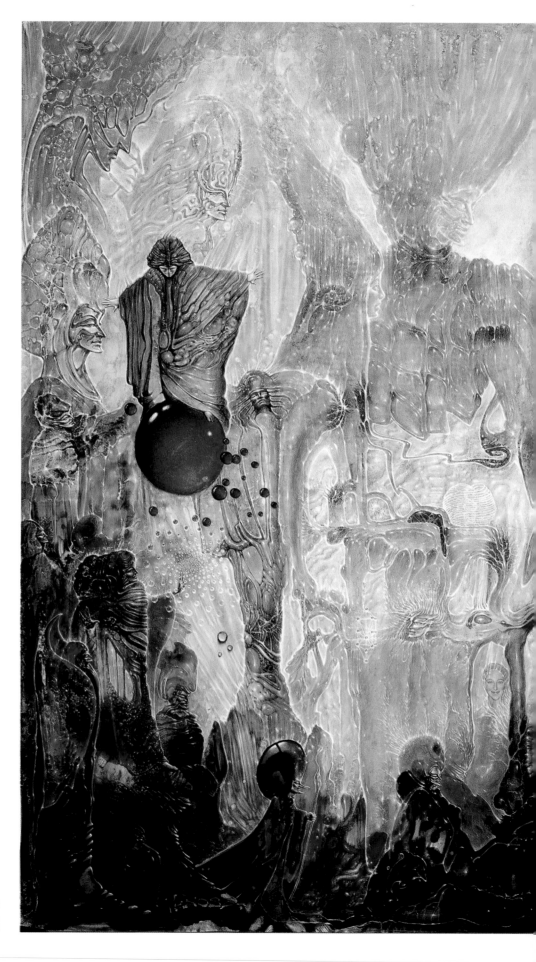

AYAHUASCA DREAM
1996, OIL ON CANVAS, 152 X 218 CM.
PRIVATE COLLECTION

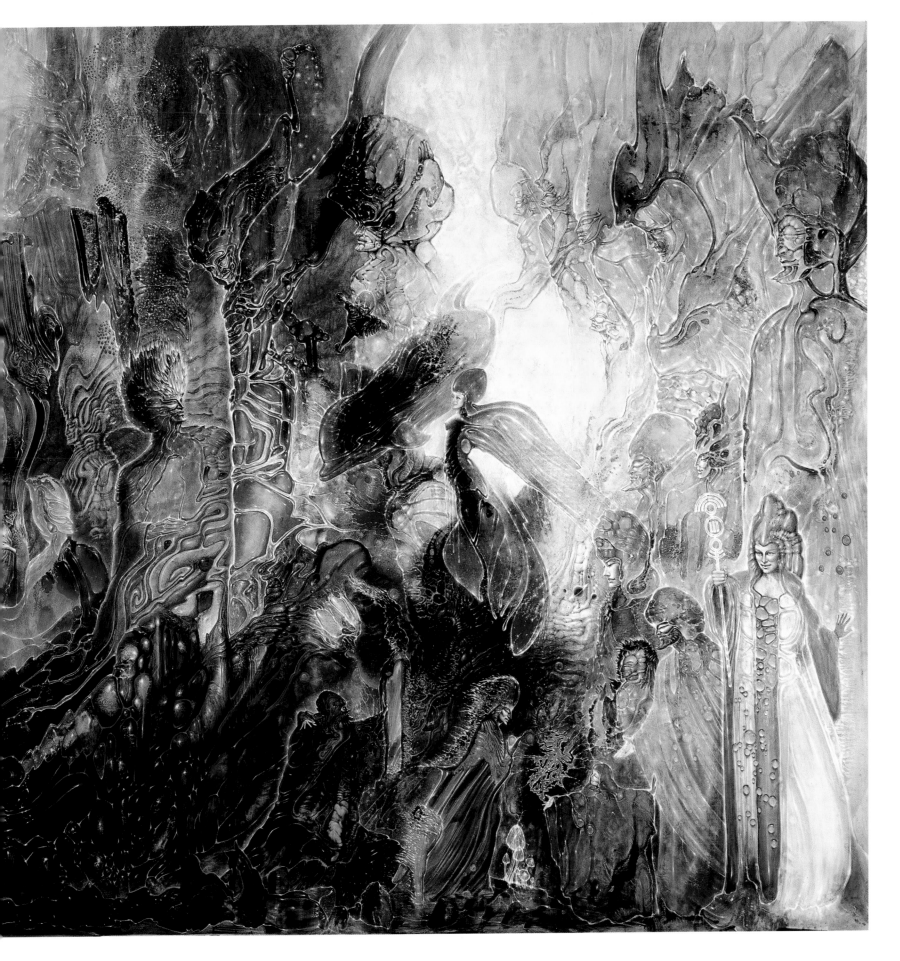

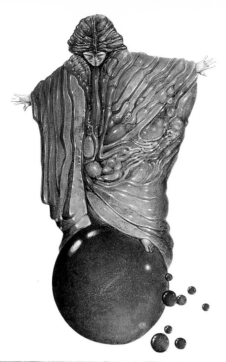

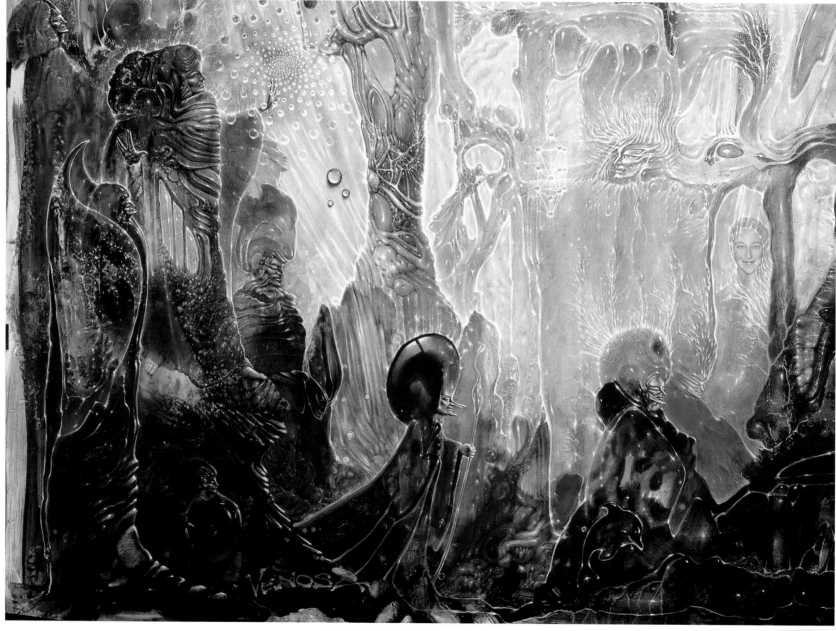

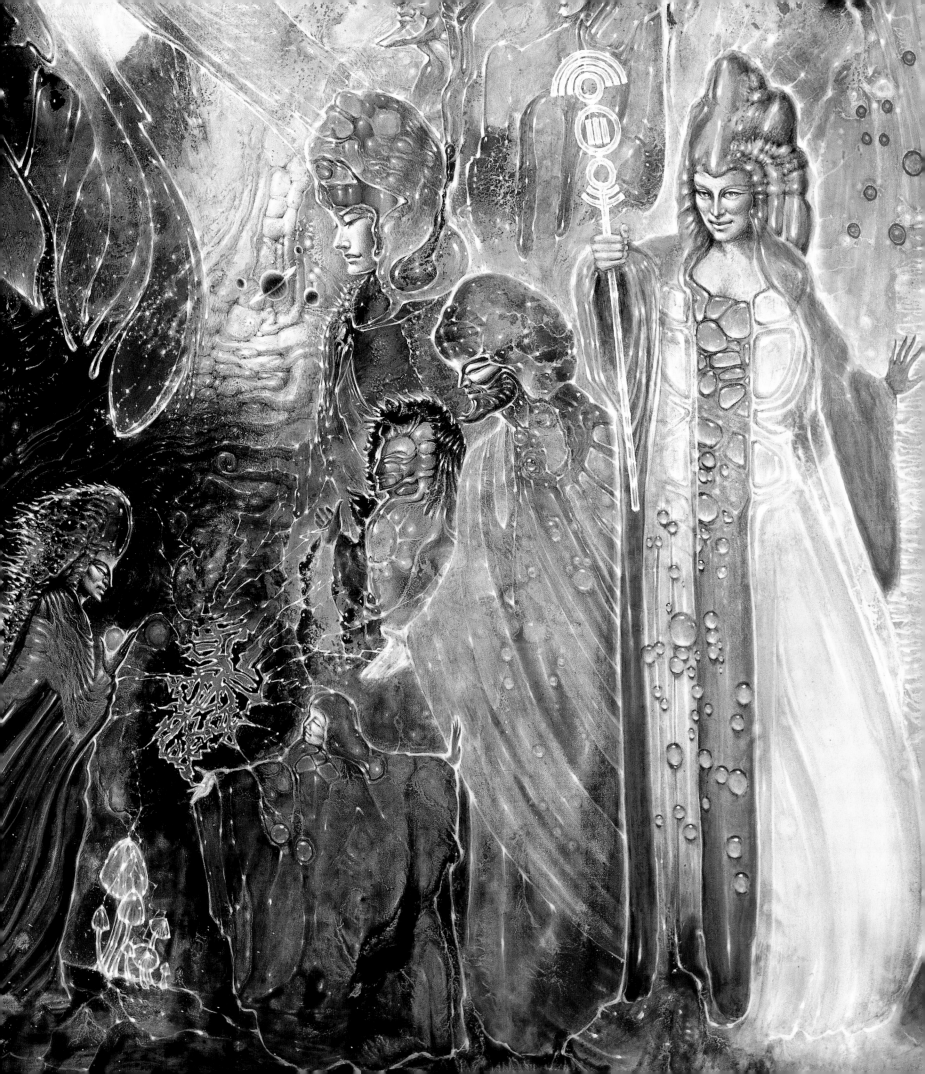

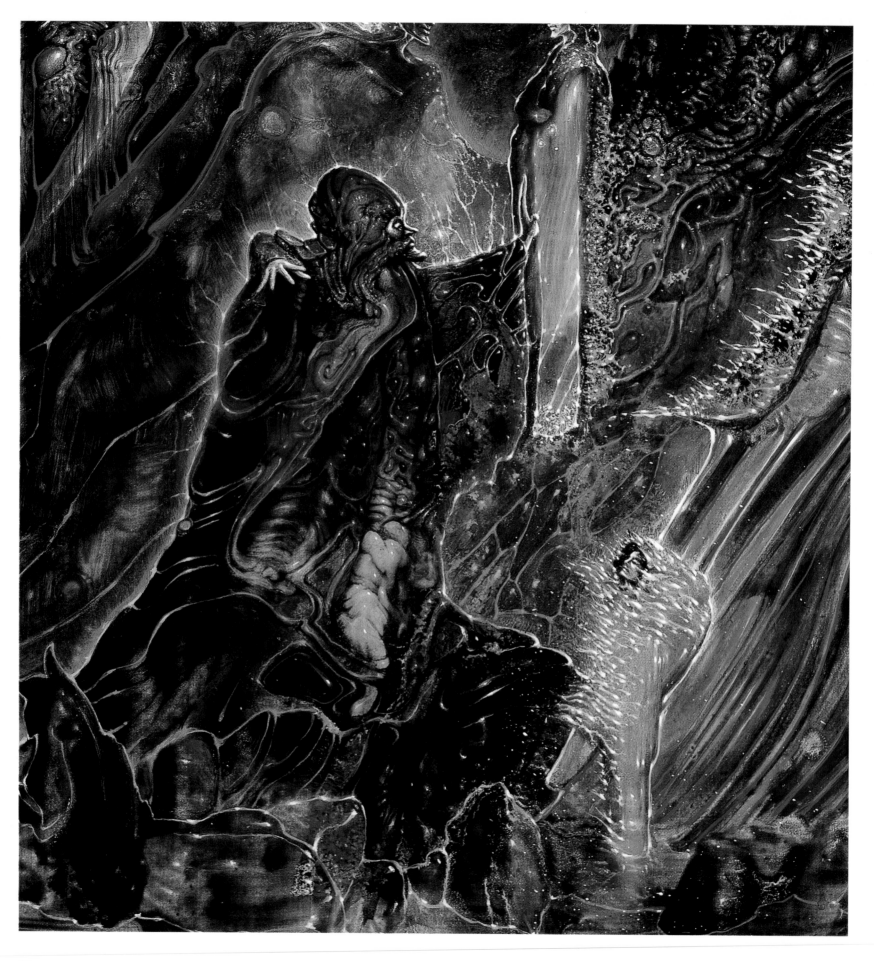

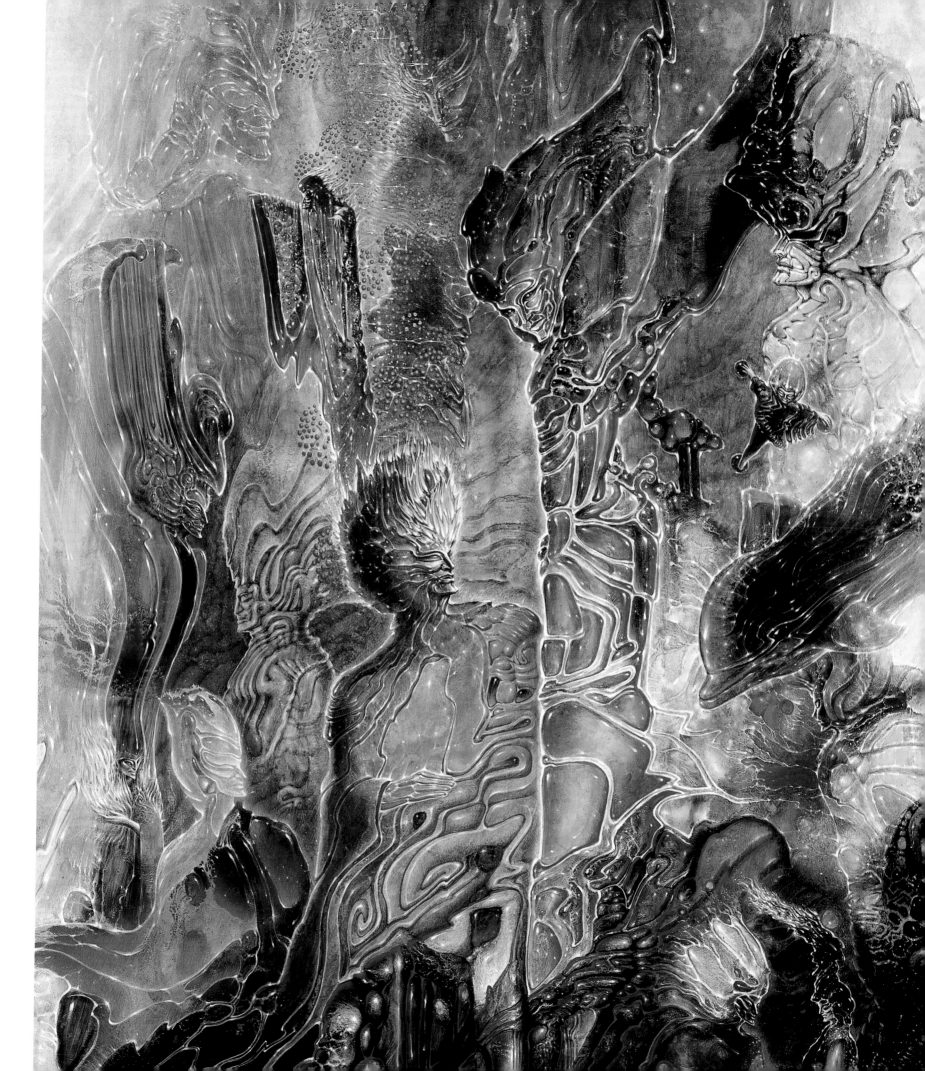

ZIP
1988, OIL ON MASONITE, 9 X 6 CM.
PRIVATE COLLECTION

GRIFFIN
1998, OIL ON MASONITE, 31 X 31 CM.
COLLECTION: SUSAN B. THOMPSON, DENVER

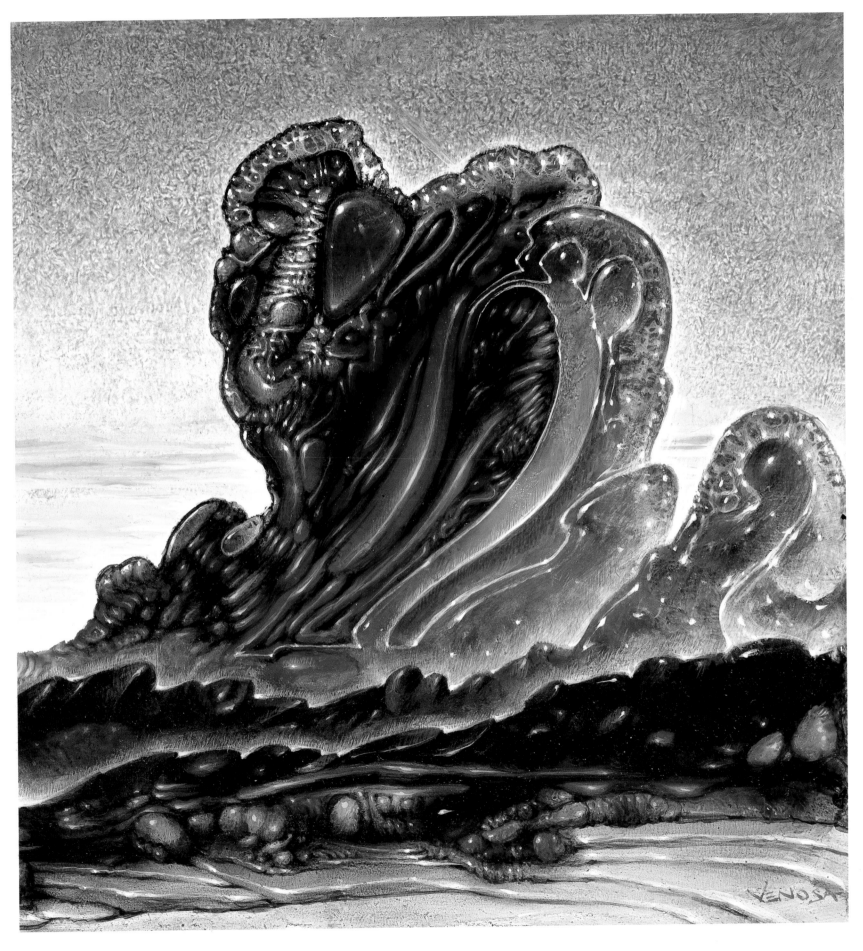

The Buddha nature, fractal and recessional, emerges from and returns to the chatter of atoms and the constraints of the morphological field, landscape as the child of general statistical flux is a recurring theme.

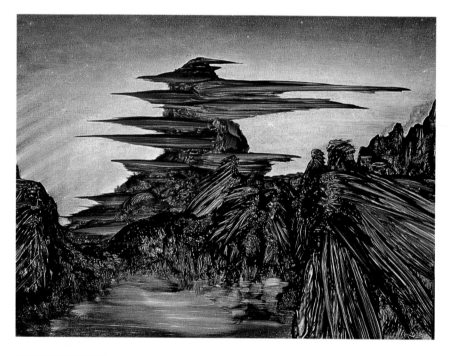

MANSION WORLD
1976, OIL ON CANVAS, 24 X 30 CM.
COLLECTION: MARIA EICHINGER, MUNICH

TOWARDS EDENTIA
1974, OIL ON MASONITE, 30 X 40 CM.
COLLECTION: MARIA MAUTNER-MARKOV, VIENNA

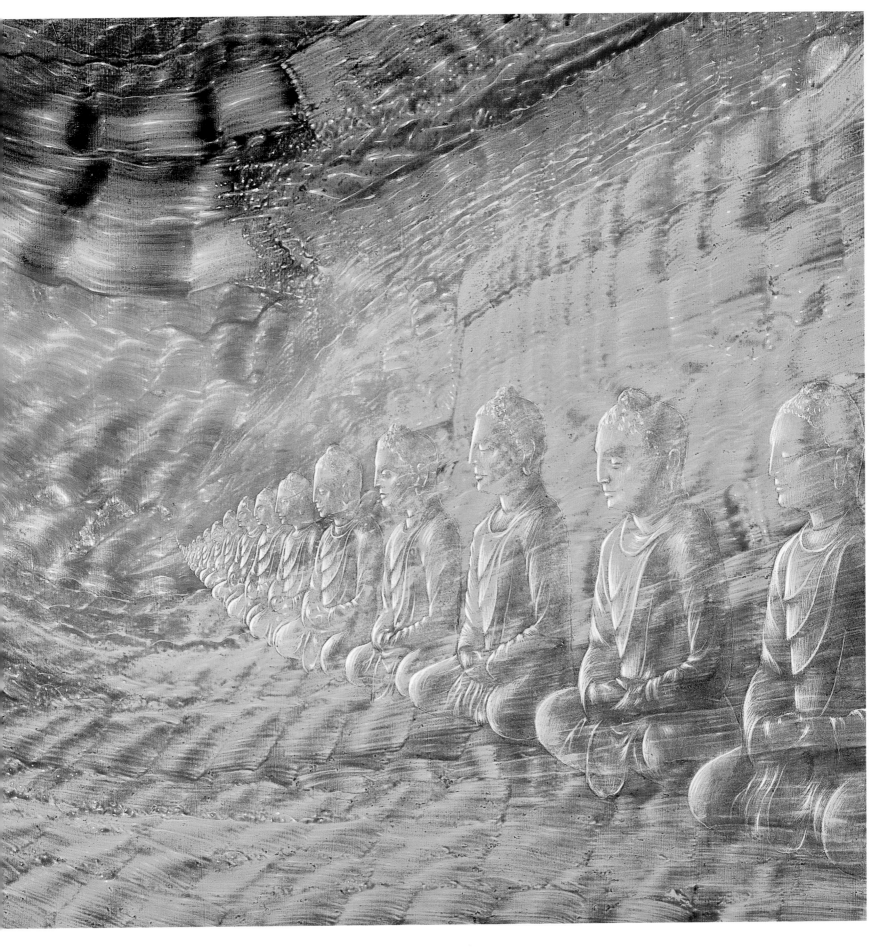

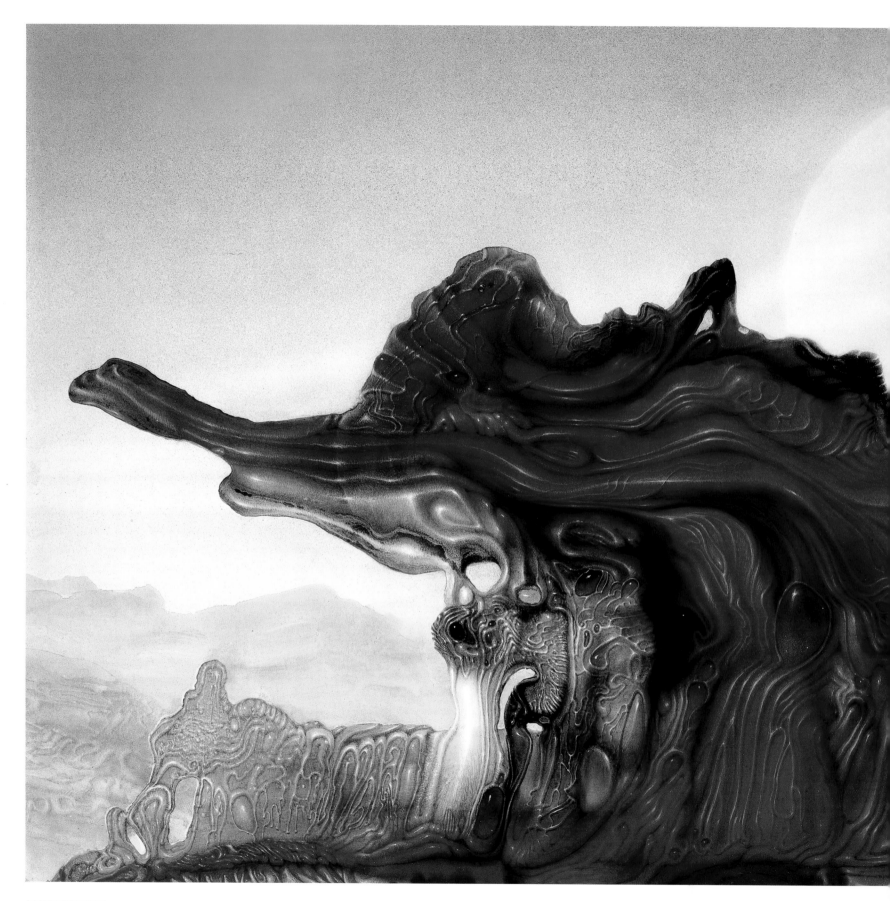

LANDESCAPE IV
1981, OIL ON MASONITE, 70 X 92 CM.
PRIVATE COLLECTION

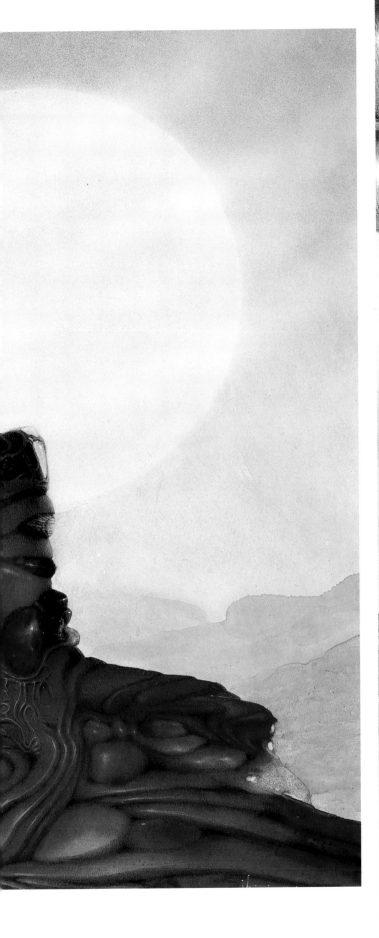
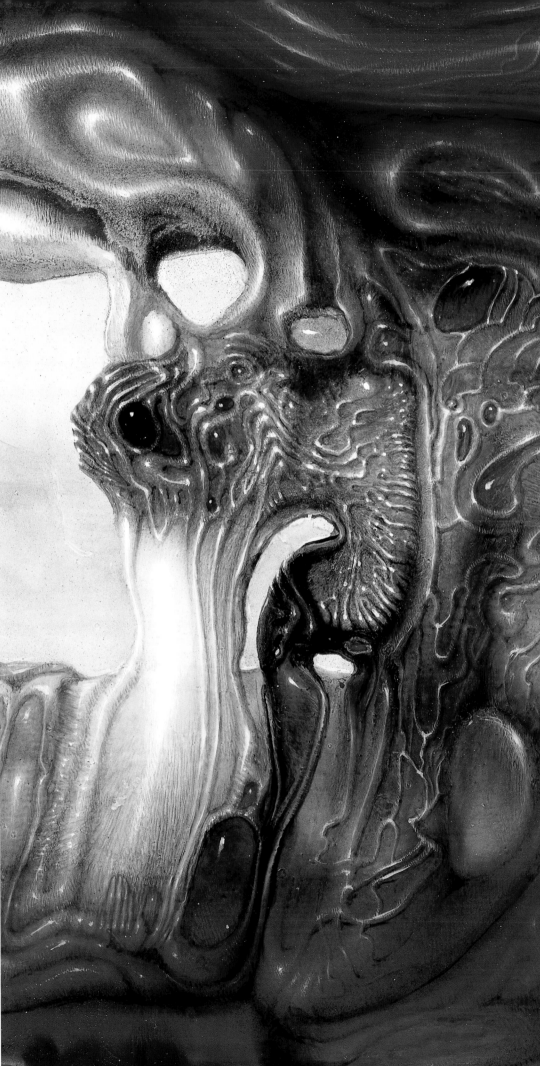

Viscera, jewels, landscape, and flesh, intermingled and at many scales, provide the visual vocabulary of a higher dimensional language of association and feeling. The behavior of paint, not resisting the artist's intent but synchronistically anticipating it, aids the emergence of these alchemical visions.

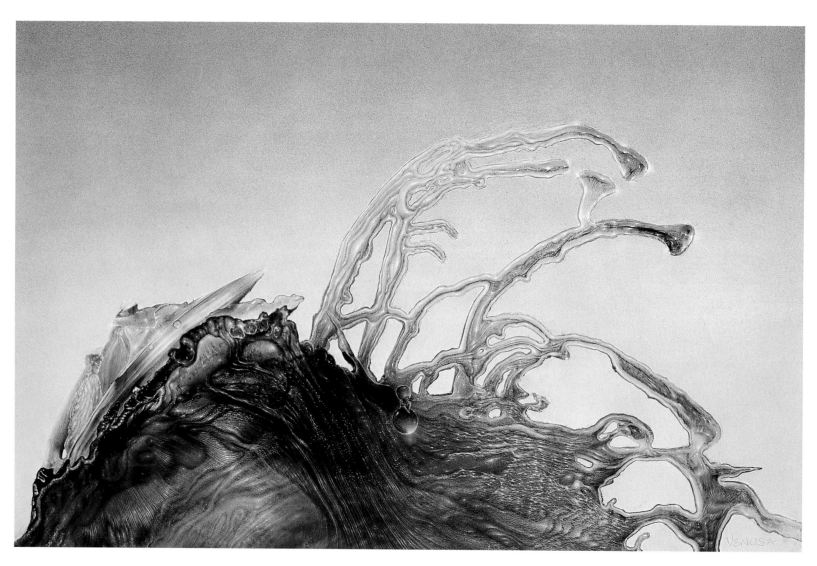

DEVA KNOLL
1979, OIL ON MASONITE, 29 X 43 CM.
COLLECTION: FRANCIS AND LUCIENNE GASC, PARIS

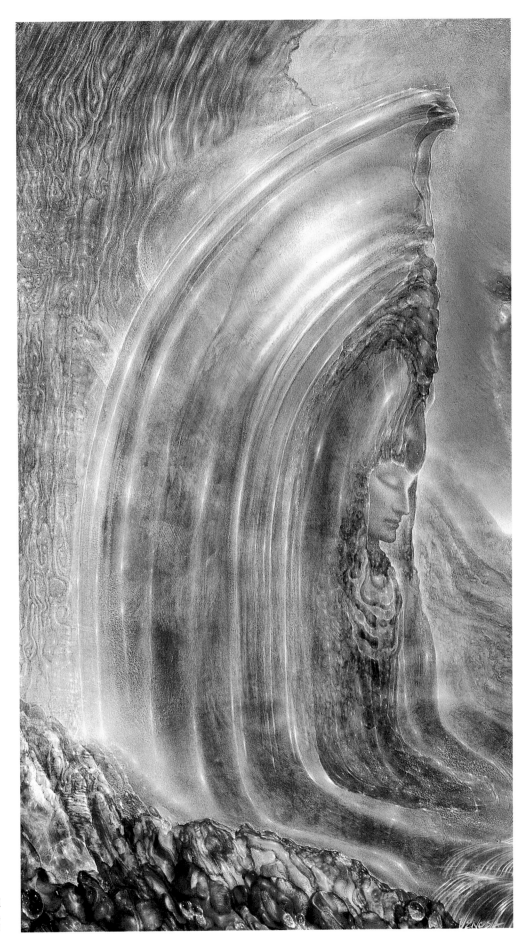

BUDDHASPHINX
1979, OIL ON MASONITE, 53 X 30 CM.
COLLECTION: CAROLYN HARVEY, SAN JOSE

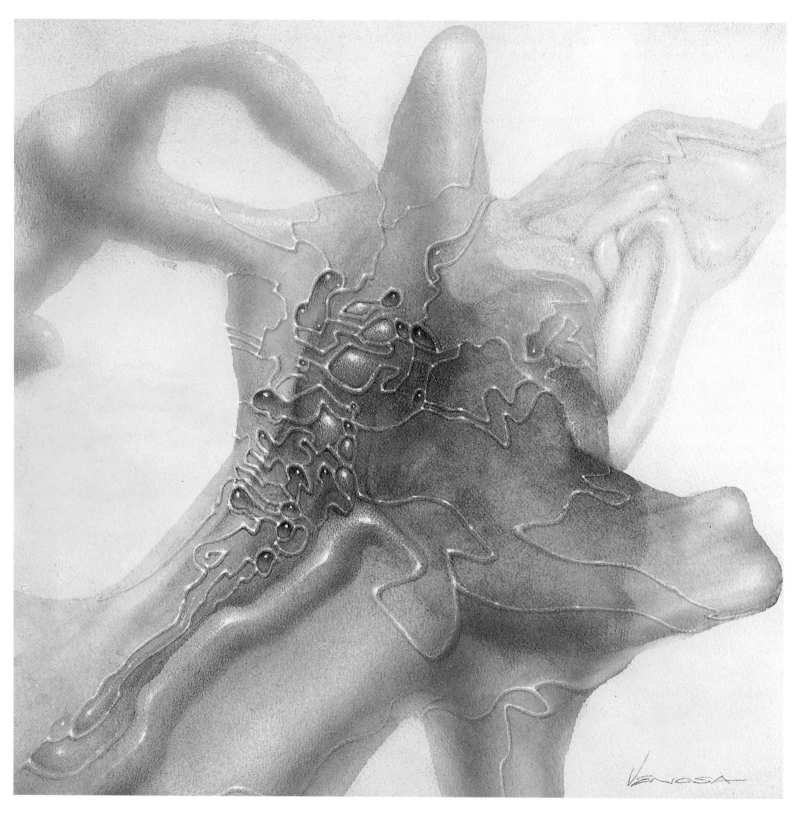

MINDSEND V
1980, WATERCOLOR, 40 X 40 CM.
PRIVATE COLLECTION

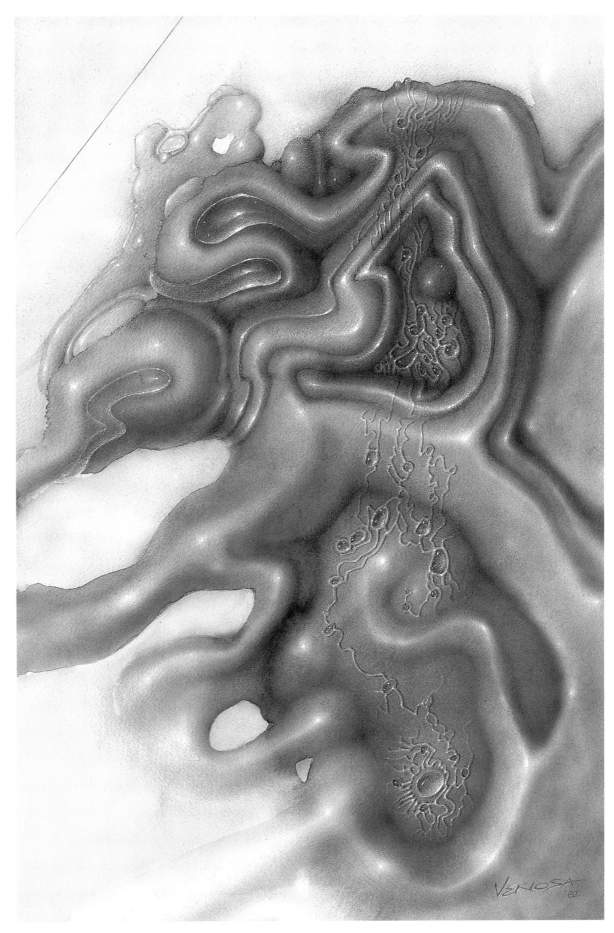

MINDSEND IV
1980, WATERCOLOR, 50 X 40 CM.
COLLECTION: TERENCE McKENNA, HAWAII

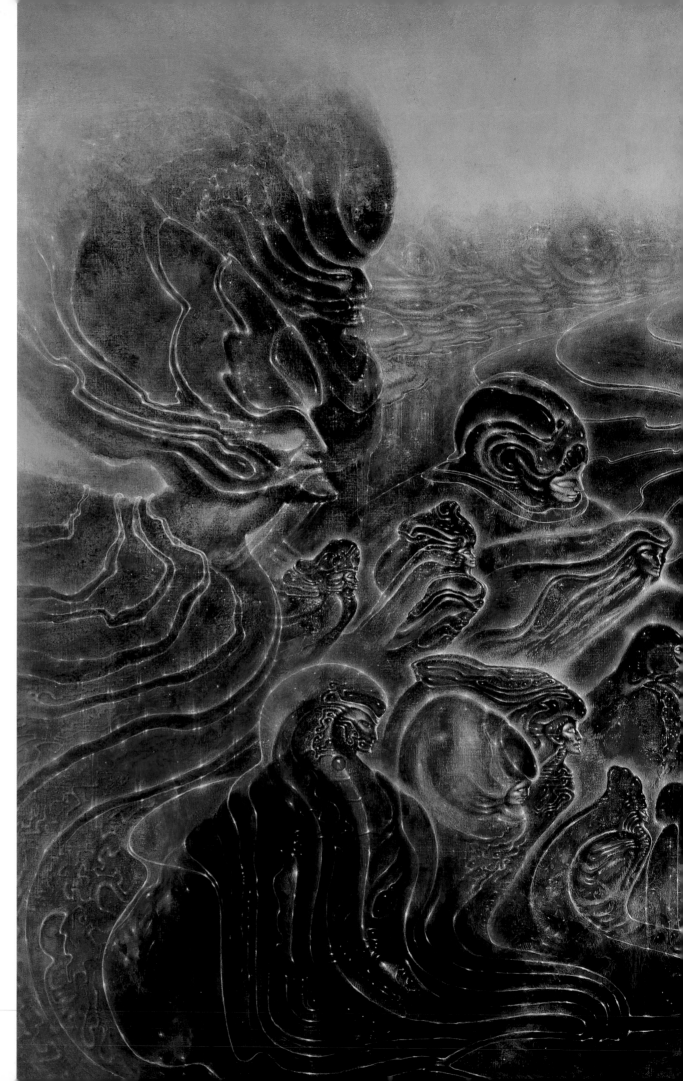

Astral Circus, without doubt, is Venosa's masterpiece. Here painterly intent and depth of spiritual vision are united at the zenith of the artist's powers. *Astral Circus* is akin to two of the most *outré* works in the western canon, Hieronymus Bosch's *Garden of Earthly Delights*, and the lesser known, but equally phantasmagorical, *Fairy Feller's Masterstroke* by Victorian fratricide, Richard Dadd. All three of these works flawlessly, indeed, photographically, render and reveal a teeming world of tiny creatures busy in a timeless, otherworldly dimension. This theme of myriads of diminutive human figures is poignant and prescient. The riot of detail bathes the eye, and the rich reverie of associations has a narrative radiance like epic poetry. Whether what is revealed is eternity or imagination, the emotional impact is undeniable.

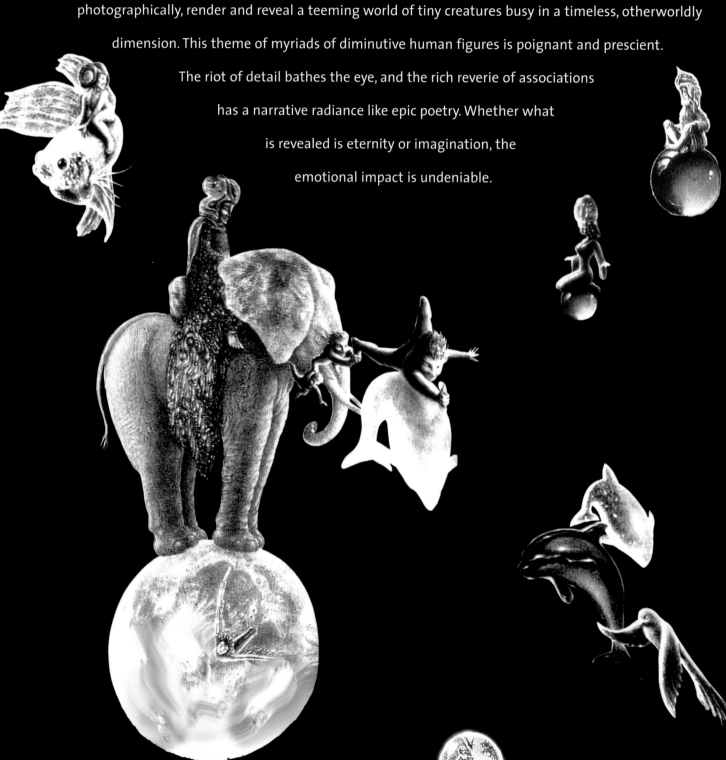

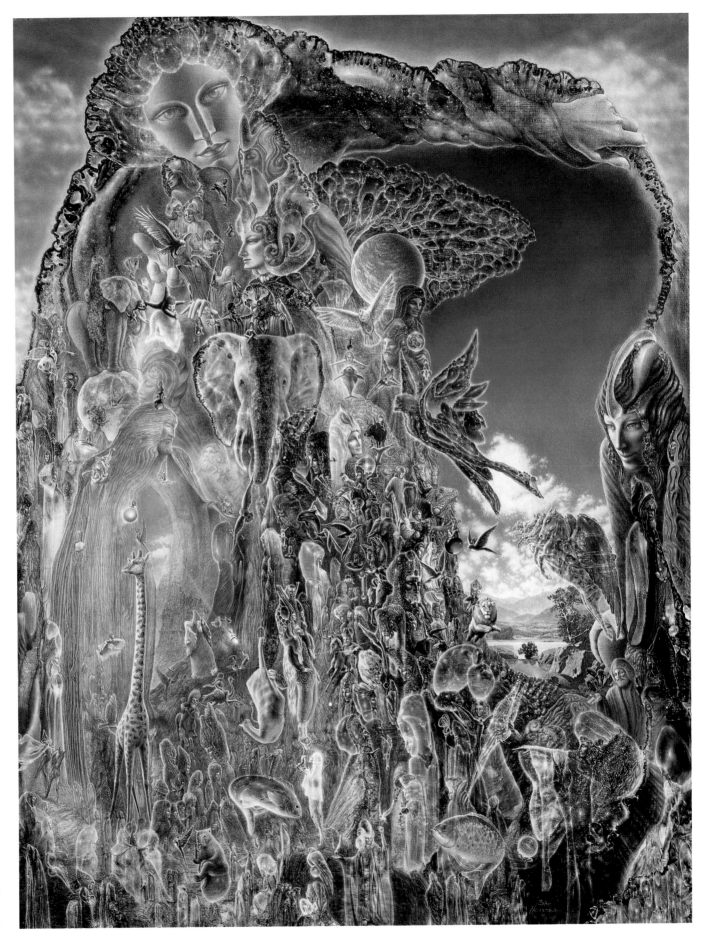

ASTRAL CIRCUS
1976–78, OIL ON MASONITE,
115 X 90 CM.
PRIVATE COLLECTION

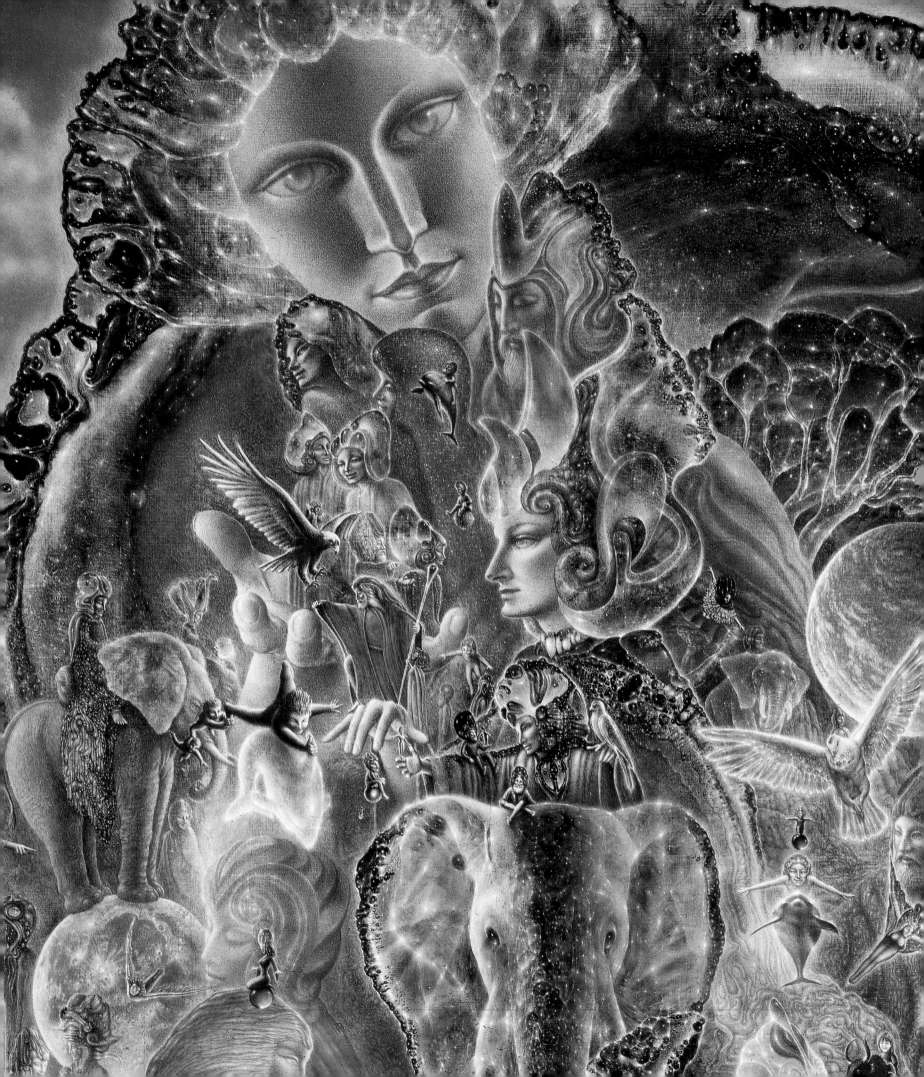

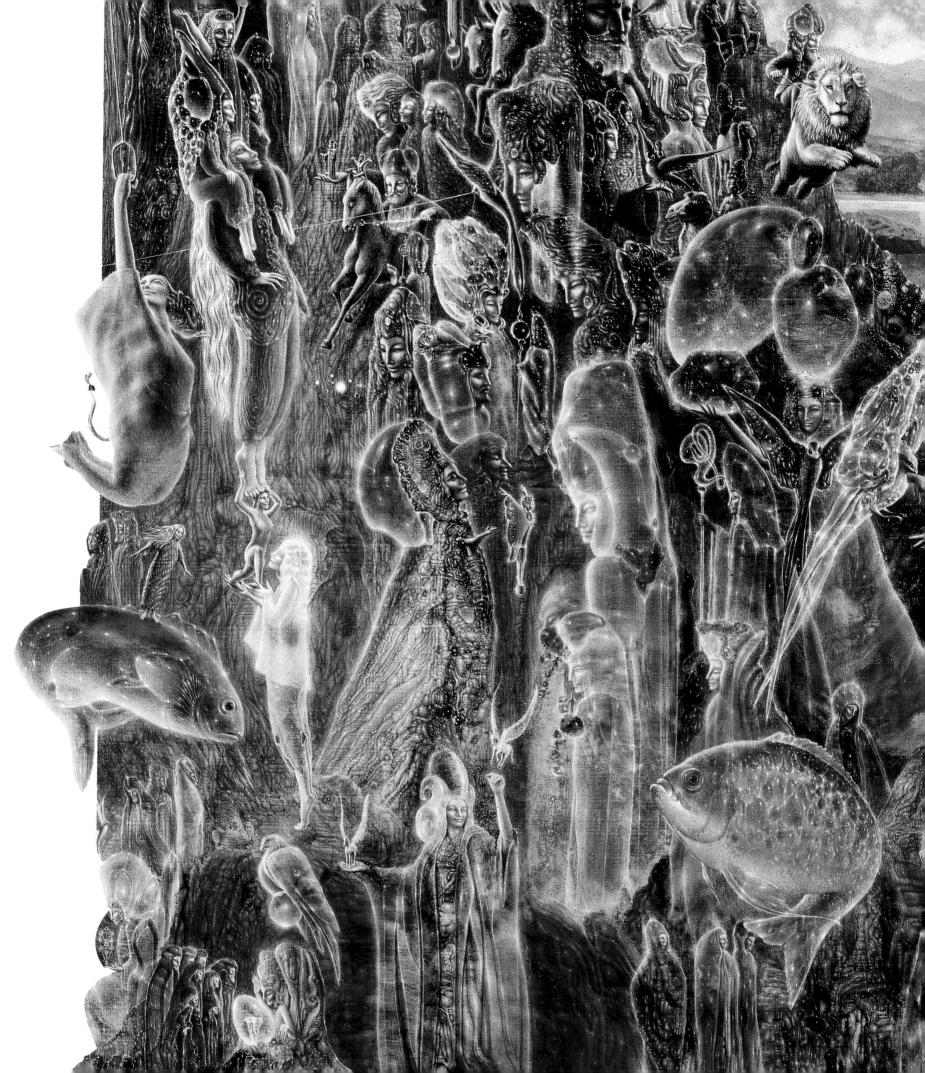

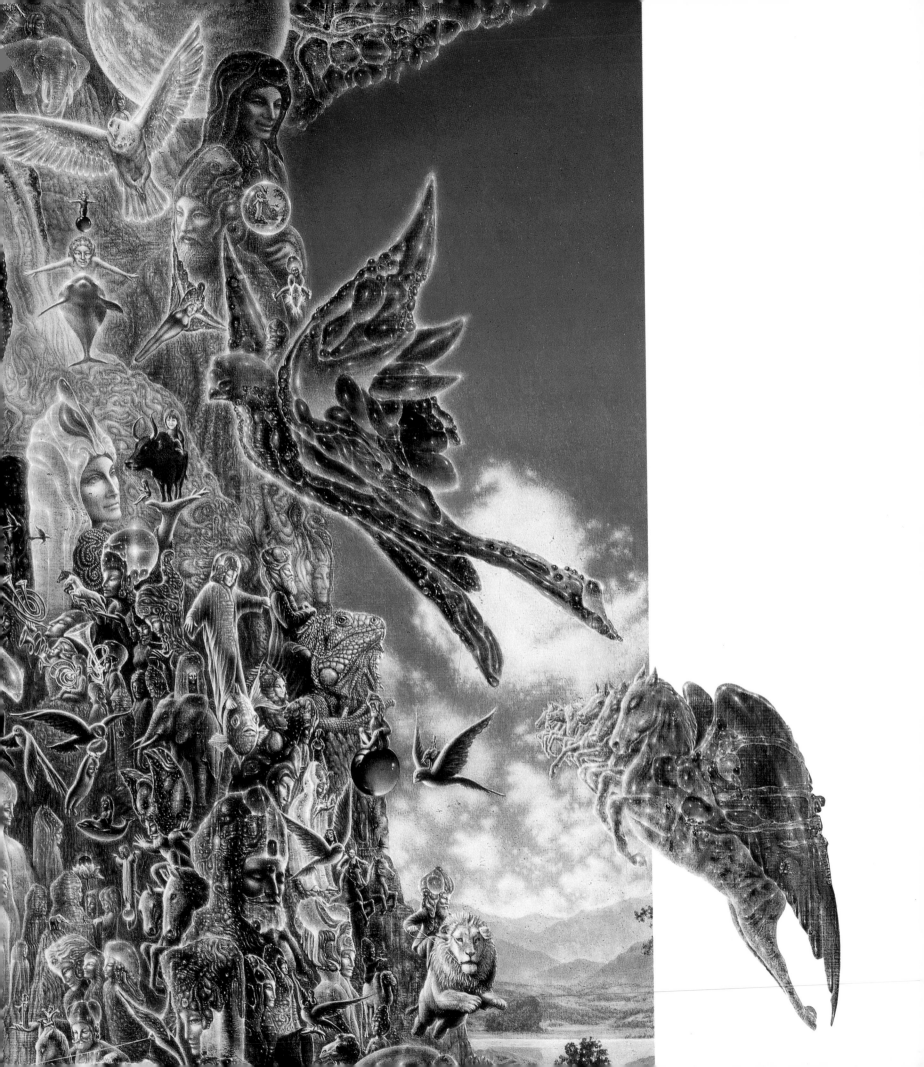

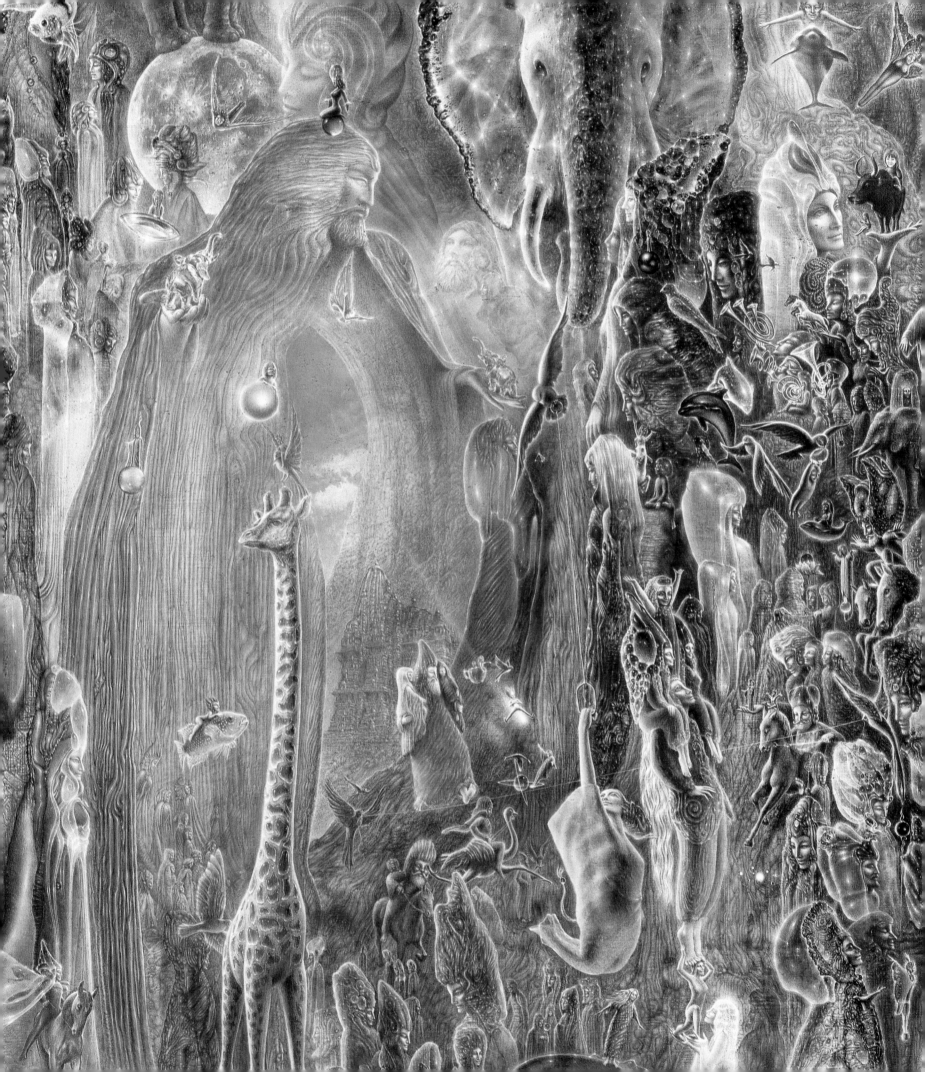

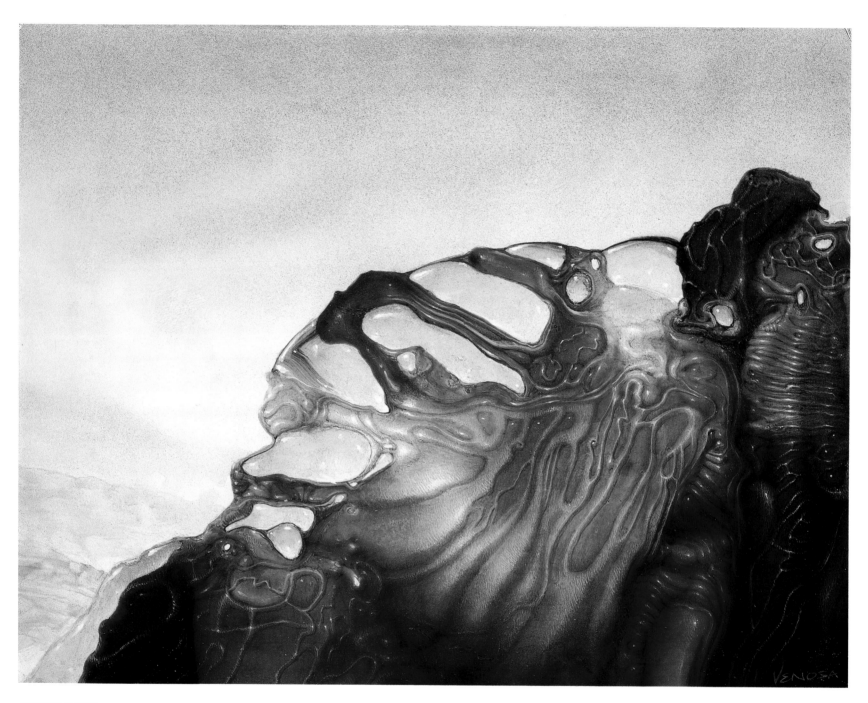

CRYSTAL RIDGE
1988, OIL ON MASONITE, 30 X 40 CM.
COLLECTION: DR CHRISTIAN SCHMIDT, MUNICH

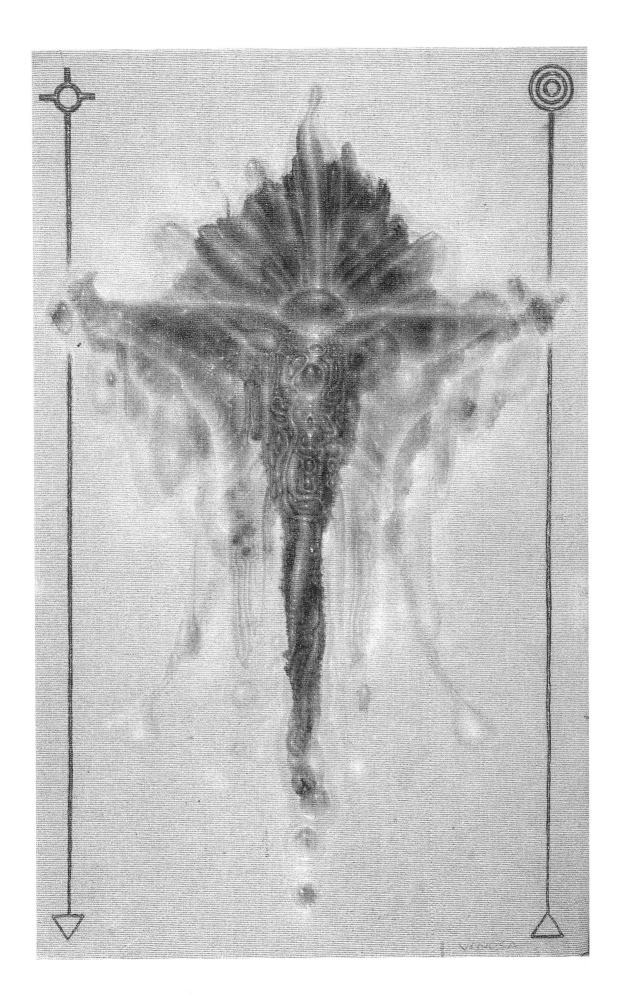

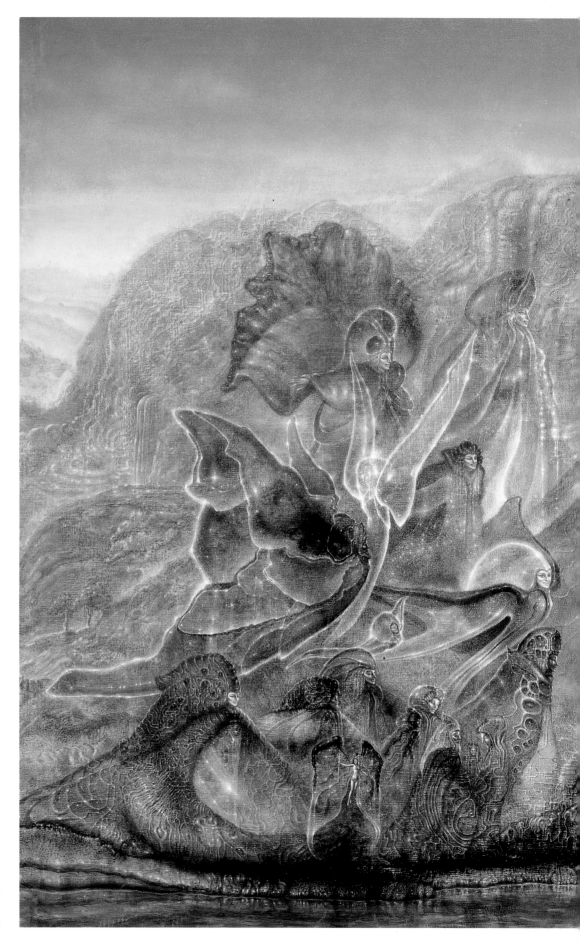

CELESTIAL HOST
1982, OIL ON CANVAS, 92 X 152 CM.
COLLECTION: JOHN HAY, BOULDER, COLORADO

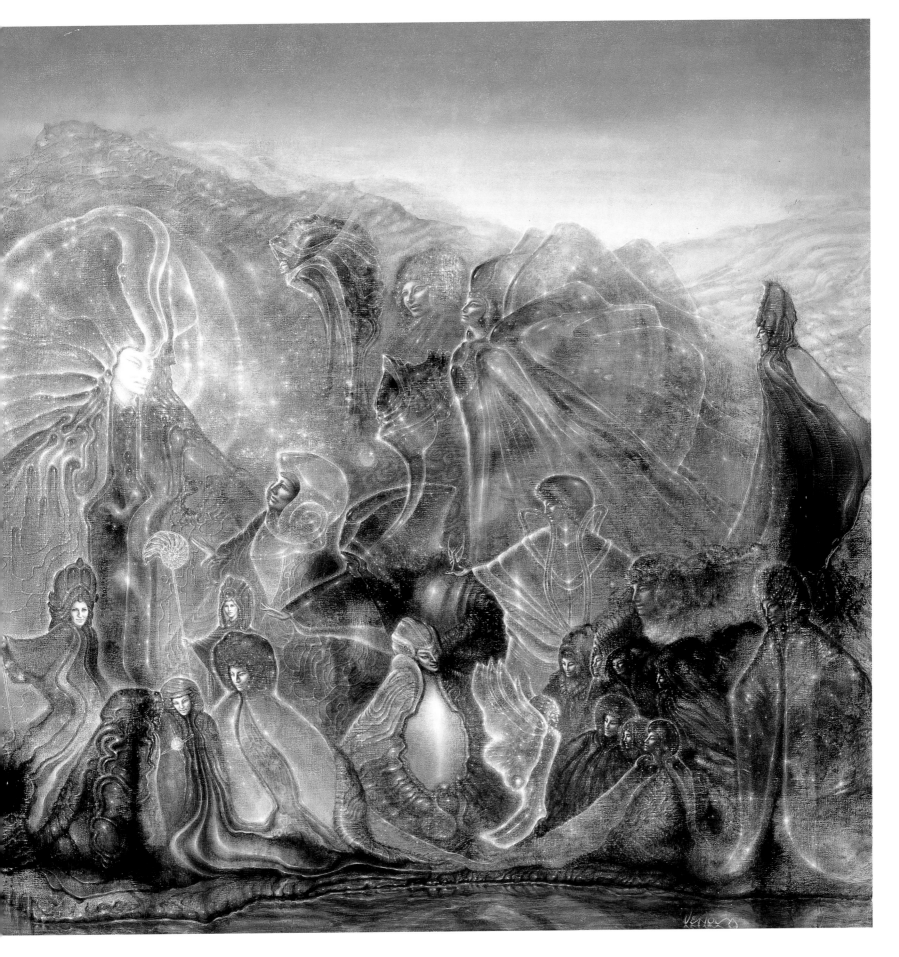

The flowing images in the artist's mind are myriad. They upwell from nearly unimaginable distant worlds that nevertheless are mysteriously within us.

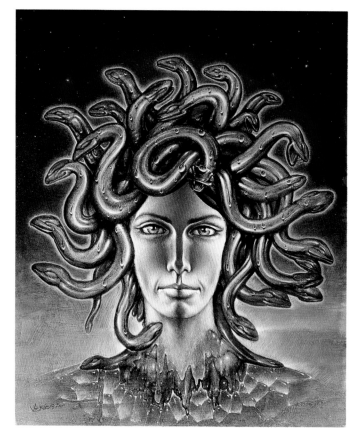

MUSCHADUSA
1995, OIL ON CANVAS, 58 X 45 CM.
COLLECTION: ECKHARD UTPADEL, MUNICH

CEREBRALATION
1982, OIL ON CANVAS, 61 X 54 CM.
COLLECTION: DR CHRISTIAN SCHMIDT, MUNICH

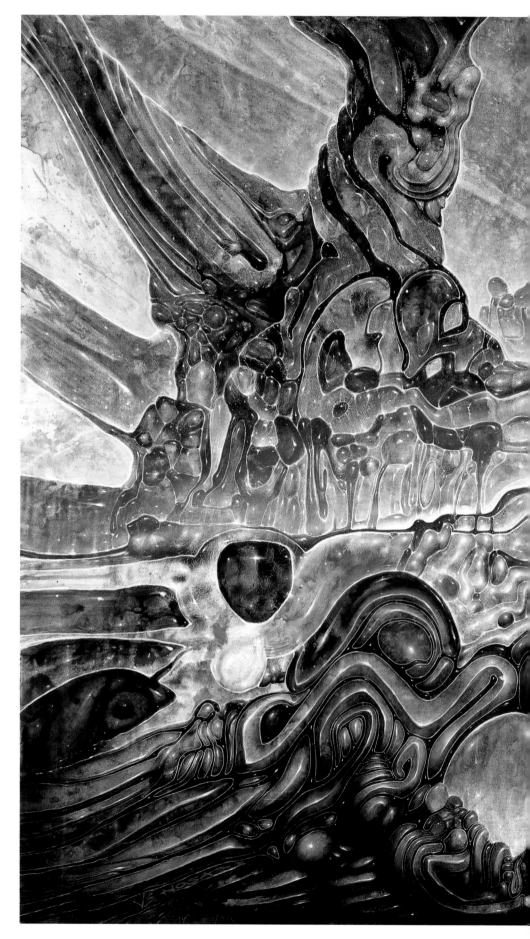

ANGELIC AWAKENING
1992, OIL ON CANVAS, 138 X 215 CM.
PRIVATE COLLECTION

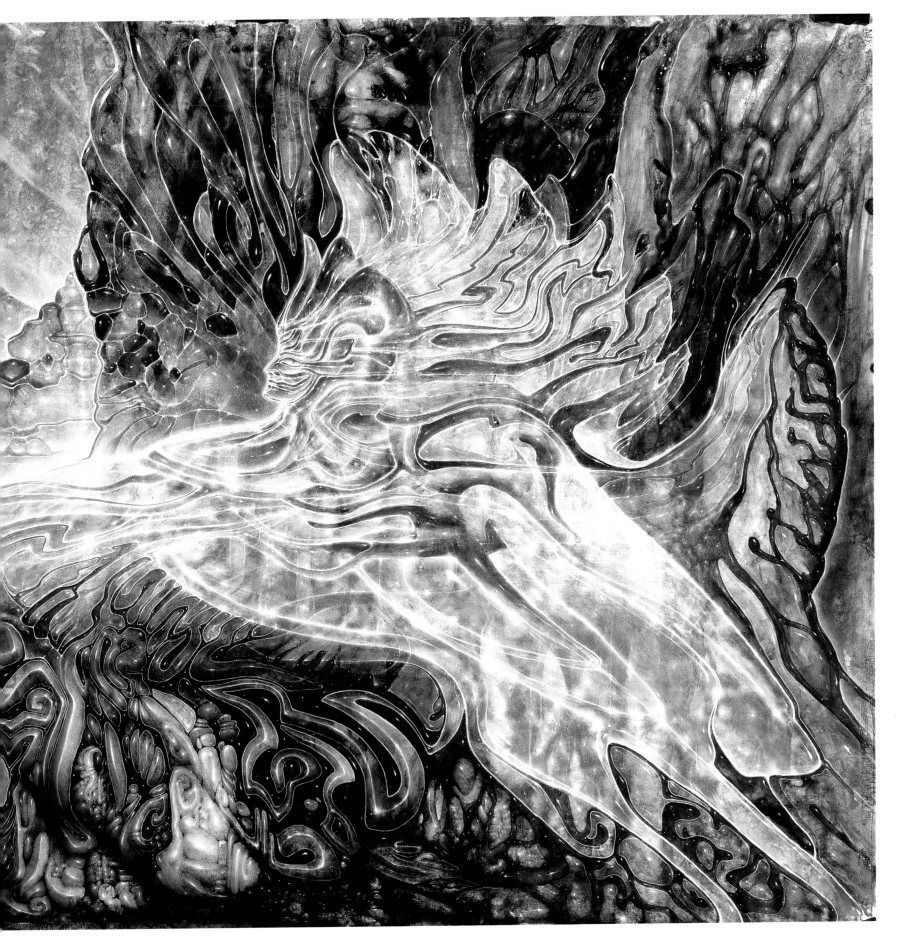

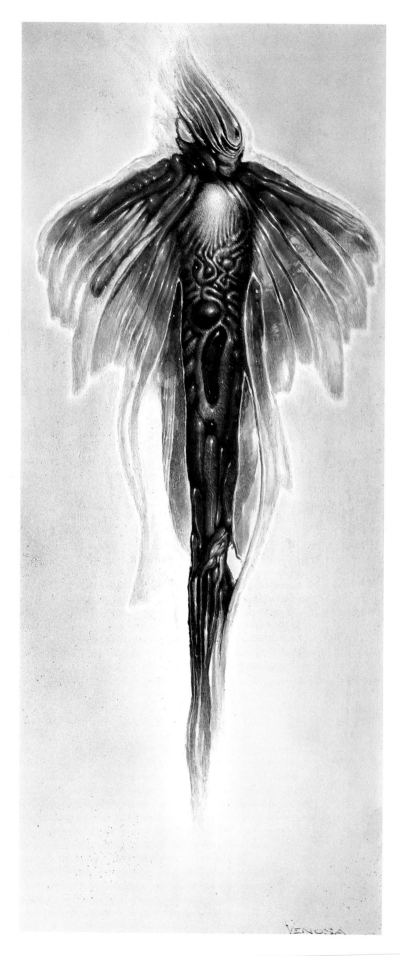

Angelic murmurs directly ignite synaptic scintilla carrying once dark visions along the neural net, now living light in the artist's alembic, a metamorphosis into the final perfected elixir of form and color.

SIENNA ANGEL
1987, OIL ON MASONITE, 36 X 16 CM.
COLLECTION: JOHN SMAINES, ASPEN, COLORADO

The Mysterium Magnum reveals itself through a hypnogogic haze, peripheral billows and evaporative dreams moving at tachyonic speed, elevating and intoxicating the mind with angel-scented pheromones and the luminosity of jungle tryptamines, leaving the radiant Sphere as the only evidence of its existence.

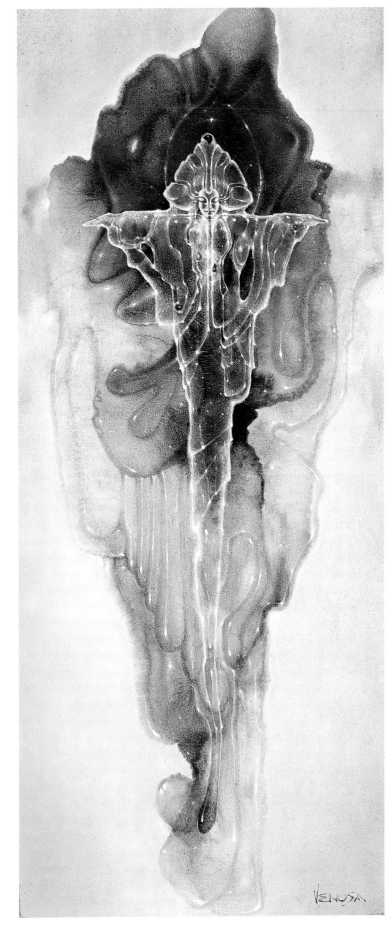

BLUE ANGEL
1985, OIL ON CANVAS, 30 X 16 CM.
TERWILLIGER-THOMAS COLLECTION, CHICAGO

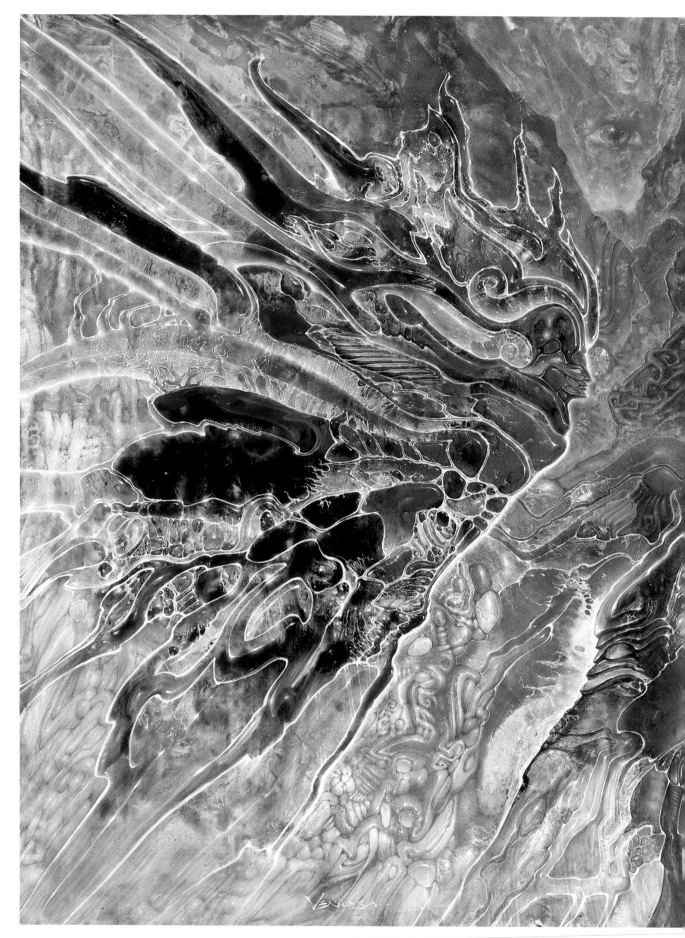

DOS ANGELES
1993, OIL ON CANVAS, 138 X 215 CM.
PRIVATE COLLECTION

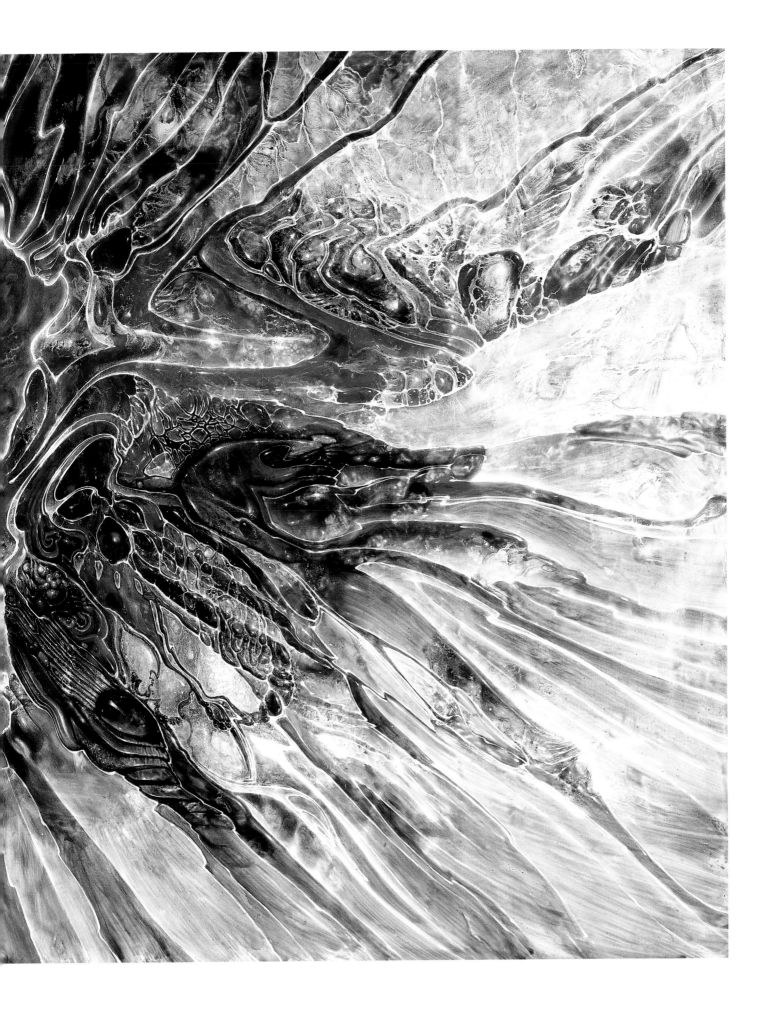

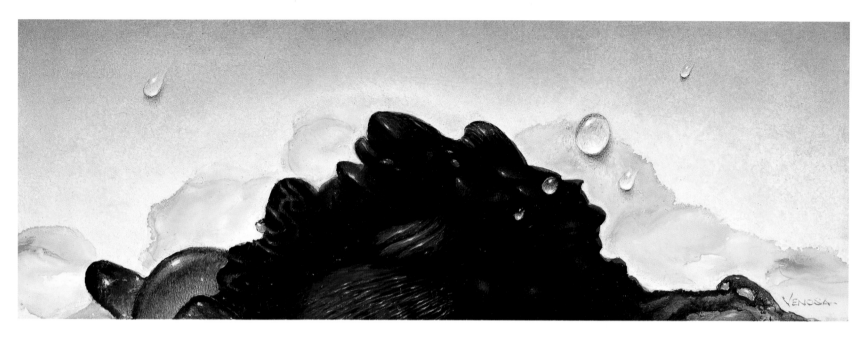

GREENSCAPE III
1987, OIL ON MASONITE, 13 X 28 CM.
PRIVATE COLLECTION

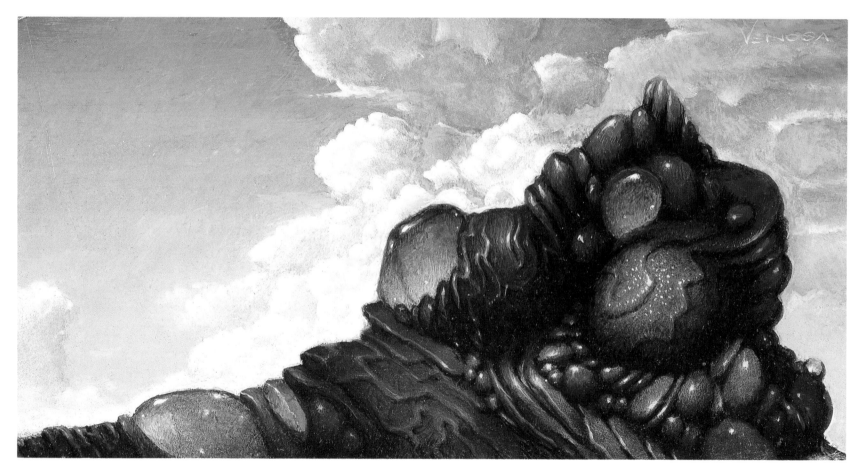

GREENSCAPE II
1987, OIL ON MASONITE, 10 X 20 CM.
PRIVATE COLLECTION

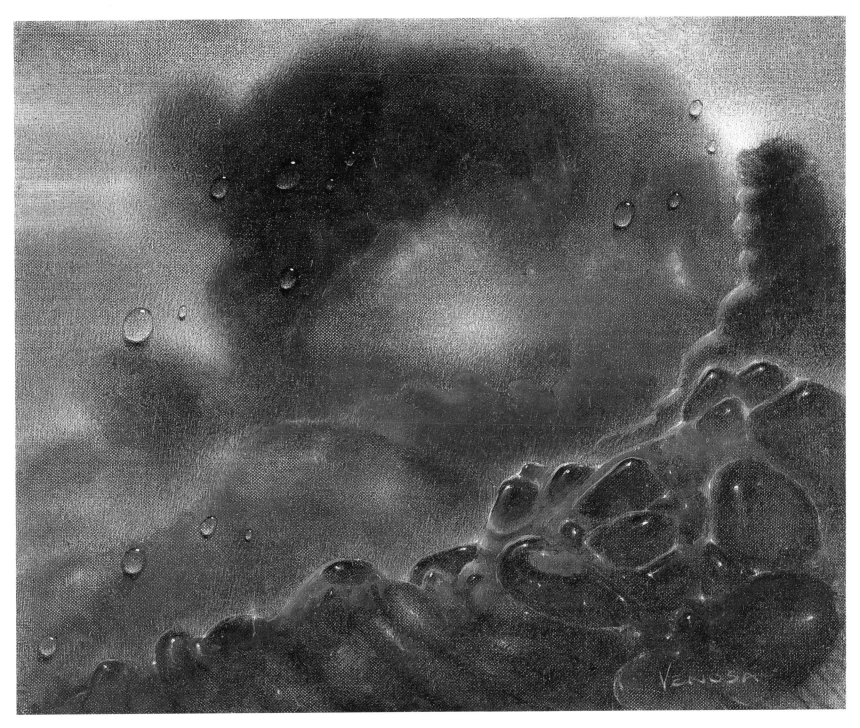

GREENSCAPE
1984, OIL ON MASONITE, 22 X 27 CM.
COLLECTION: CLAYTON ANDERSON, SANTA CRUZ, CALIFORNIA

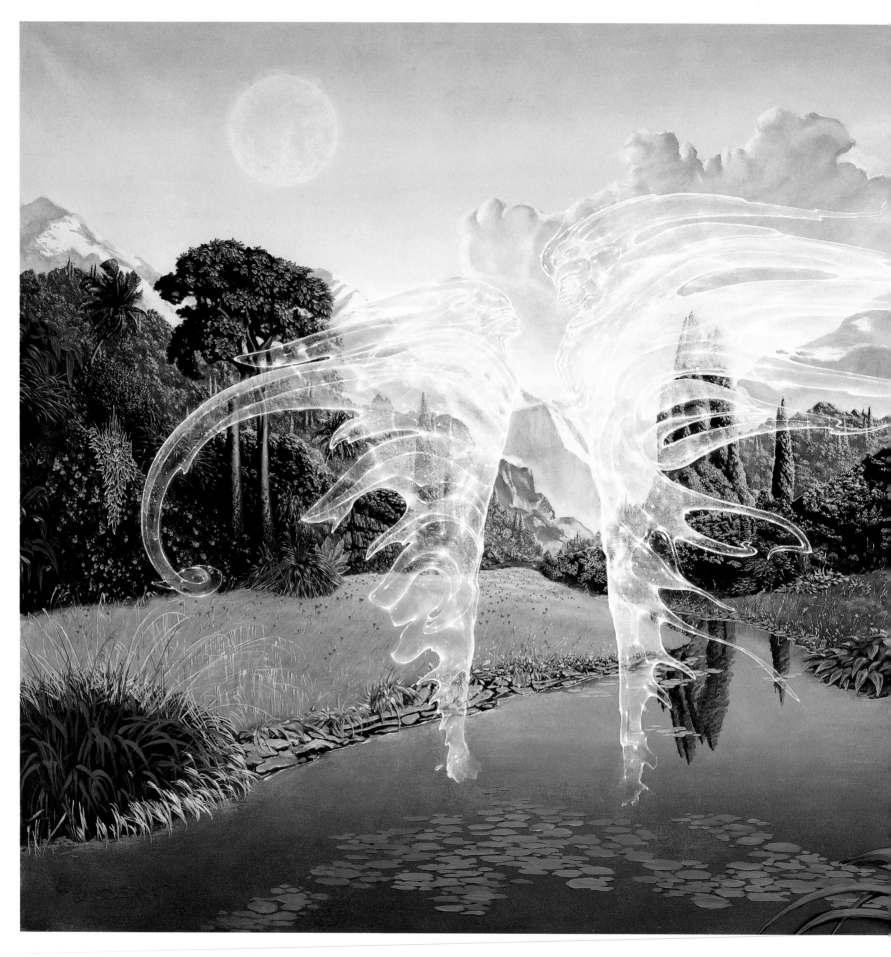

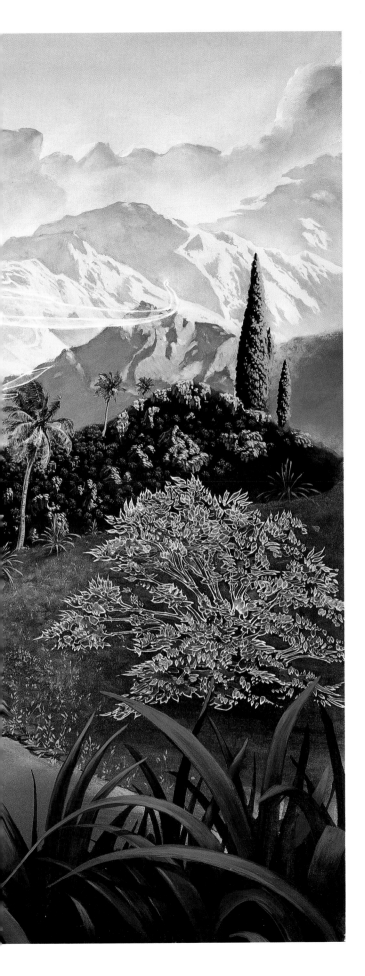

Morphic perturbations of geography emerge when Venosa's eye catches the fleeting encounter of mental species. Fey creatures flickering between the quantum interstices. Glimpsed rarely by lumpen minds marooned in real time.

GARDEN OF DELIGHTS
1992, OIL ON CANVAS, 92 X 132 CM.
COLLECTION: PAUL KLAVER, TORONTO

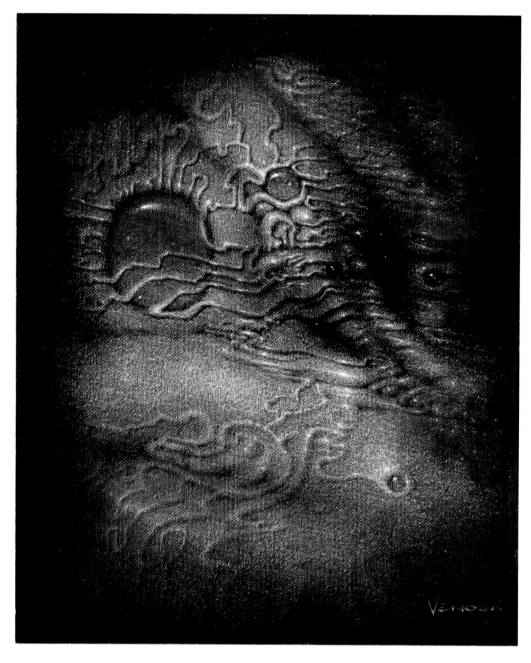

DREAMSCAPE II
1983, OIL ON MASONITE, 26 X 22 CM.
PRIVATE COLLECTION

ANGELIC MANIFESTATION
1974, OIL ON CANVAS, 100 X 70 CM.
COLLECTION: JASON McKEAN, SAN FRANCISCO

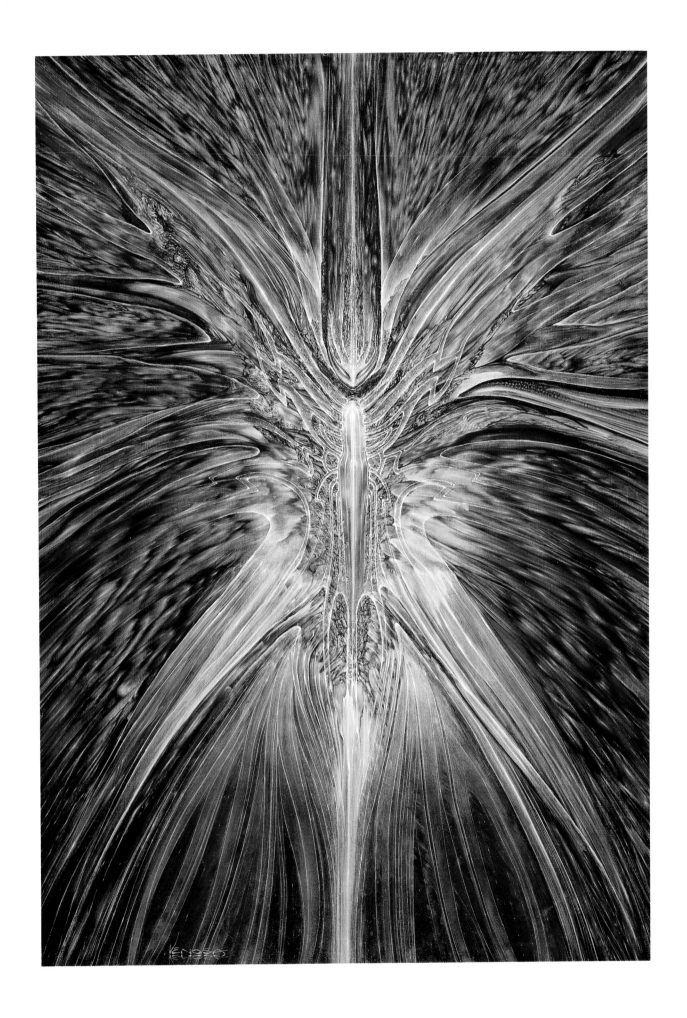

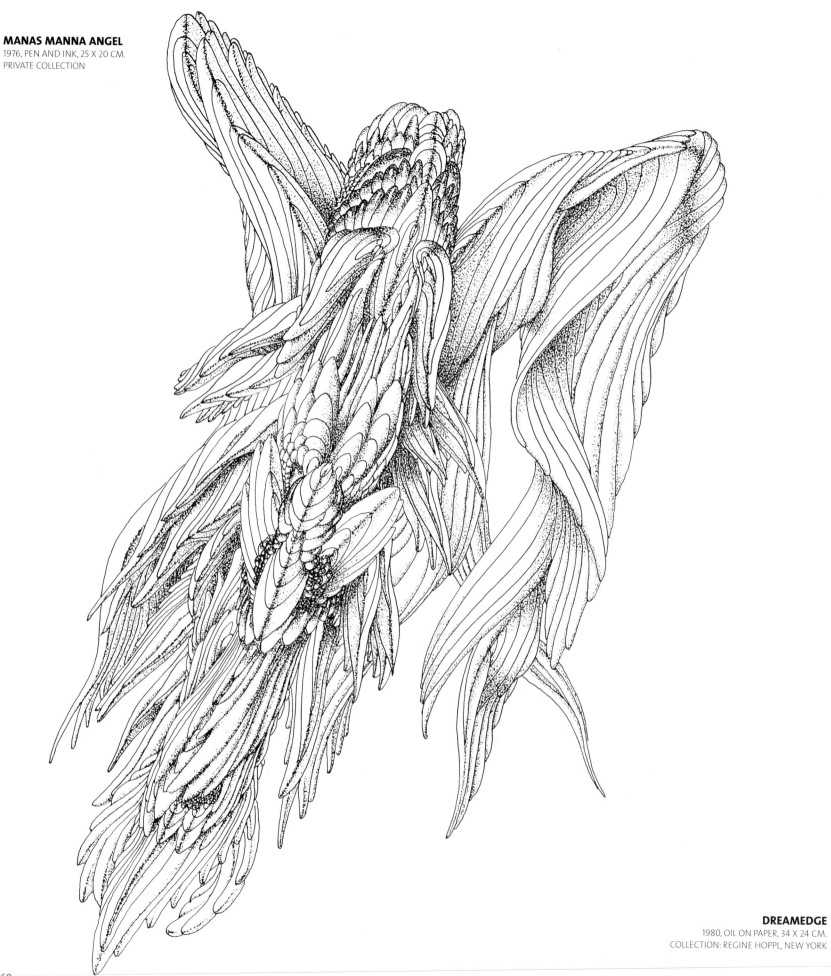

MANAS MANNA ANGEL
1976, PEN AND INK, 25 X 20 CM.
PRIVATE COLLECTION

DREAMEDGE
1980, OIL ON PAPER, 34 X 24 CM.
COLLECTION: REGINE HOPPL, NEW YORK

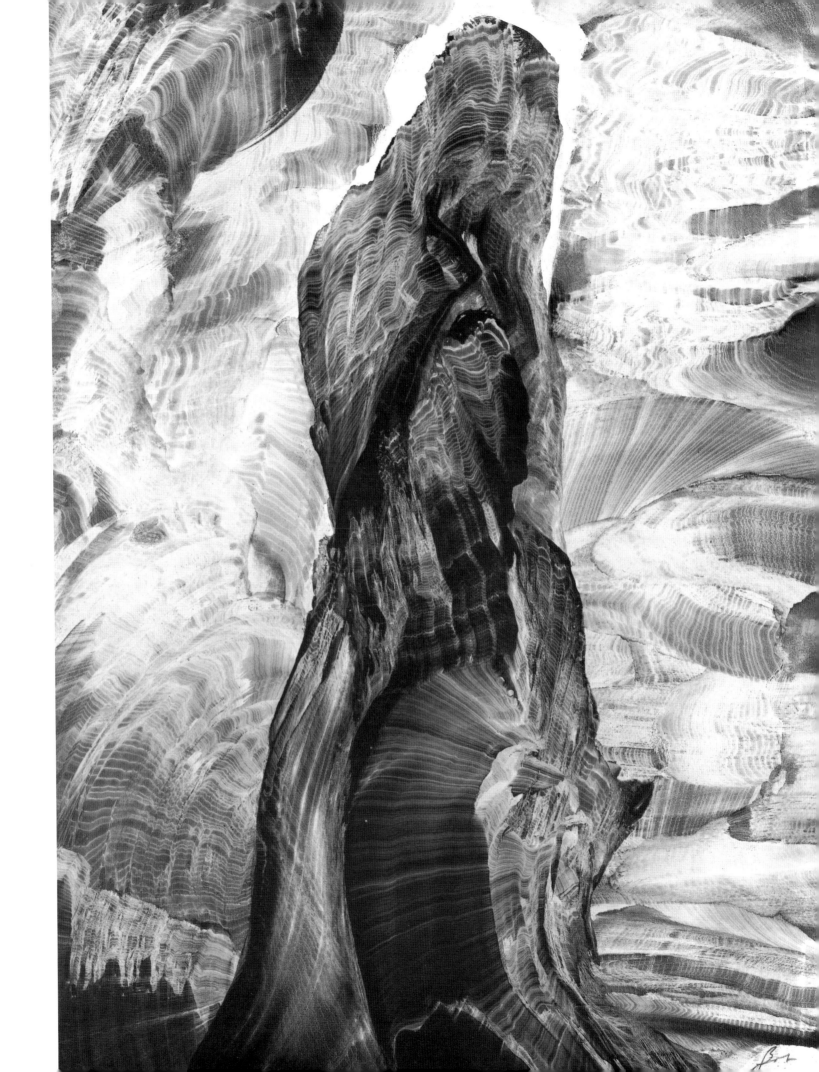

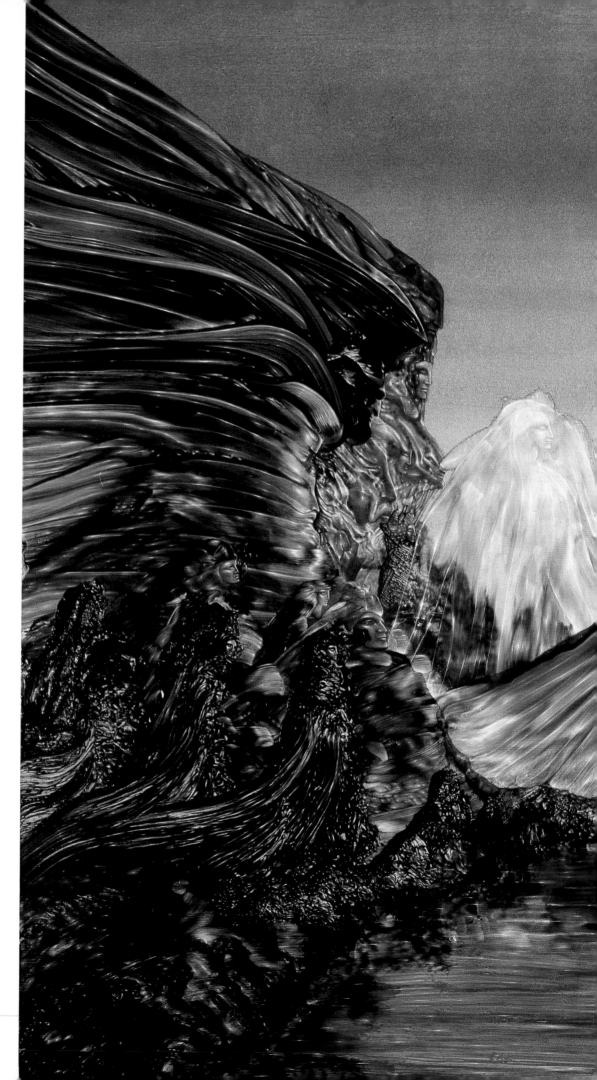

ORDINATION OF MELCHIZEDEK
1974, OIL ON CANVAS, 70 X 100 CM.
COLLECTION: SEPP MOSER, VIENNA

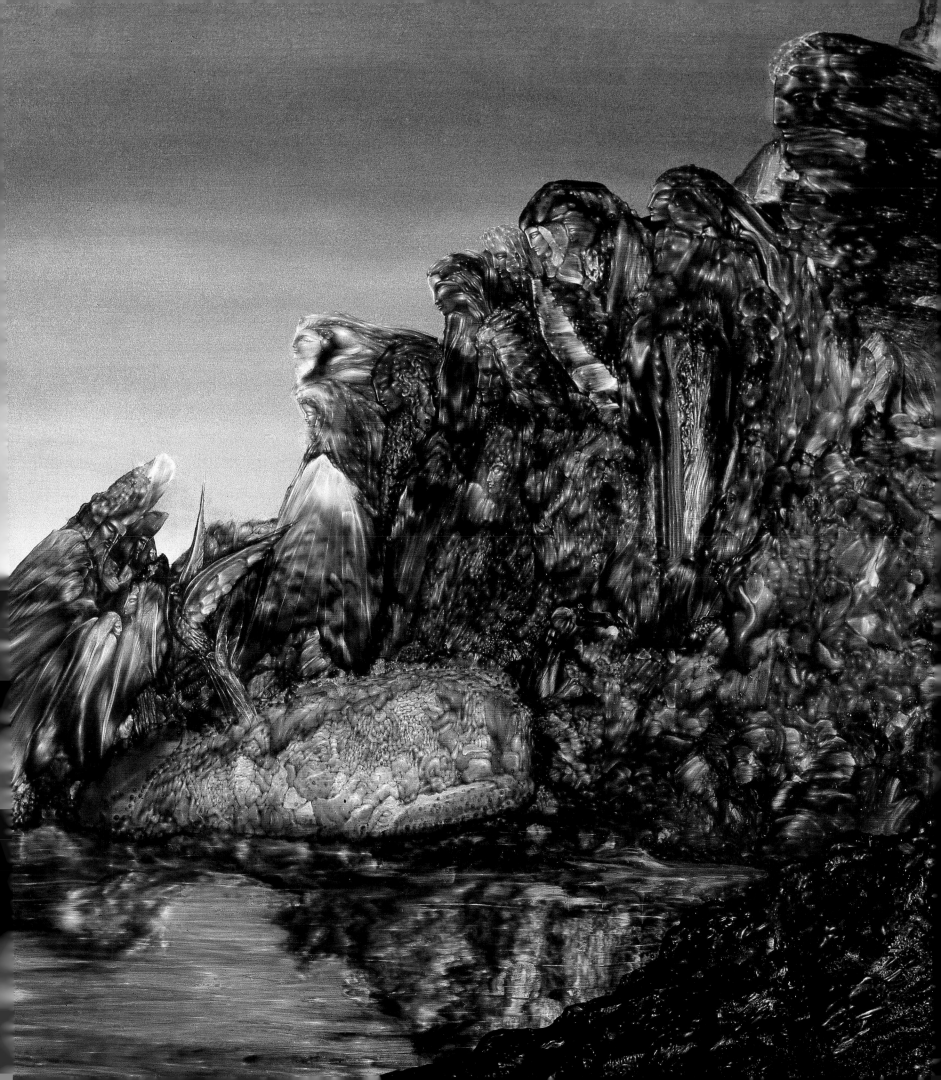

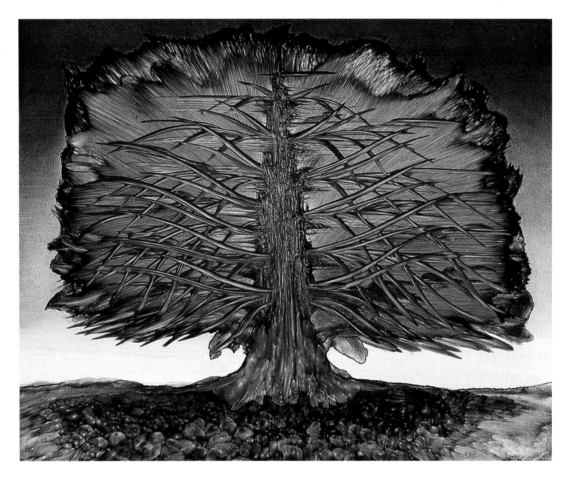

MAGICIAN'S TREE
1973, OIL ON CANVAS, 40 X 50 CM.
COLLECTION: D.K. MEINERS, AMSTERDAM

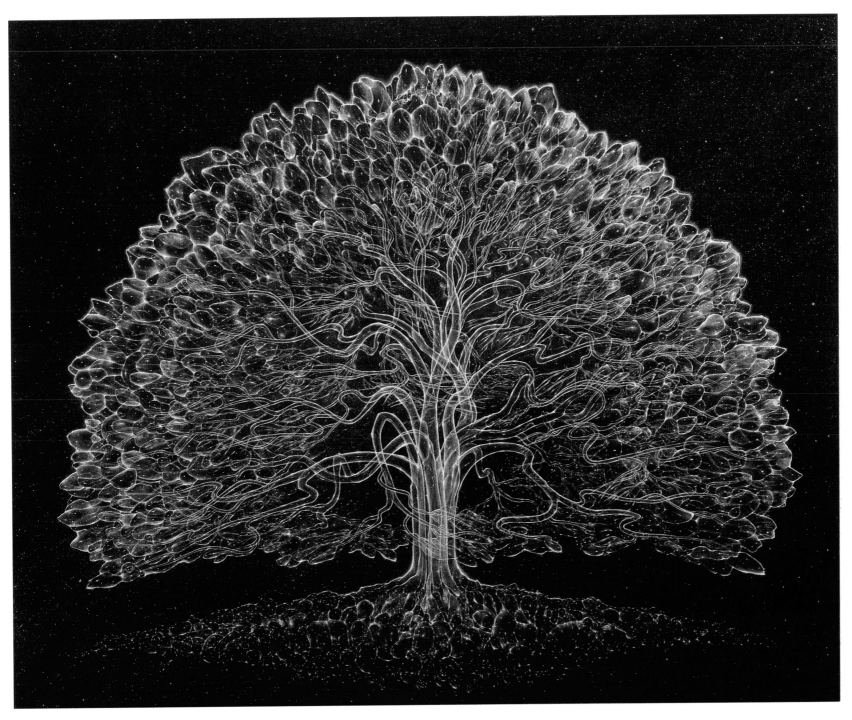

CELESTIAL TREE
1976, OIL ON MASONITE, 80 X 100 CM.
COLLECTION: SIMON MUNDY, CADAQUÉS, SPAIN

BIRTH OF A NEBULA
1973, OIL ON CANVAS, 70 X 100 CM.
COLLECTION: HANS WEWELKA, VIENNA

Alien worlds adrift in the parsecs of imagination, rescued for inspection by the visionary hand and eye, made paint by destiny and intent.

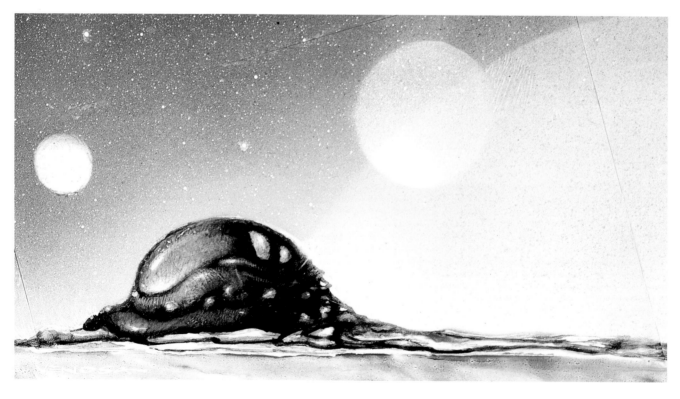

TWO MOONS
1997, OIL ON MASONITE, 12 X 20 CM.
PRIVATE COLLECTION

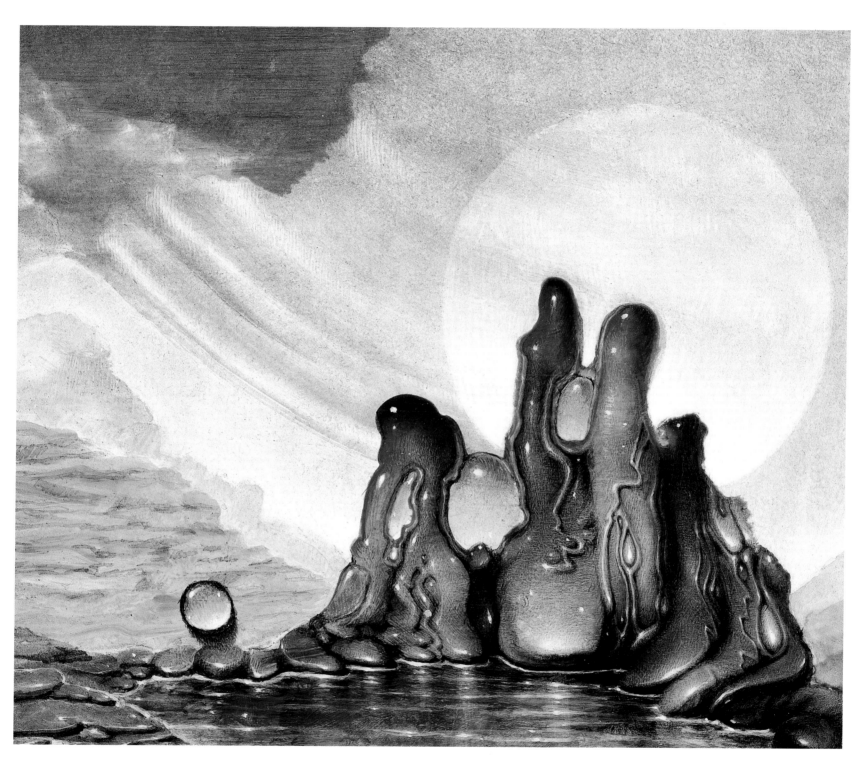

FULL MOON IV
1996, OIL ON MASONITE, 28 X 30 CM.
PRIVATE COLLECTION

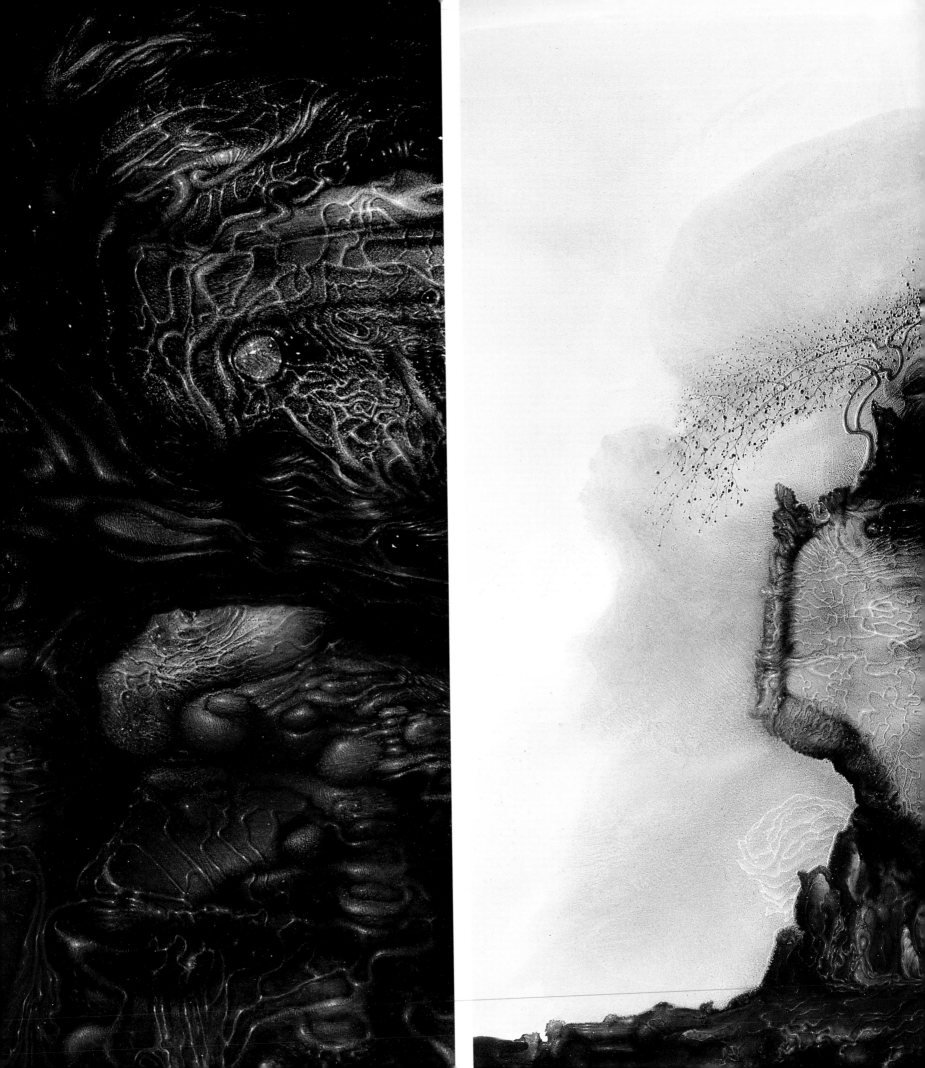

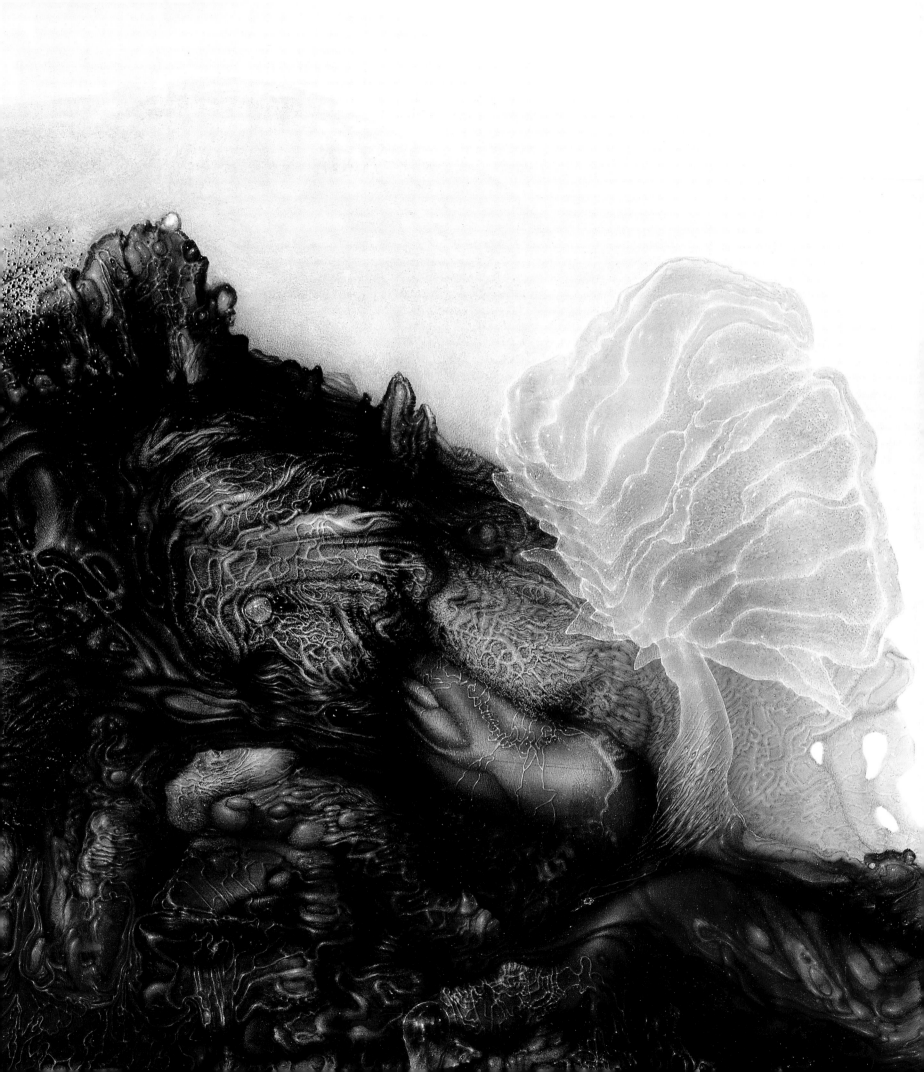

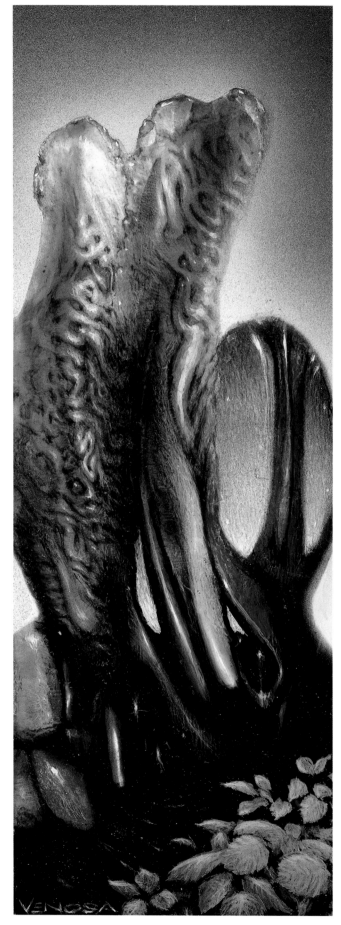

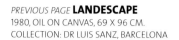

Lack of resolvable scale and attention to the pliant chemistry of paint itself links many of Venosa's paintings to the vegetatively surreal, organically dynamic world explored by Max Ernst and glimpsed in the nineteenth century by Moreau and Redon. A drug-like plasticity and the glittering surfaces of romanticized opiumscapes recur, always evoking jewels and strange flesh.

DORADO VERDE
1989, OIL ON MASONITE, 12 X 8 CM.
PRIVATE COLLECTION

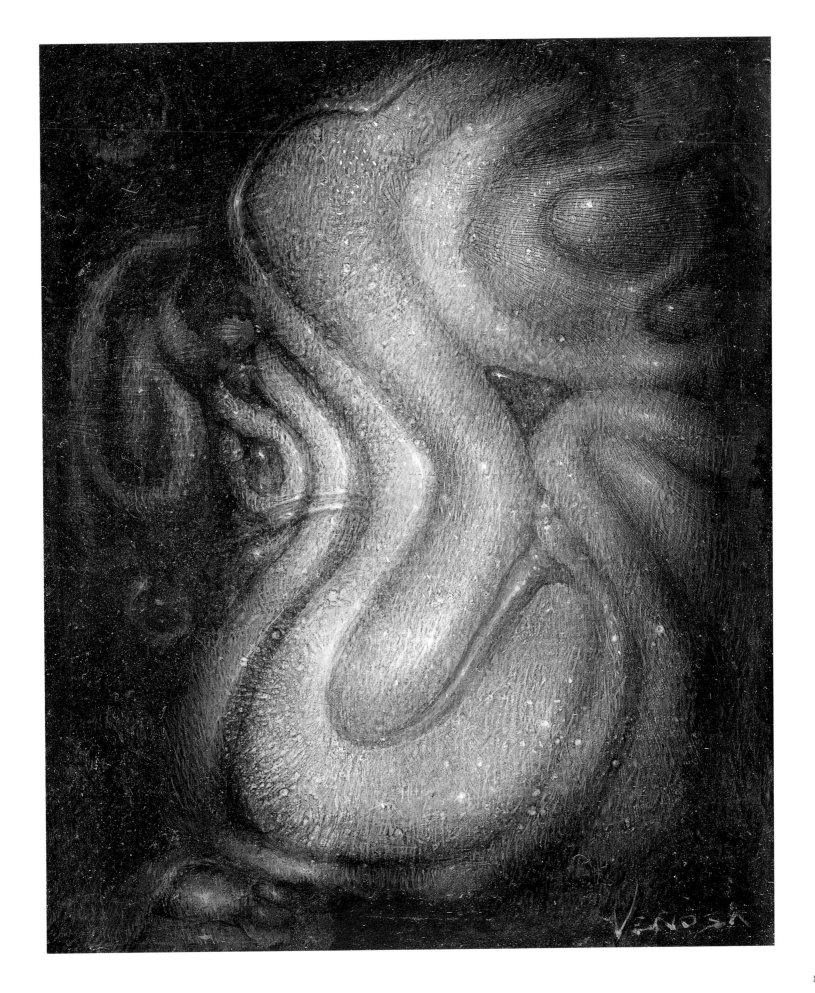

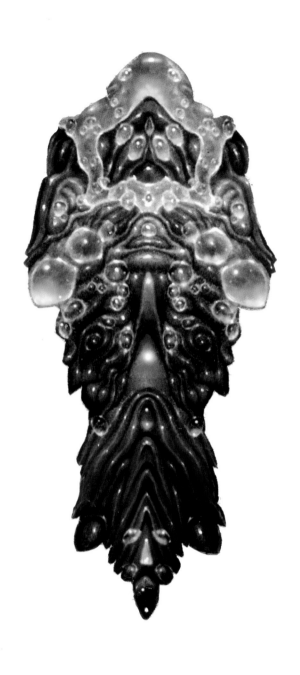

LANDESCAPE III
1980, OIL ON CANVAS, 68 X 98 CM.
COLLECTION: CEES HOFSTEE, AMSTERDAM

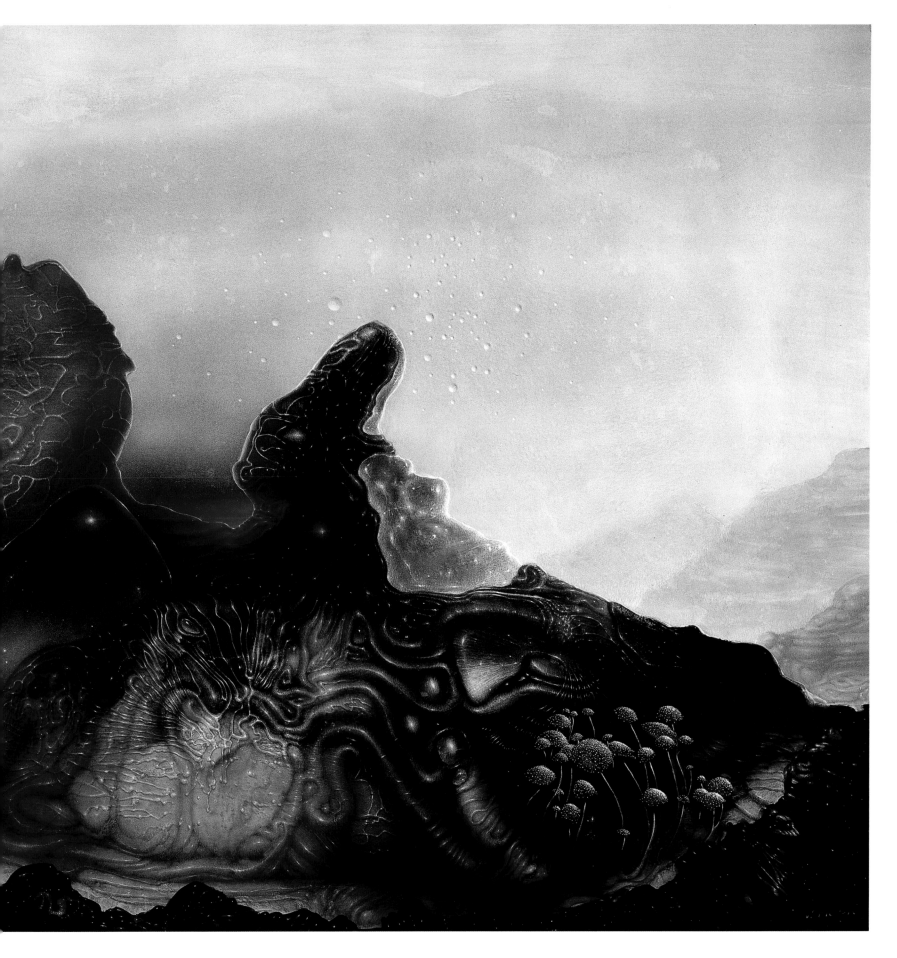

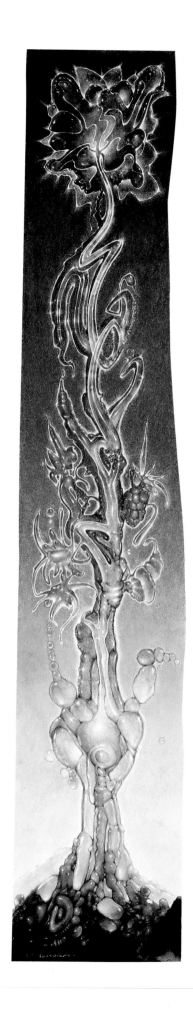

FLOR ESTREÑO
1995, OIL ON CANVAS, 135 X 30 CM.
COLLECTION: STEVE SKELTON, DALLAS

Exotic flowers, plucked from the verdant jungle of vision, fecund with the vegetable engines of creation. Psychobotanical life wearing its nature as hallucination.

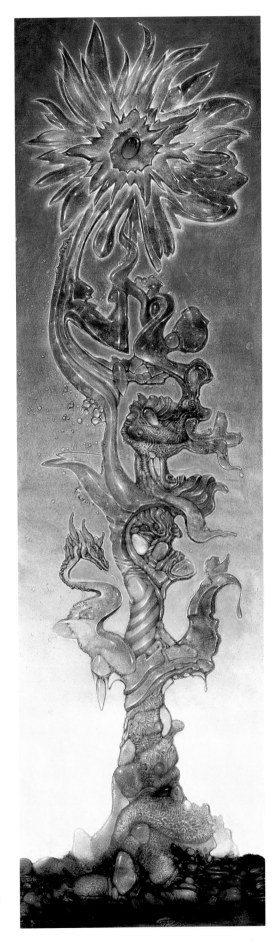

DMTree
1998, OIL ON CANVAS, 152 X 44 CM.
PRIVATE COLLECTION

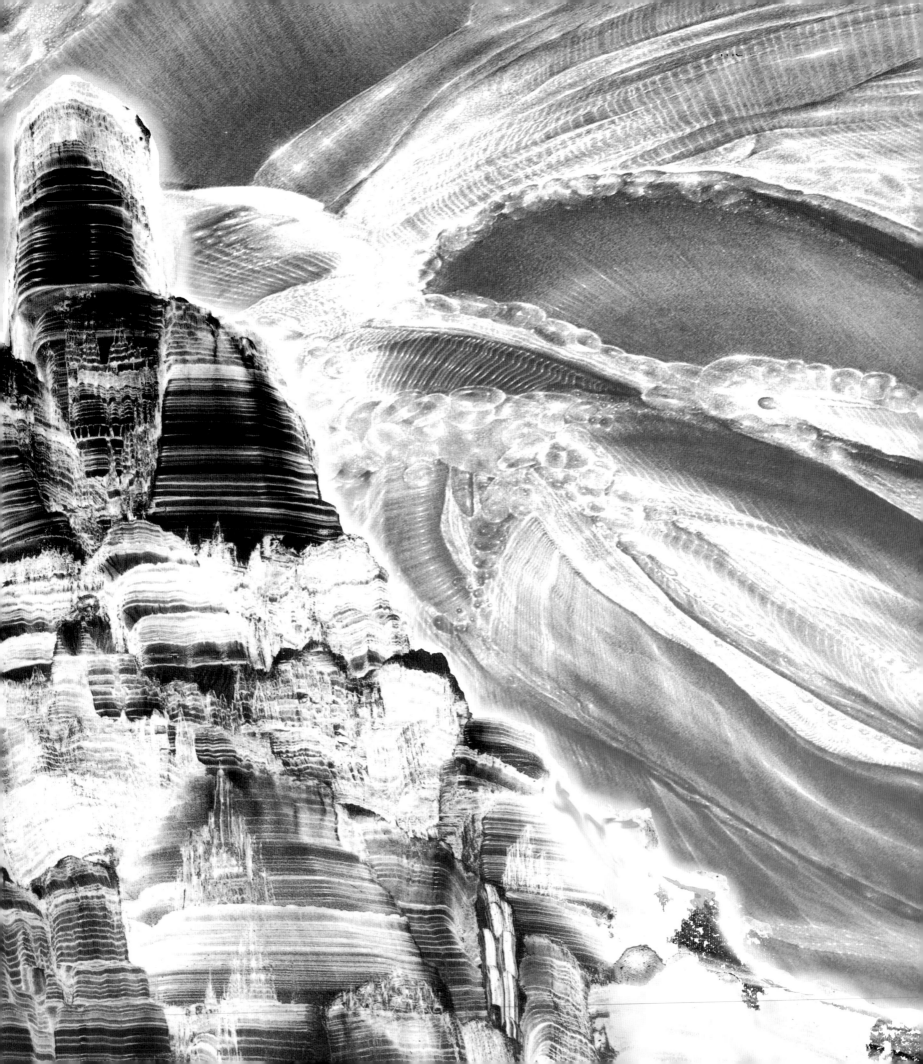

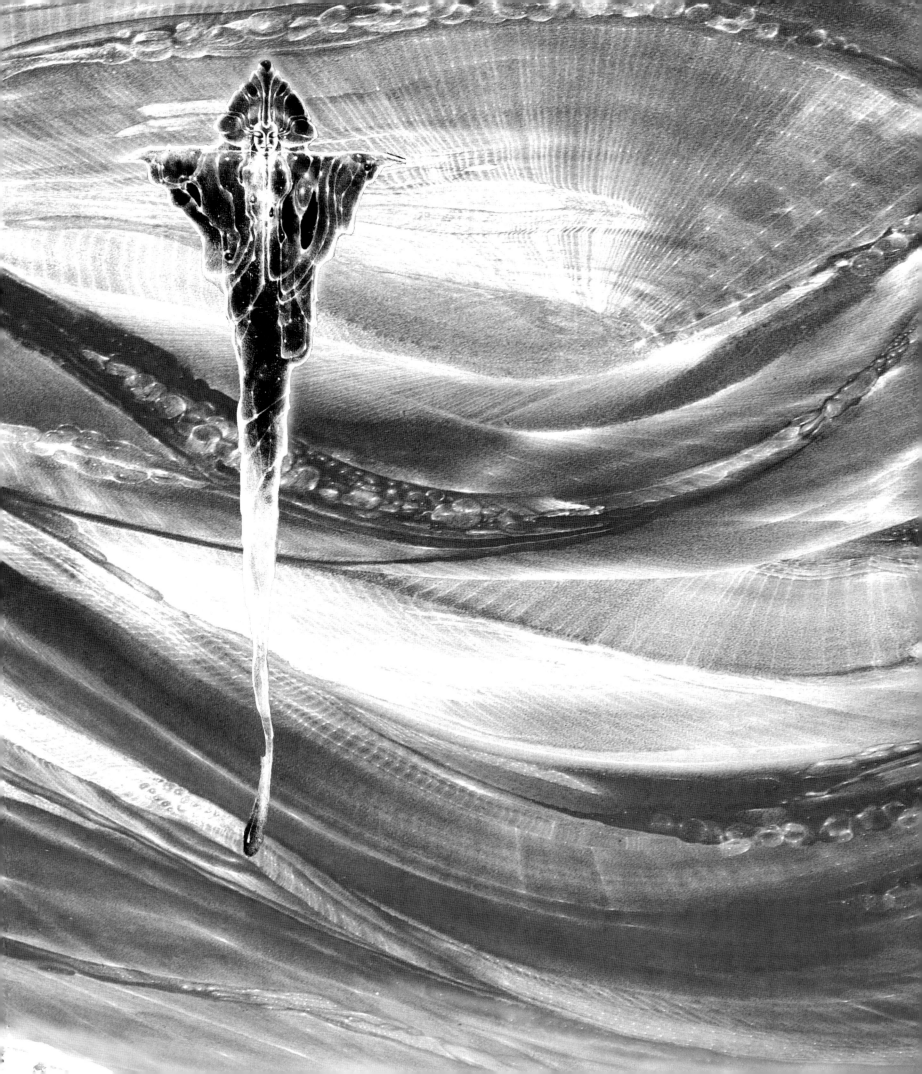

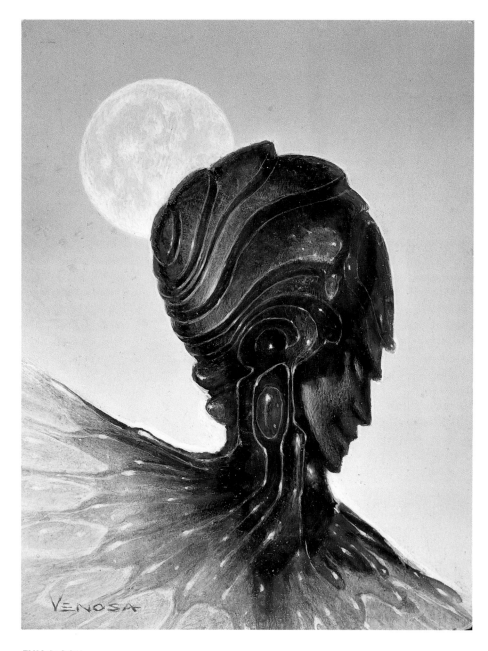

FULL MOON
1988, OIL ON MASONITE, 12 X 9 CM.
PRIVATE COLLECTION

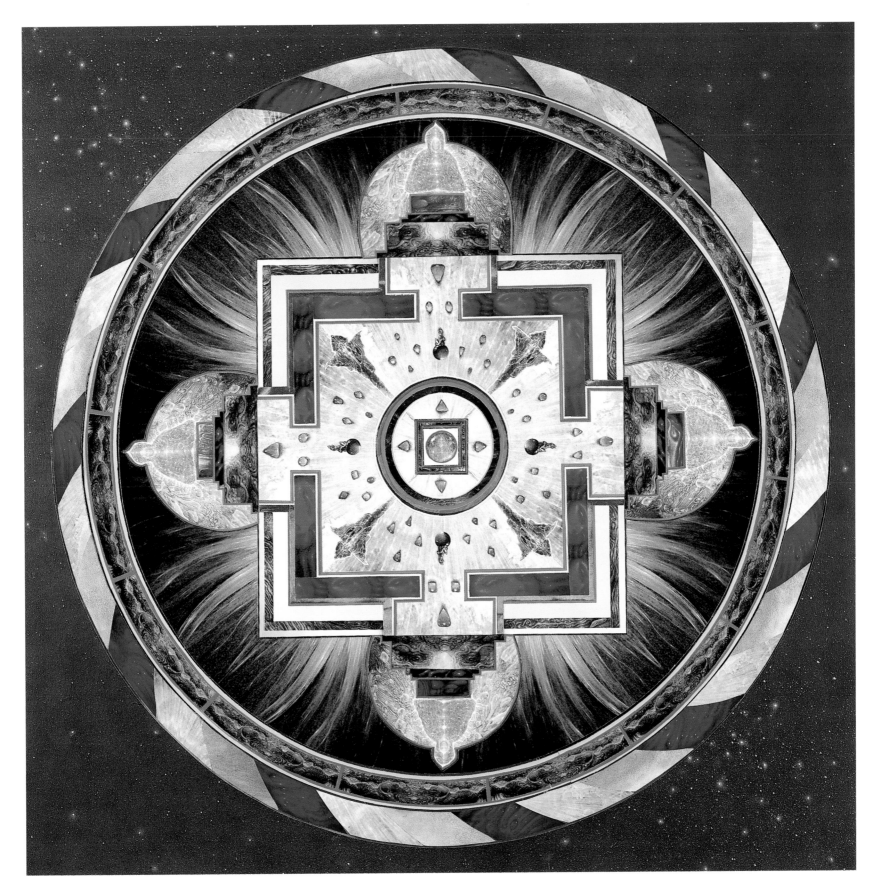

MANDALA
1995, OIL, MONTAGE, 64 X 64 CM.
COLLECTION: KITARO, WARD, COLORADO

The images on the following four pages were painted on pieces of old, sea-worn tile found along the shores of the Mediterranean. They are shown in their actual size in these two pages, and somewhat larger on pages 92 and 93.

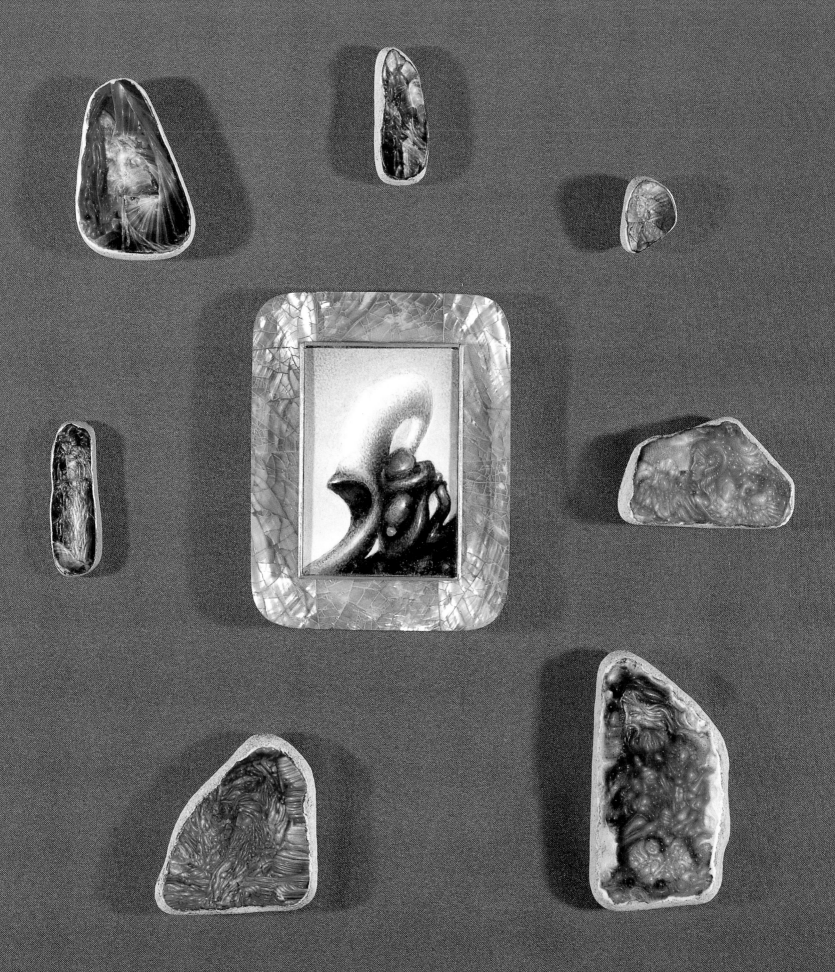

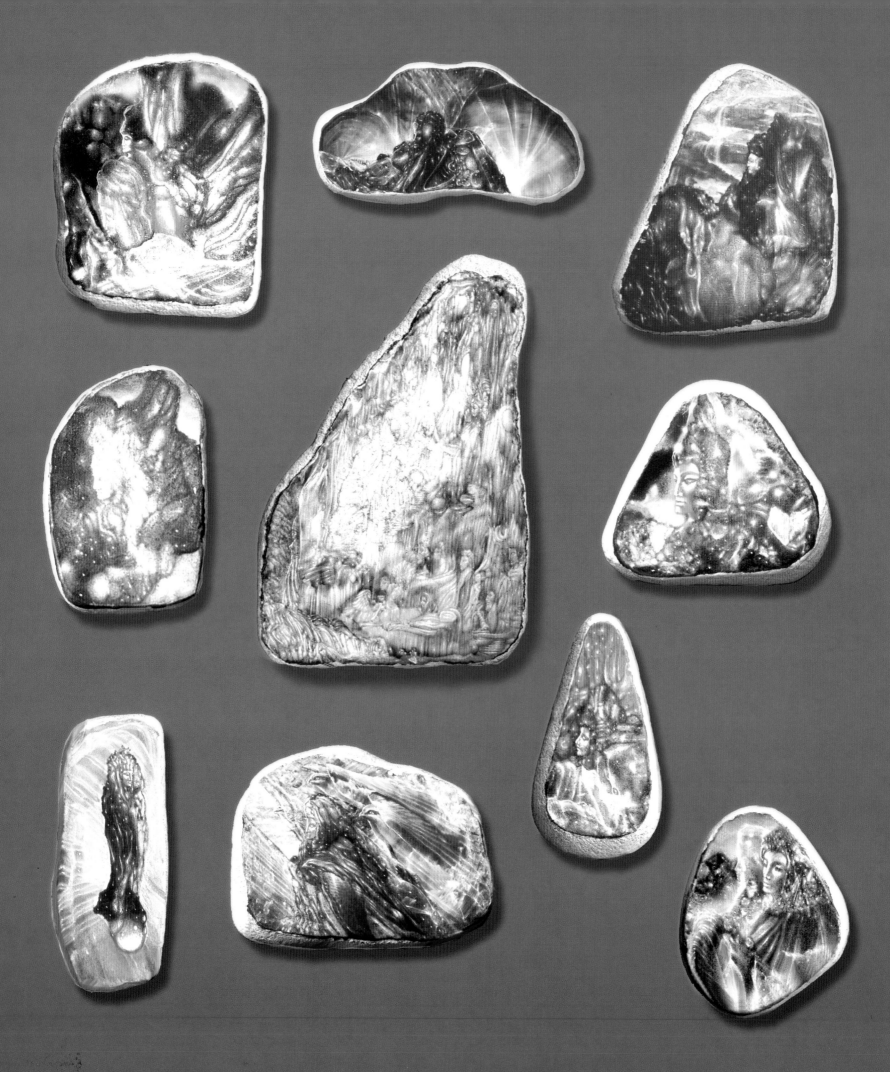

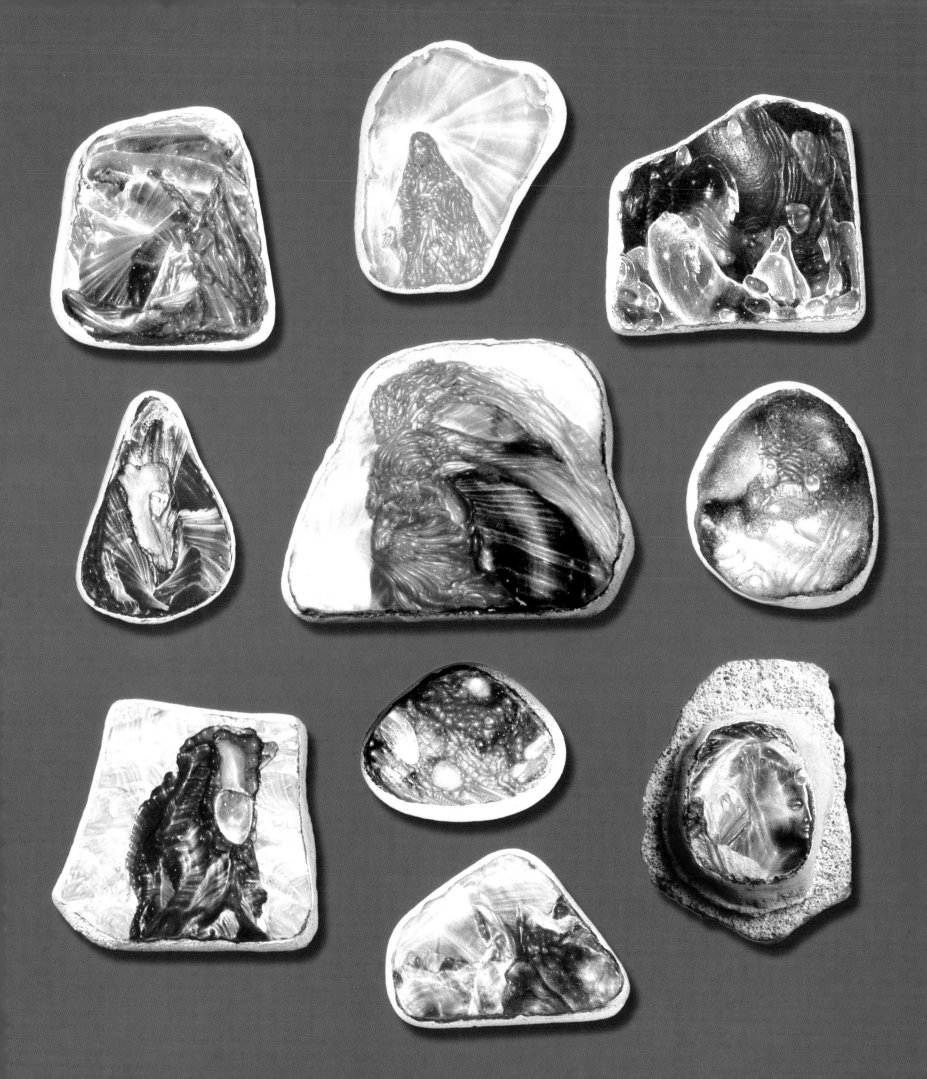

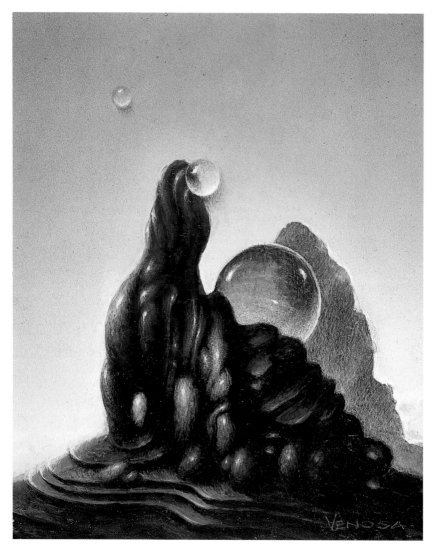

THREE SPHERES
1983, OIL ON MASONITE, 40 X 31 CM.
COLLECTION: DR VILA-MONER, BARCELONA

PRANA EXHALATION
1975, OIL ON CANVAS, 70 X 55 CM.
COLLECTION: LAND-DUVEKOT, AMSTERDAM

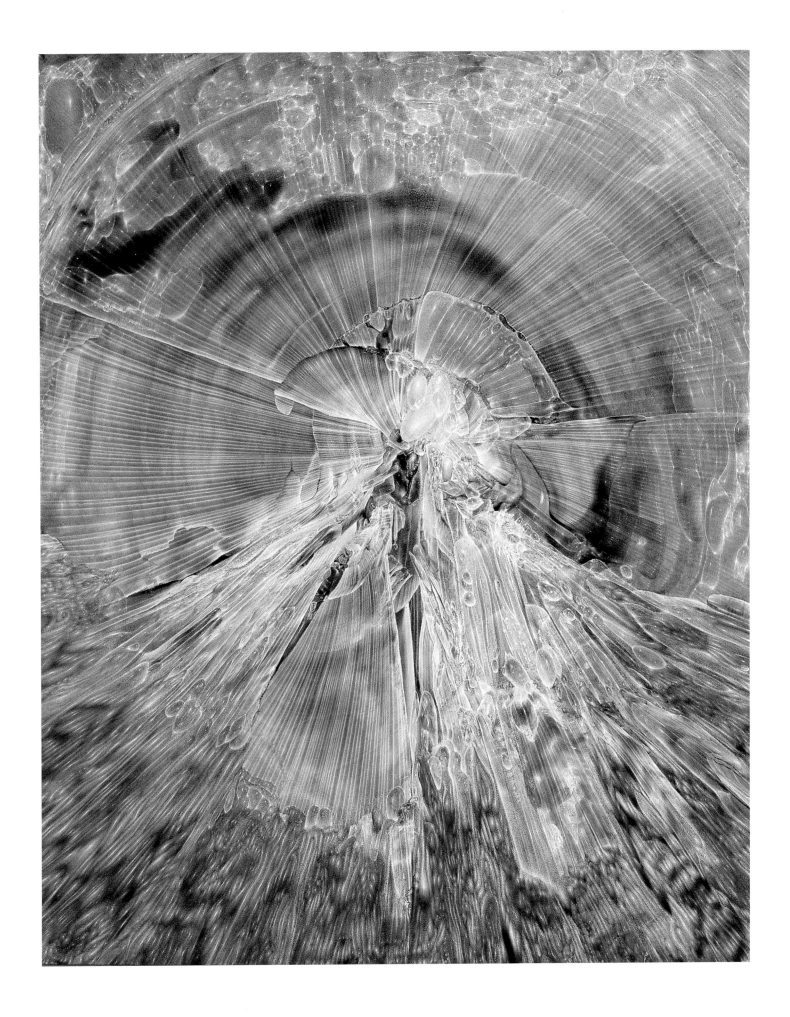

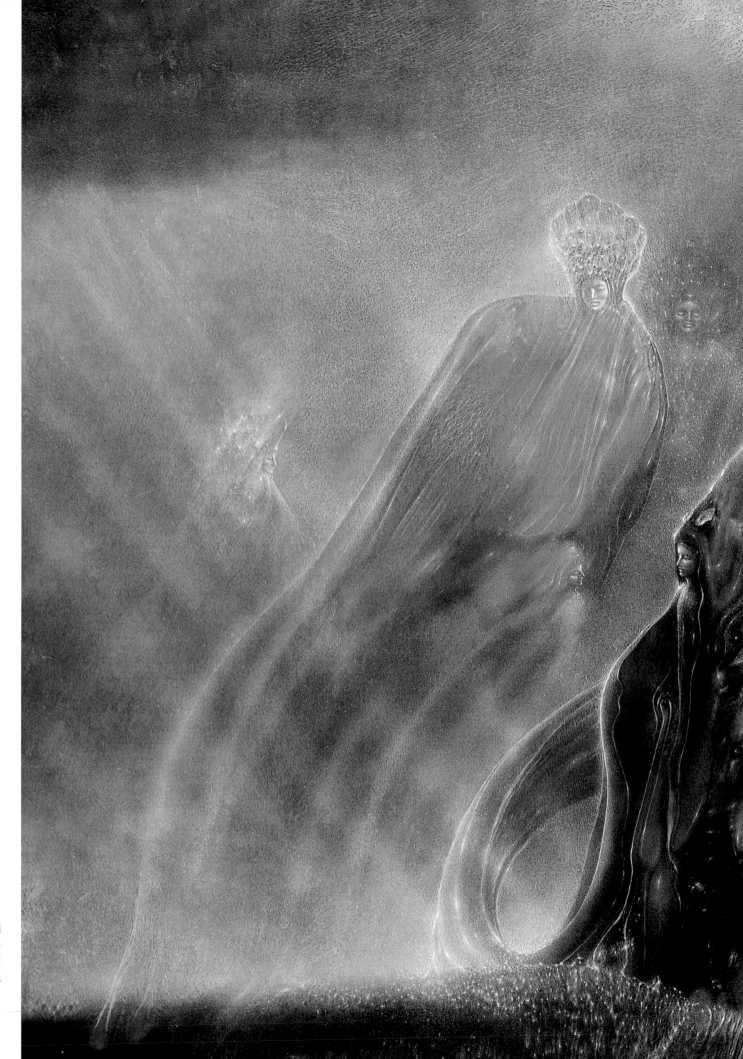

ANNUNCIATION
1979, OIL ON CANVAS,
38 X 60 CM.
COLLECTION:
JUAN QUERALT, BARCELONA

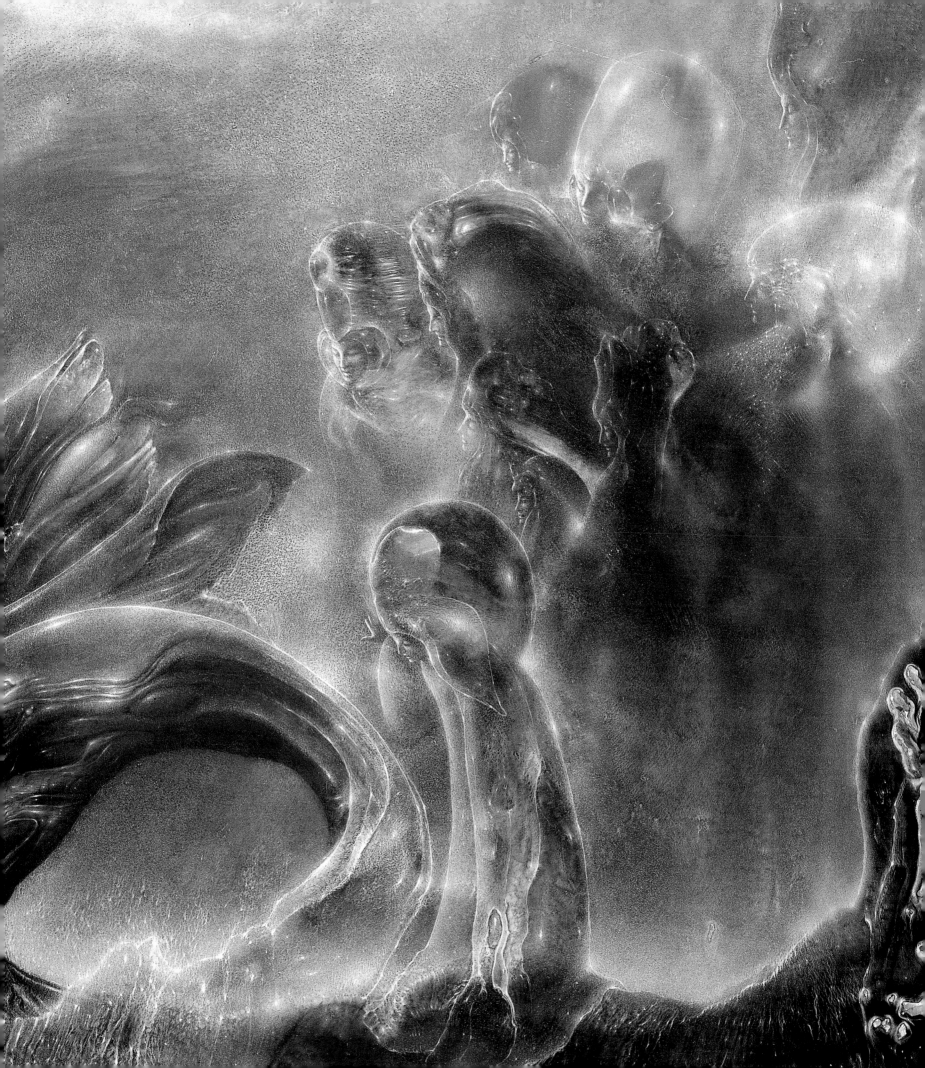

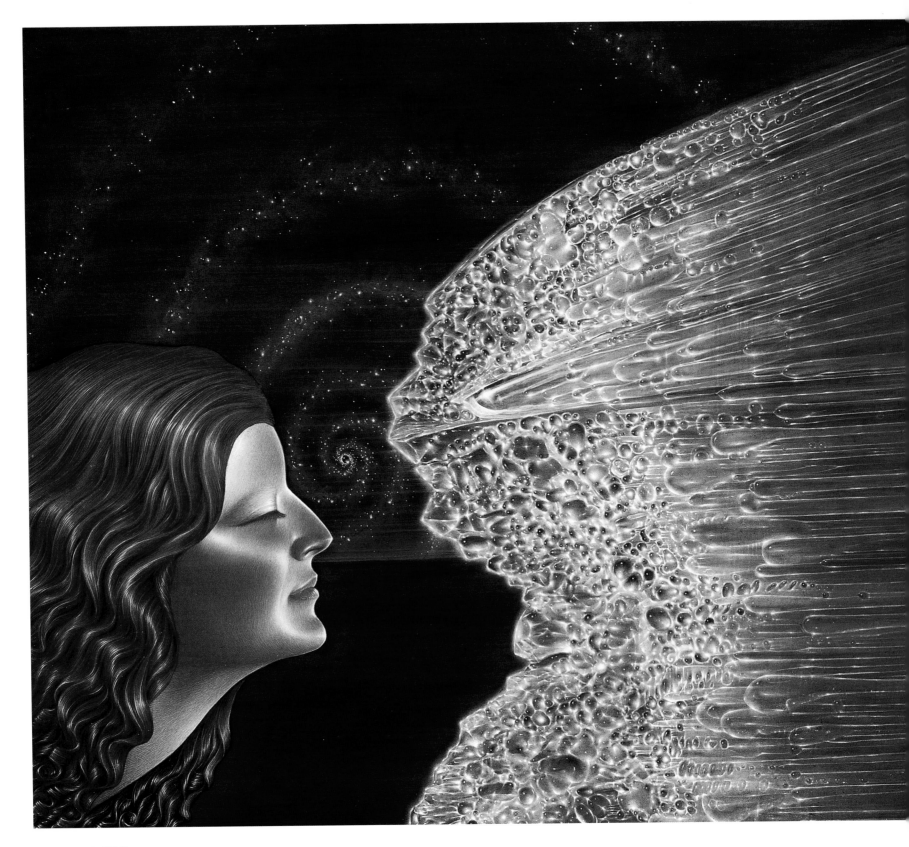

ANNUNCIATION II
1973, OIL ON CANVAS, 45 X 65 CM.
COLLECTION: NICODEMUS FRISCH, MUNICH

Epiphany of the Mother, she of endless fecundity. The mama matrix most mysterious roiling with the potential of all form, the boiling quantum vacuums of the howling Tao, source of form's fractal foam.

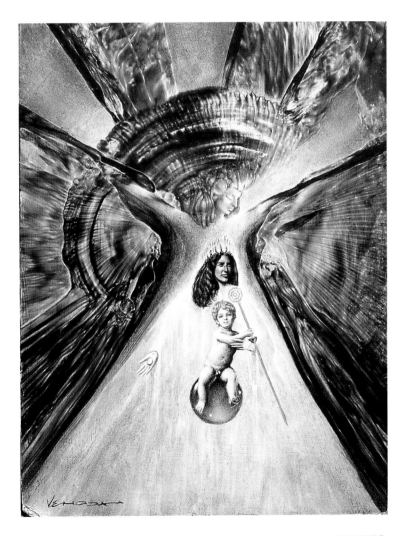

HOLY CHILD
1988, OIL ON CANVAS, 30 X 24 CM.
COLLECTION: ROSE TERWILLIGER, LOS ANGELES

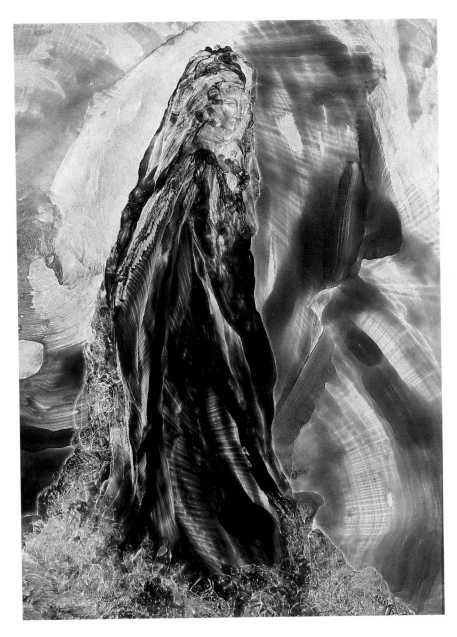

MADONNA AND CHILD
1976, OIL ON MASONITE, 50 X 40 CM.
COLLECTION: S.T. WOLS, AMSTERDAM

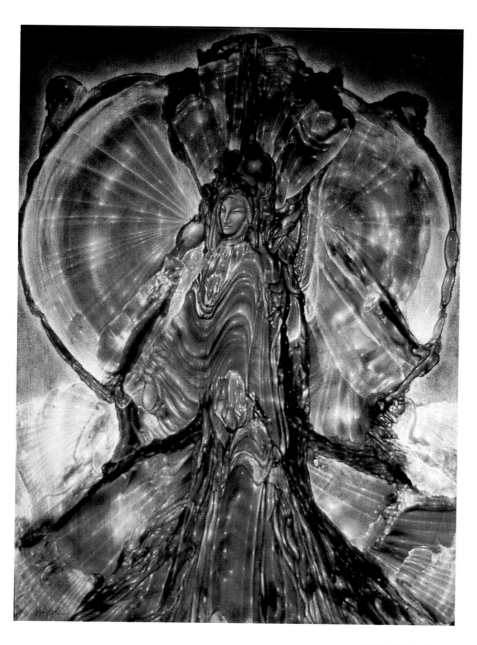

MADONNA D'ORO
1975, OIL ON MASONITE, 50 X 40 CM.
COLLECTION: ALAIN MARGOTTEN, PARIS

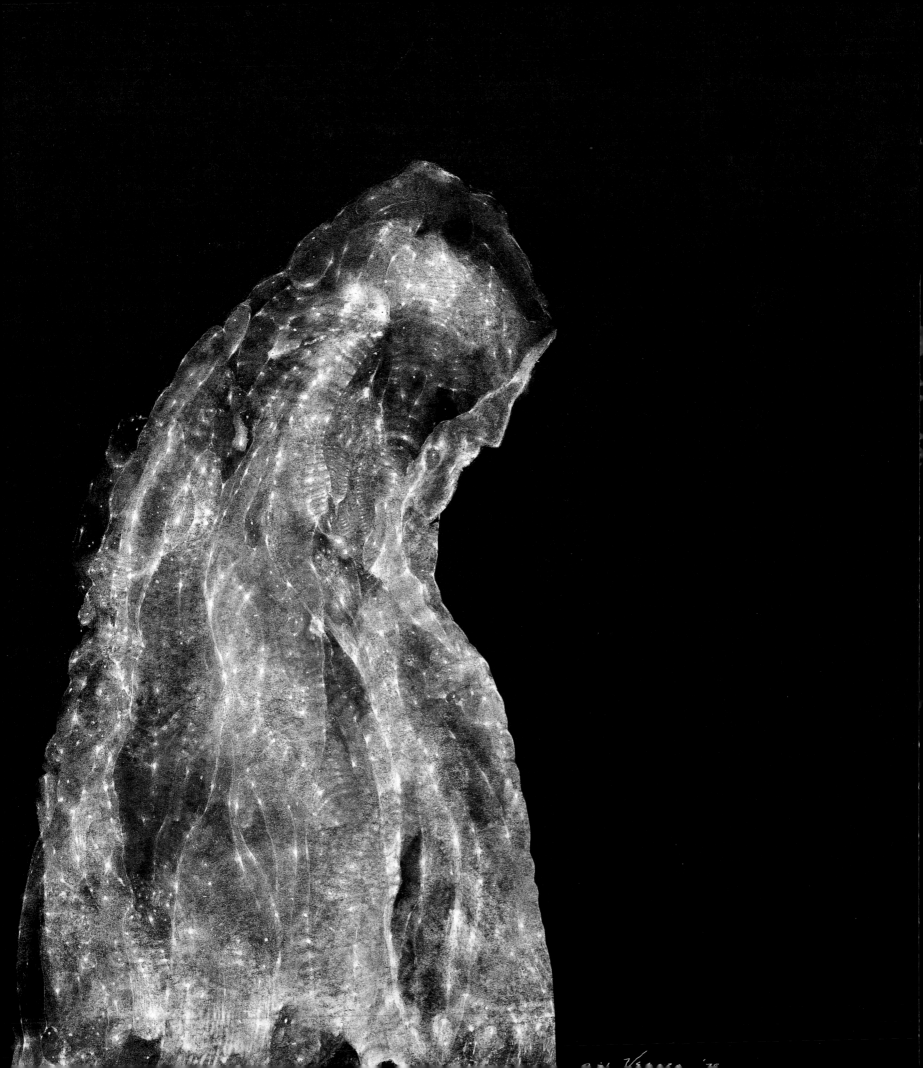

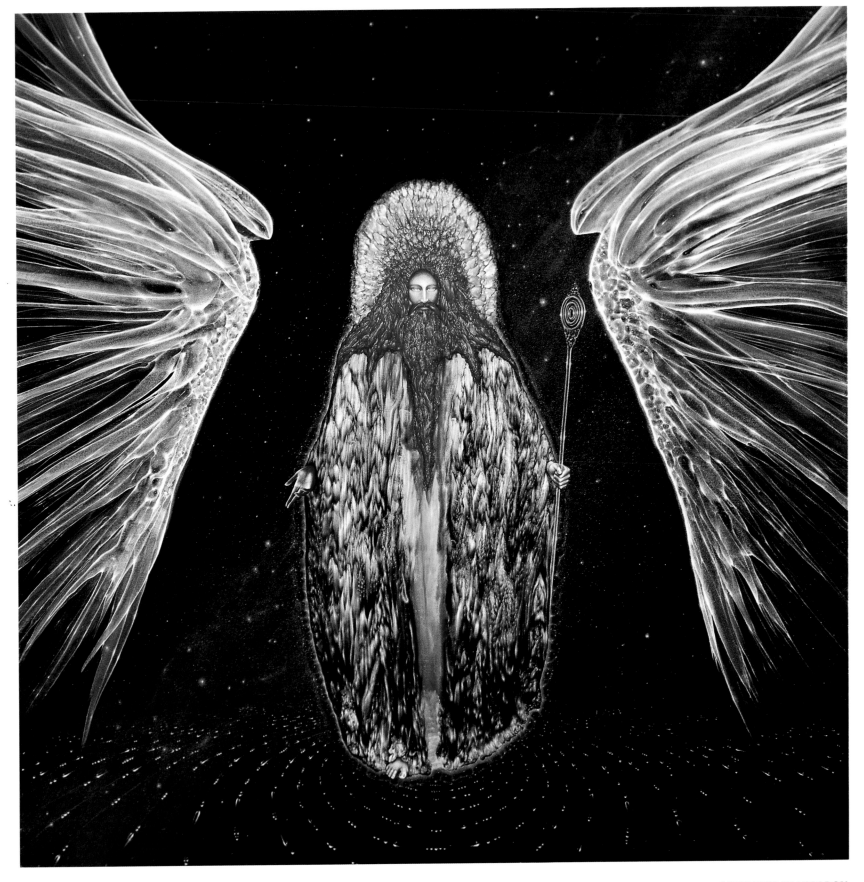

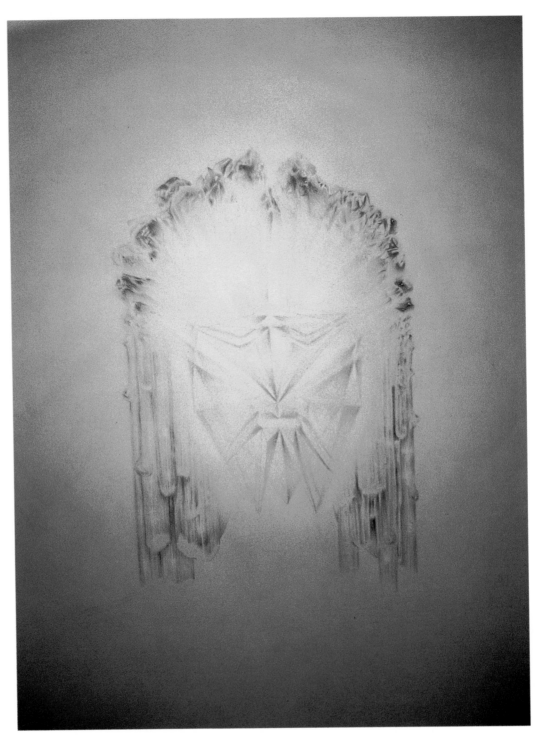

CRUCIFIXION
1974, PRE-SKETCH, PASTEL, 36 X 20 CM.
COLLECTION: GALERIE GERARD SCHREINER, GENEVA

CRUCIFIXION
1973, OIL ON CANVAS, 80 X 60 CM.
COLLECTION: SEPP MOSER, VIENNA

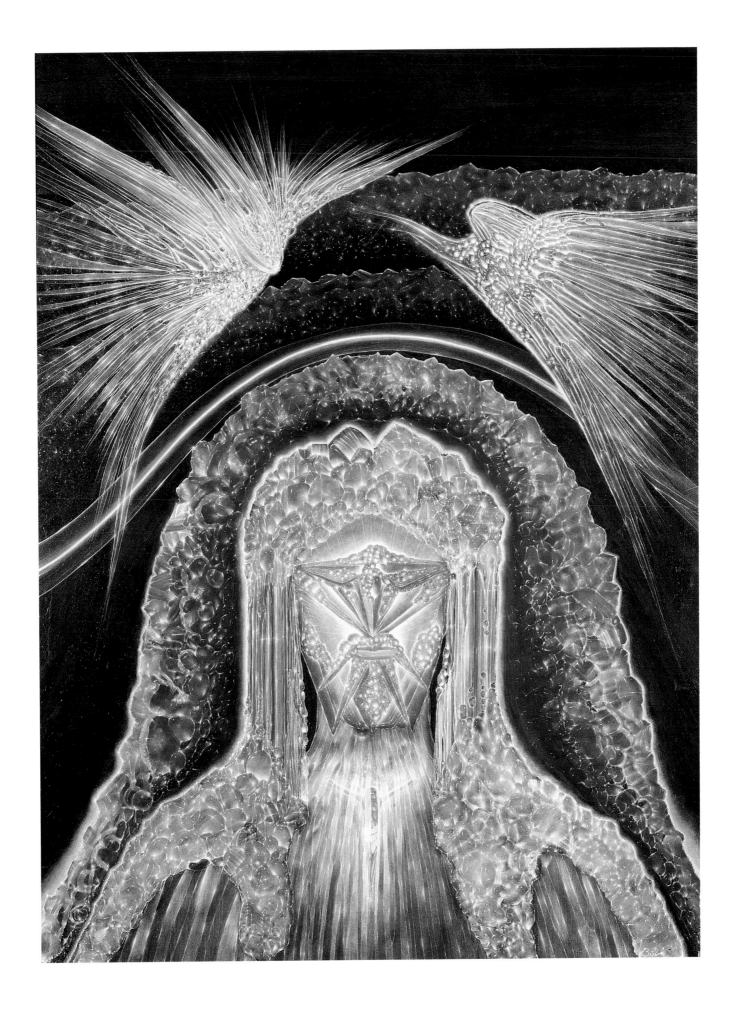

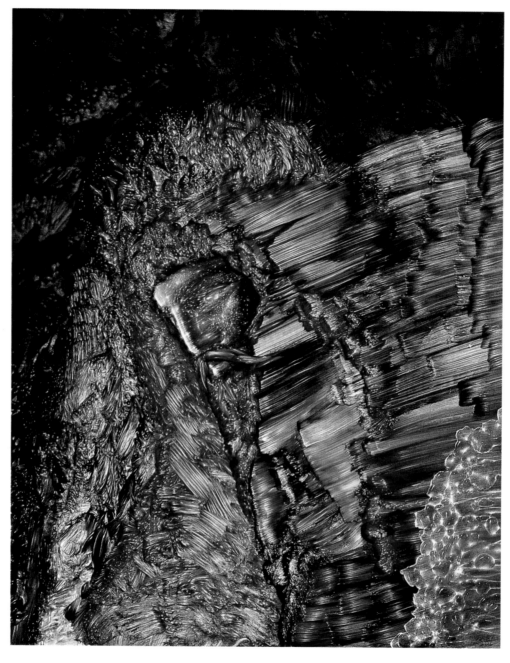

CHRISTUS METAMORPHOSIS
1975, OIL ON CANVAS, 40 X 30 CM.
COLLECTION: DIEGO DIDAC, CADAQUÉS, SPAIN

RETURN TO SOURCE
1976, OIL ON MASONITE, 116 X 90 CM.
TERWILLIGER-THOMAS COLLECTION, CHICAGO

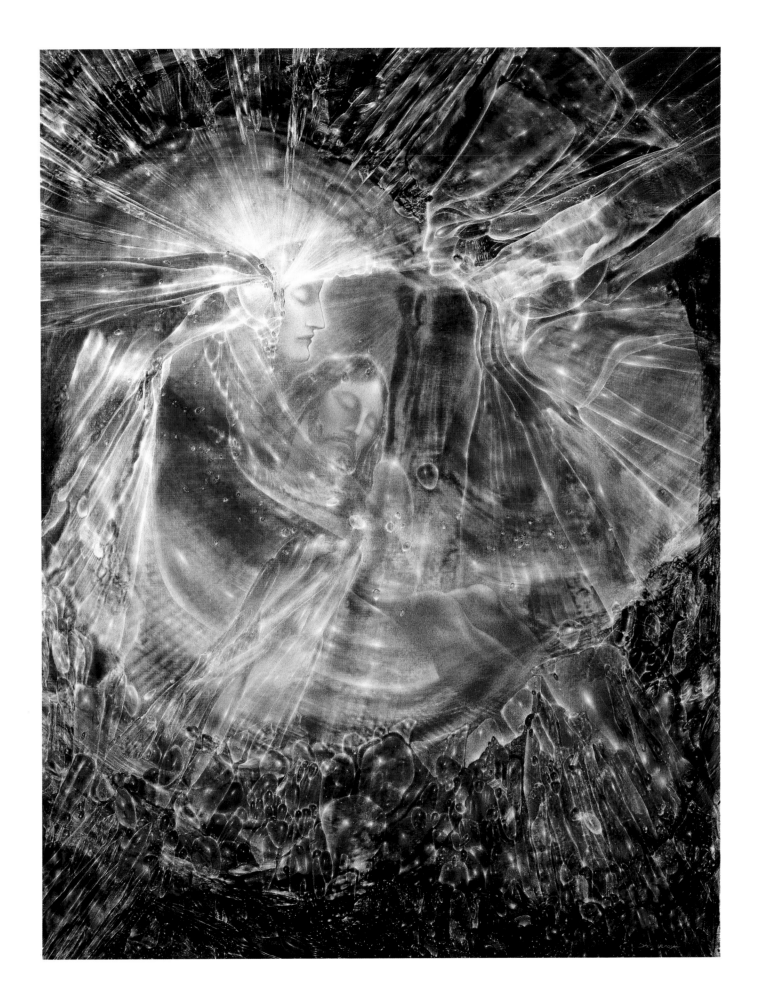

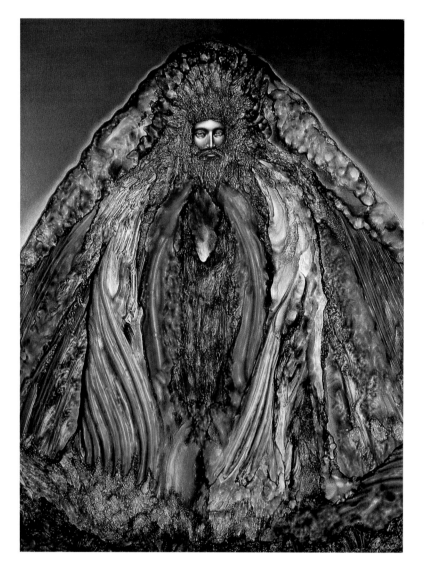

TRANSFIGURATION
1974, OIL ON CANVAS, 80 X 60 CM.
COLLECTION: DR LUIS SANZ, BARCELONA

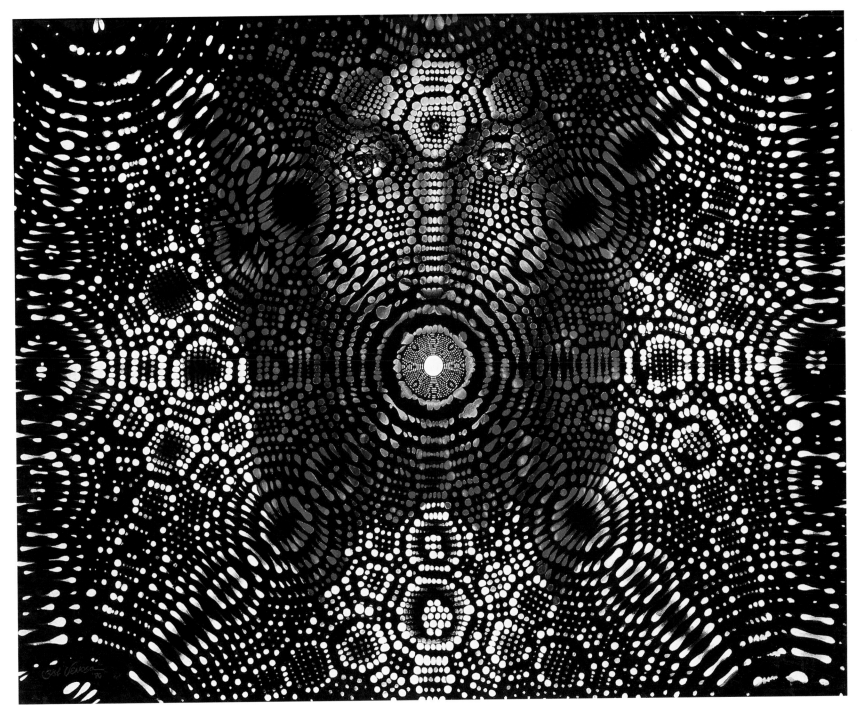

ATOMUS SPIRITUS CHRISTI
1971, OIL ON CANVAS, 70 X 90 CM.
COLLECTION: SANDRA JONES, NEW ORLEANS

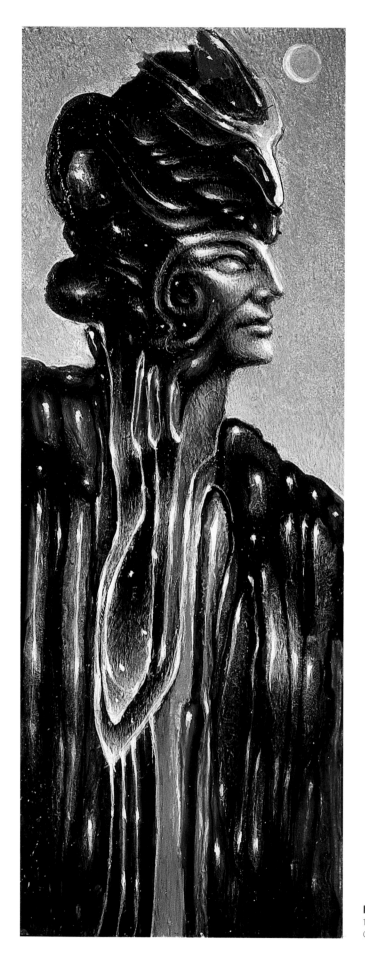

Levels pierced and the shamanic rupture of plane is achieved. Culture's scales fall from the pilgrim's startled eyes and the previously unseen and unimaginable exudes its ontological presence into the visual dialogue which anticipates evolving, decaying, and struggling organism.

NEW MOON
1988, OIL ON PAPER, 14 X 5 CM.
COLLECTION: DR VILA-MONER, BARCELONA

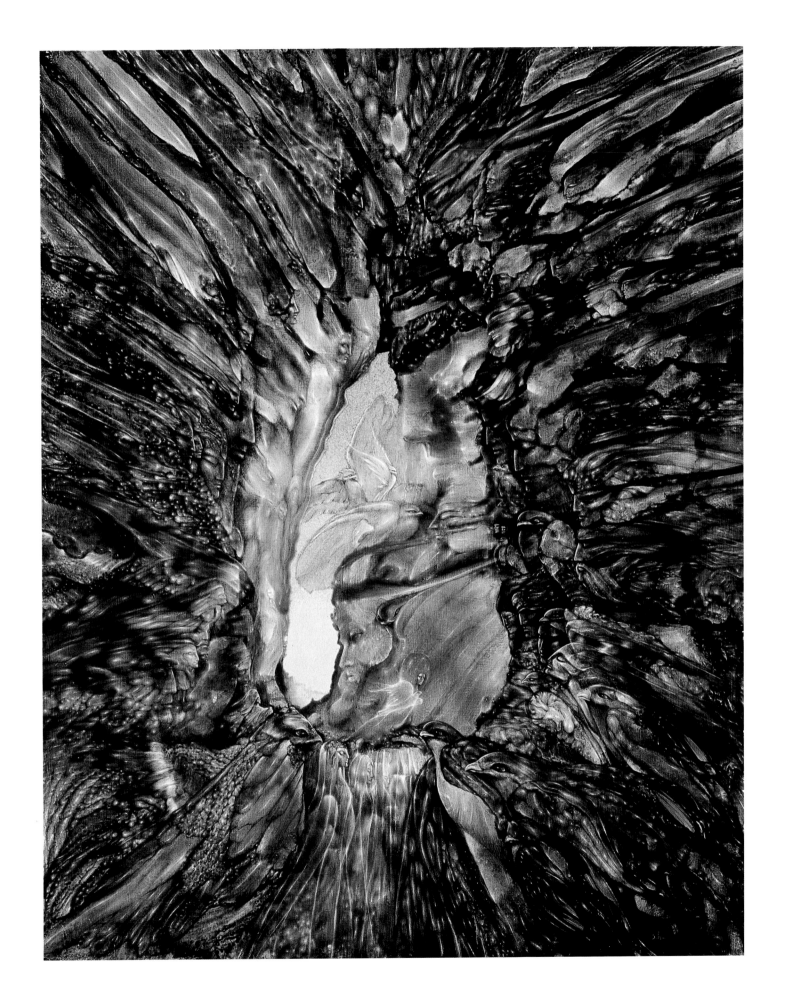

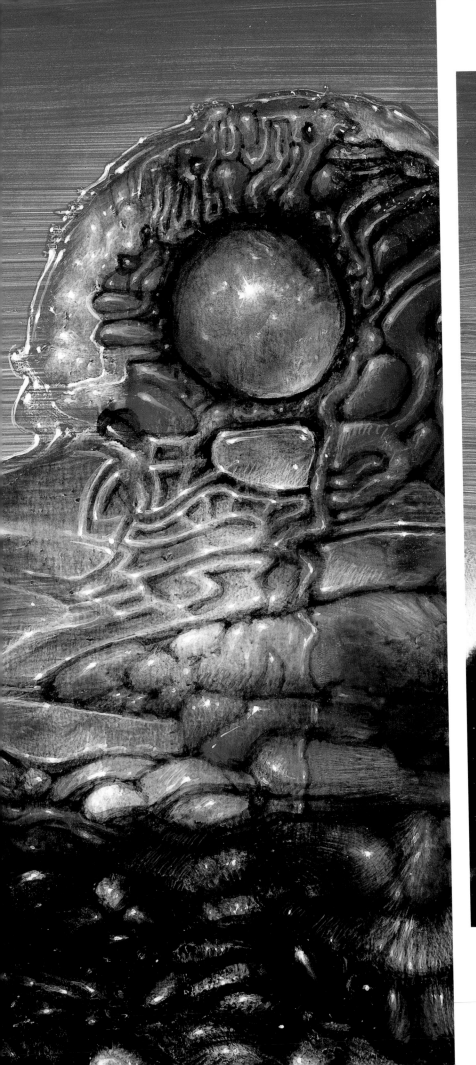
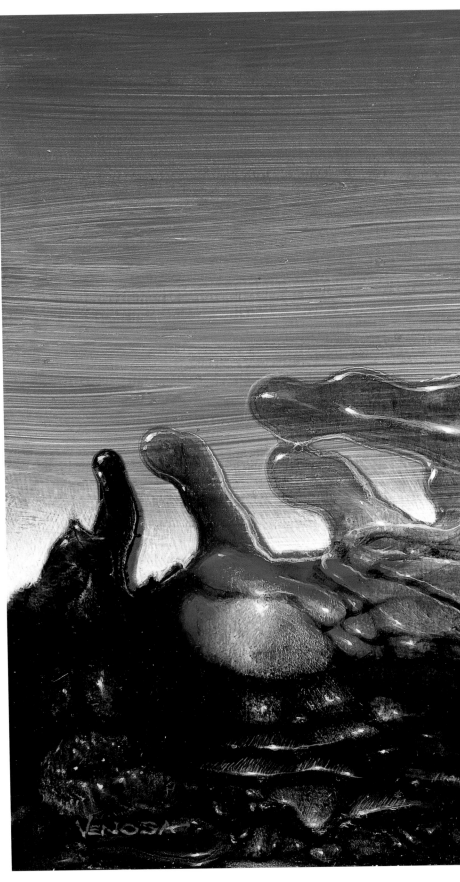

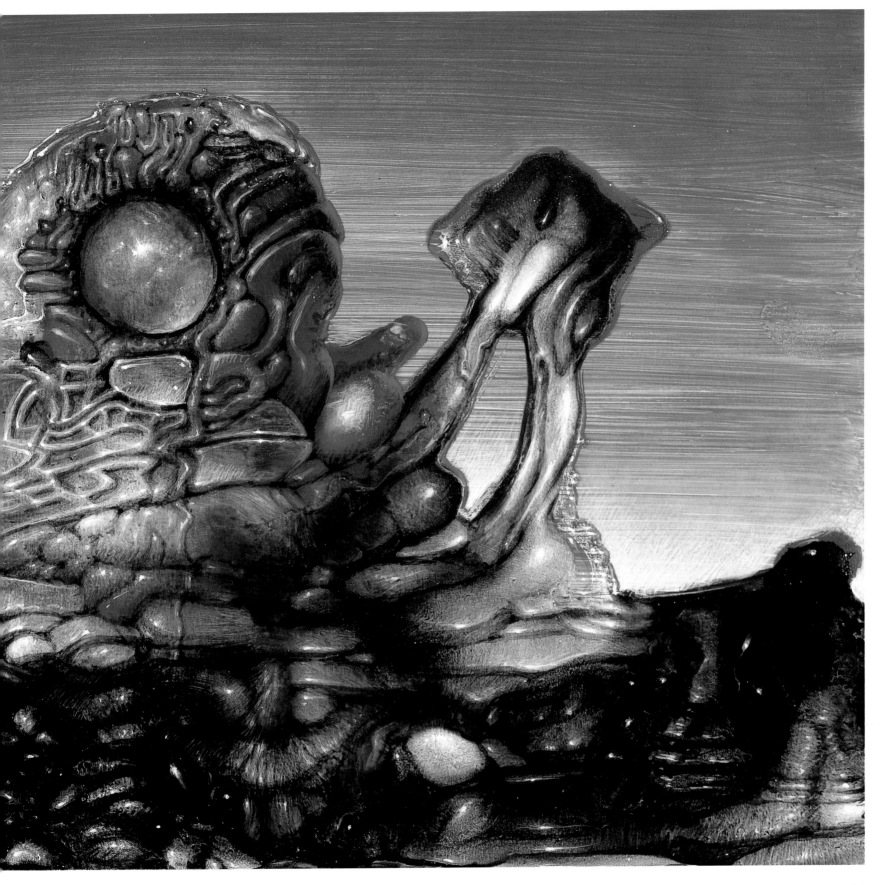

CRYSCAPE
1997, OIL ON MASONITE, 30 X 46 CM.
COLLECTION: SUSAN B. THOMPSON, DENVER

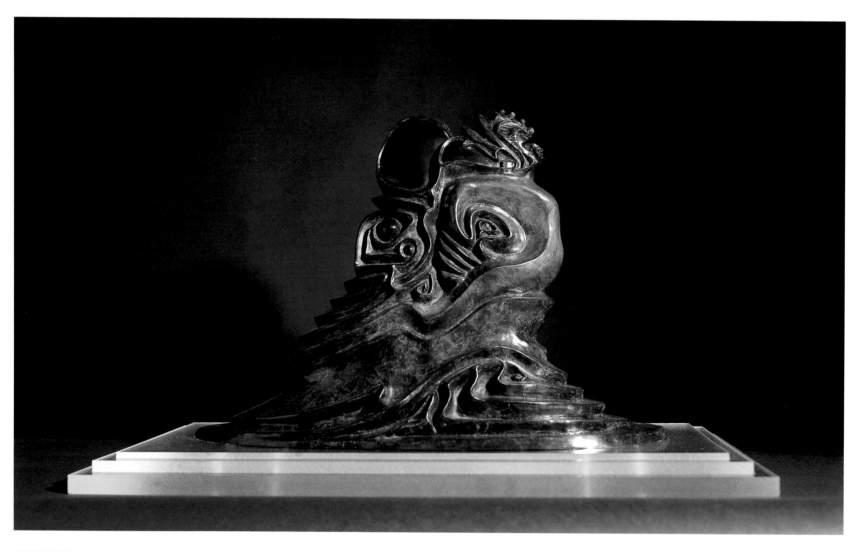

MINDSEND
1989, BRONZE, 35 X 43 X 25 CM, EDITION OF 25

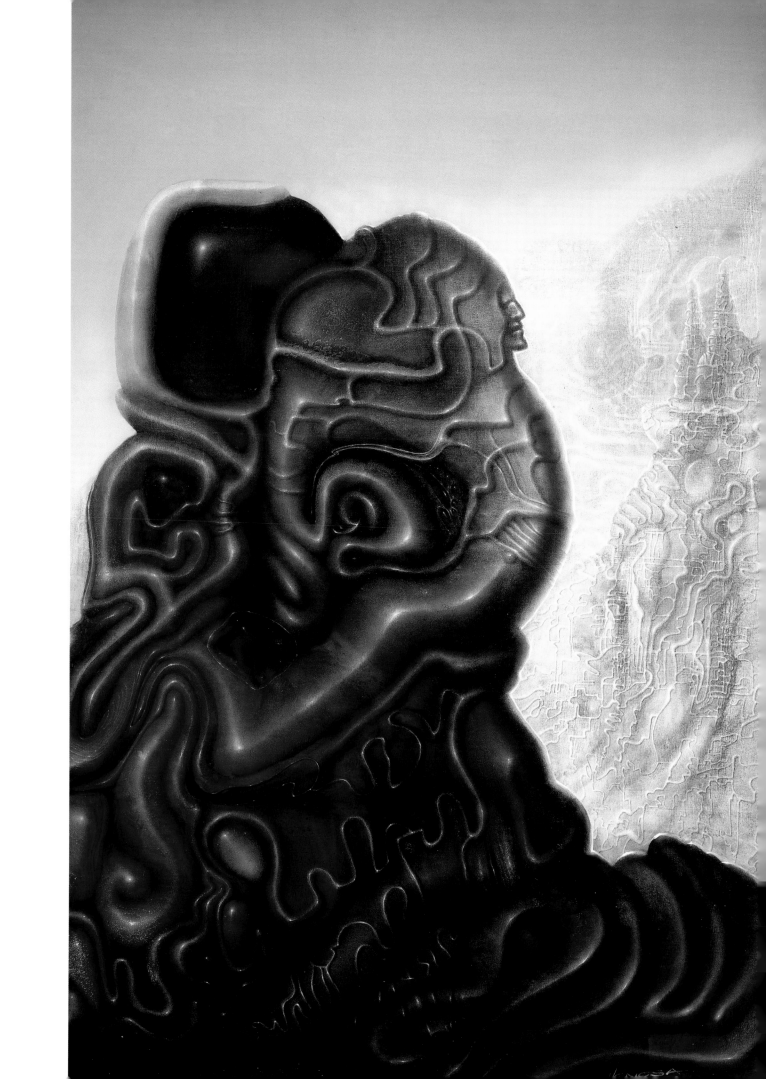

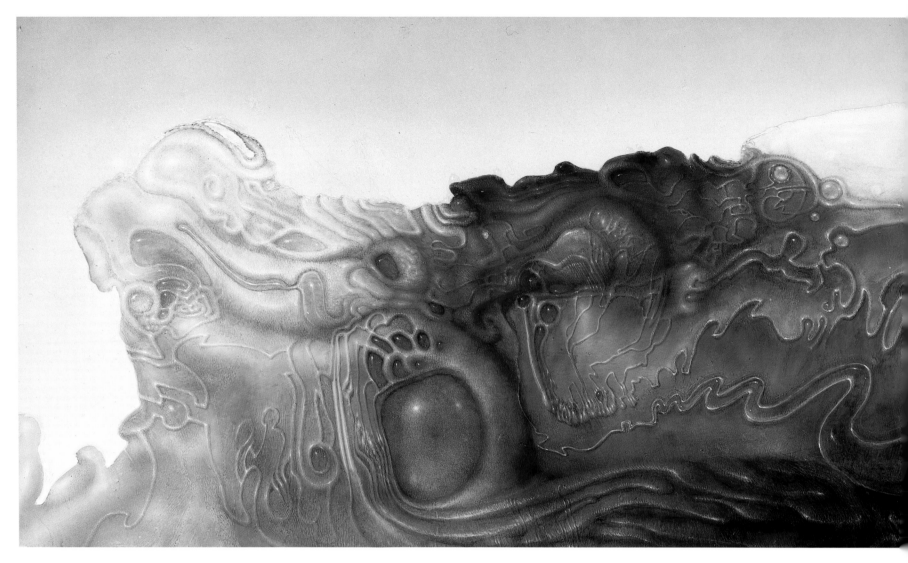

NOOSPHERE
1985, OIL ON MASONITE, 37 X 76 CM.
PRIVATE COLLECTION

Glyptoglossia, the visual cousin of glossolalia, unfolds in a world made of alchemical substances smelt in the furnace of psychedelic contemplation. Secret messages intrude, shaping and embedded in the forms of metal, organs, crystals, water, and light. Everywhere form mutates toward syntax. Nature alien and alive strains toward memories of itself, thus to direct its future unfolding.

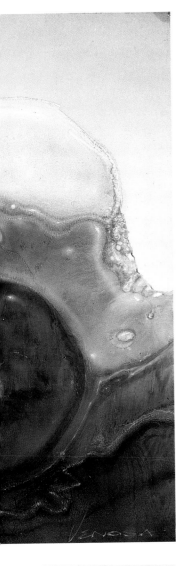

Everything is sign. Venosa's images have a Paleolithic smoothness, inhabiting human minds for millennia. The memes he glimpsed have grown polished as rubbed agate, cool as watery opals, with the passage of terrible amounts of time.

NOOSPHERE II
1986, OIL ON MASONITE, 25 X 66 CM.
PRIVATE COLLECTION

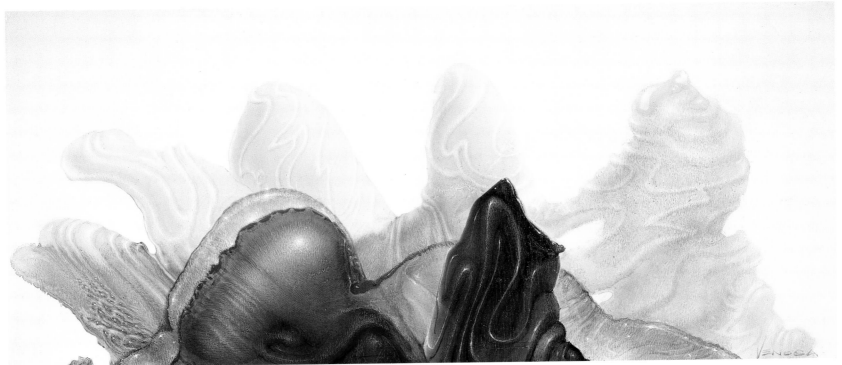

Life and the Waters of Life recur as a theme in the drama of shape-shifting and renewal. Flesh is wet and so is the inter-tidal zone. They are shifting mercurial boundaries where we find ourselves between two worlds. The sense of the difference is vertiginous.

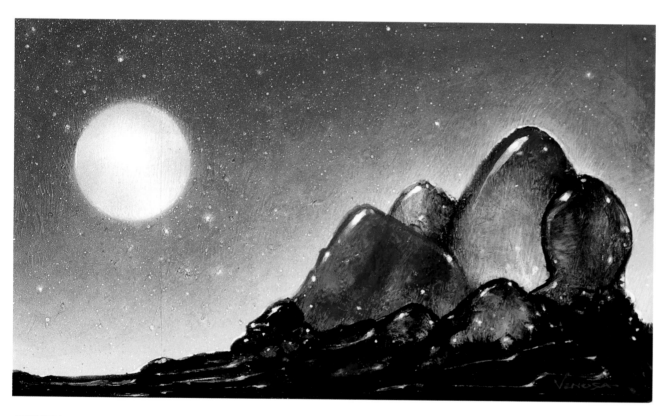

CRYSCAPE III
1996, OIL ON MASONITE, 14 X 20 CM.
PRIVATE COLLECTION

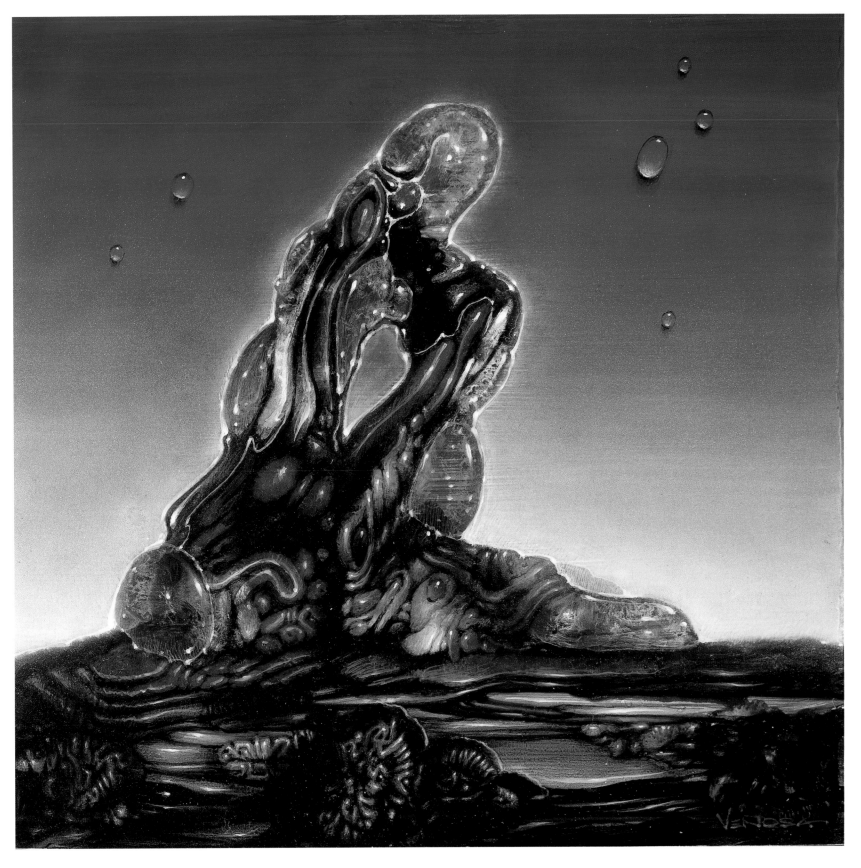

CRYSCAPE II
1997, OIL ON MASONITE, 30 X 30 CM.
COLLECTION: JEFFERY BEARD, DENVER

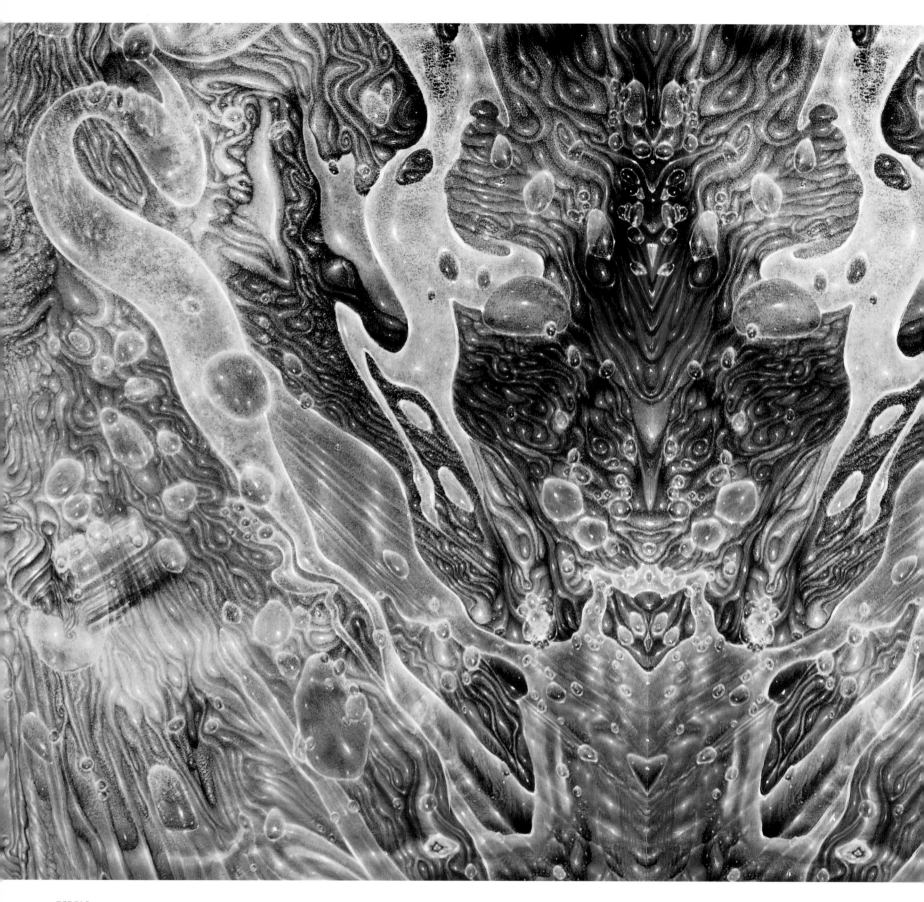

ESPEJO
1990, OIL, MONTAGE, 30 X 60 CM.
PRIVATE COLLECTION

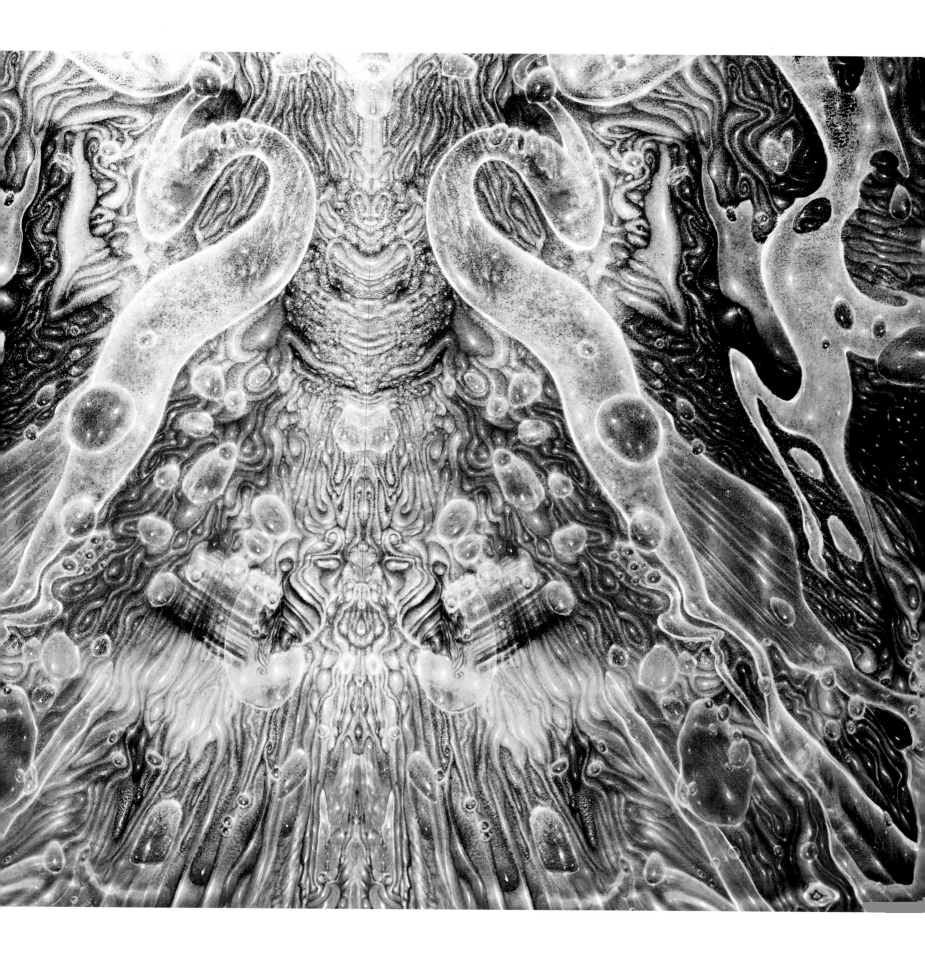

Oceanic strangeness and the felt presence of the Other mingle in visions of worlds ruled by extreme regimes of temperature and pressure. Liquid metal thinking worlds whose depths are inhabited by hopes far too eerie for Man to even begin to suppose.

MINDSEND II
1987, OIL ON CANVAS, 20 X 38 CM.
COLLECTION: JOHN HAY, BOULDER, COLORADO

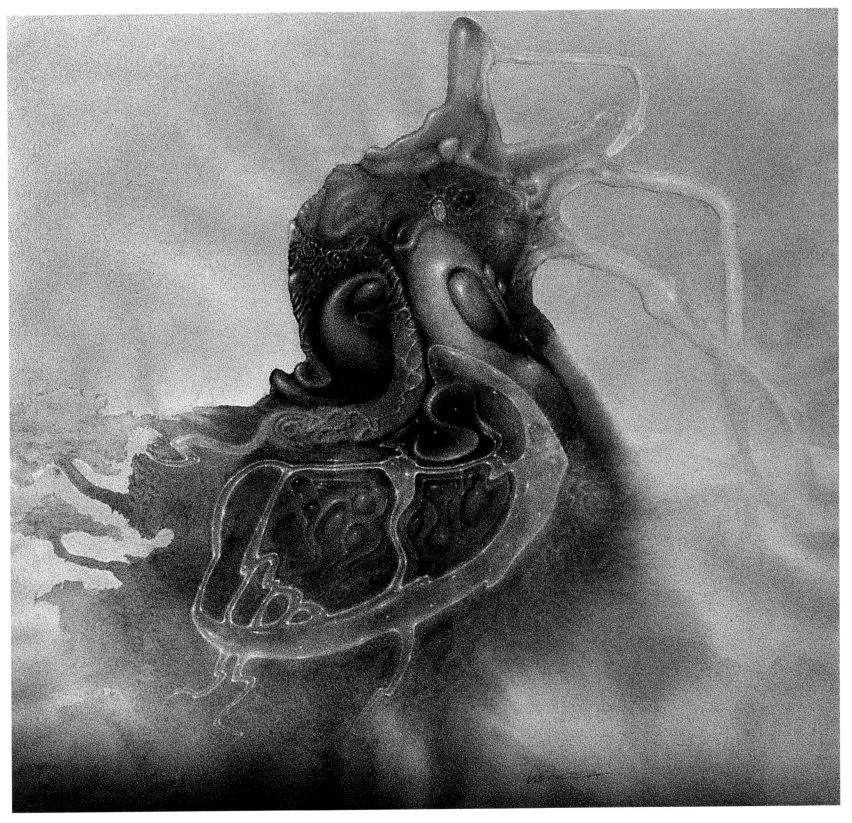

MINDSEND III
1983, WATERCOLOR, 40 X 40 CM.
TERWILLIGER-THOMAS COLLECTION, CHICAGO

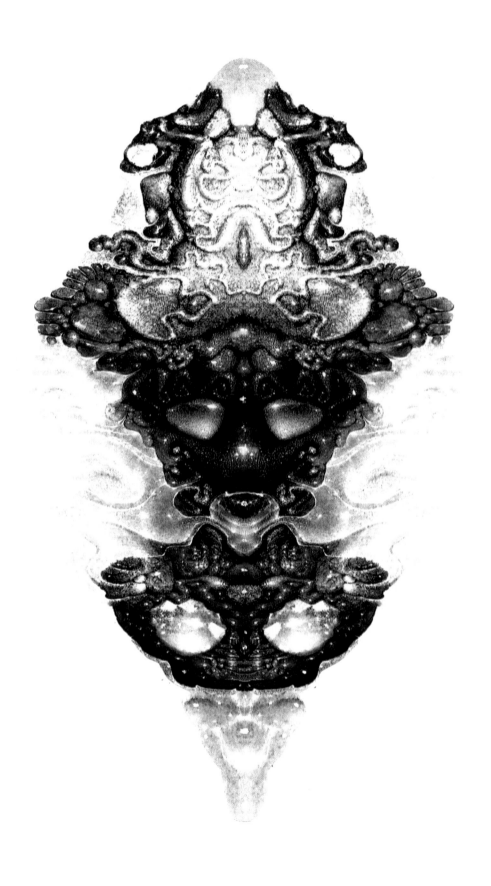

DRIFTS ANGEL
1996, OIL, MONTAGE, 66 X 50 CM.
PRIVATE COLLECTION

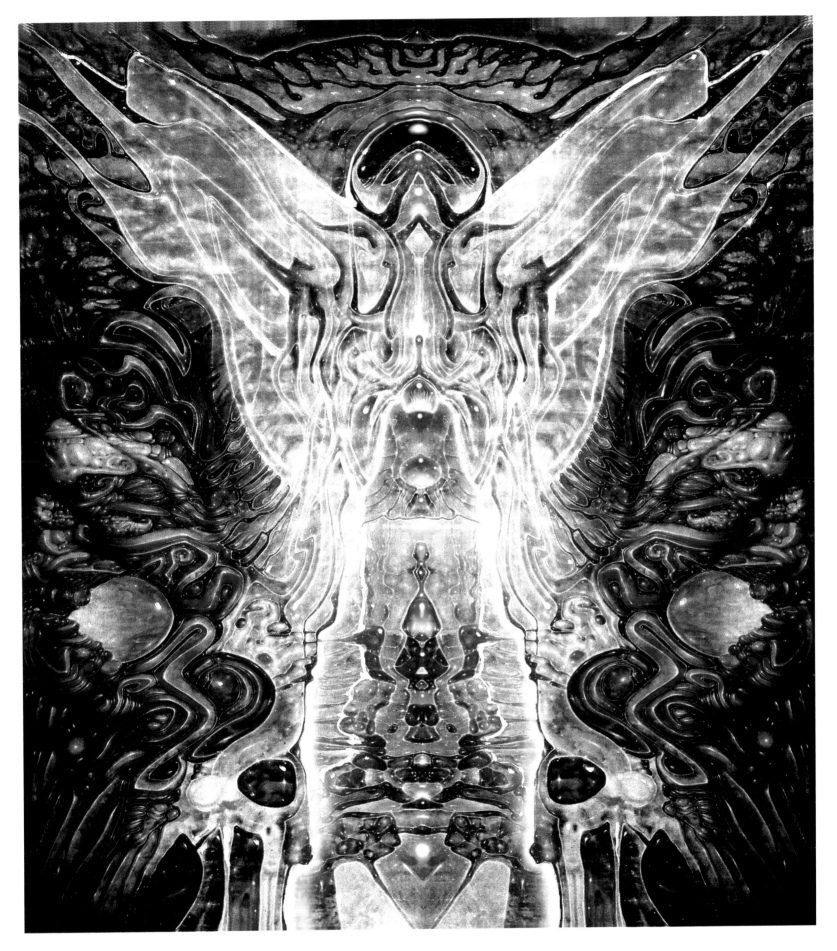

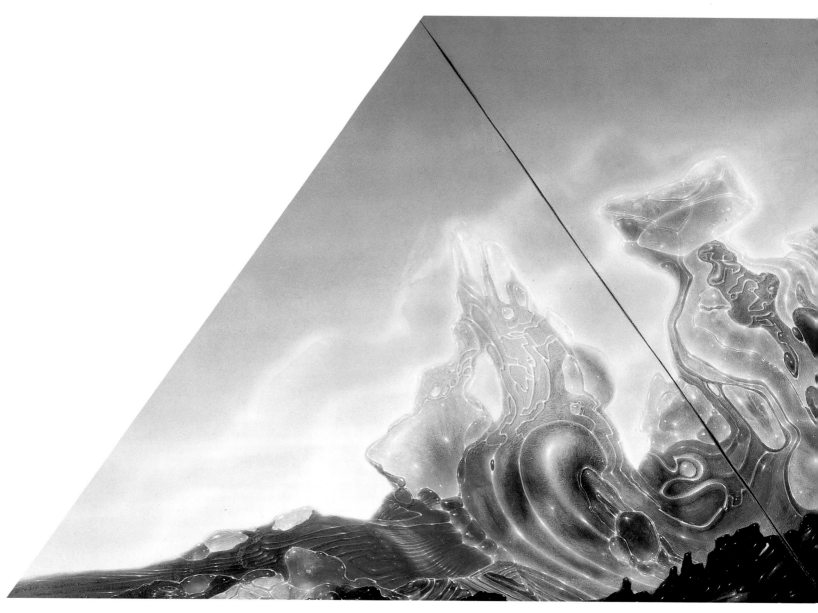

TRES PARTES
1986, OIL ON MASONITE, 60 X 178 CM.
COLLECTION: JOANN HAY, BOULDER, COLORADO

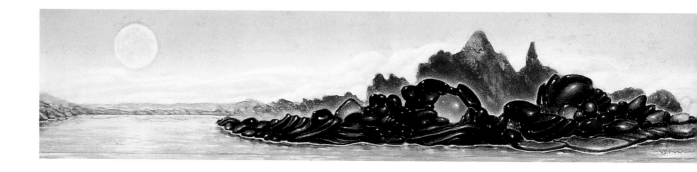

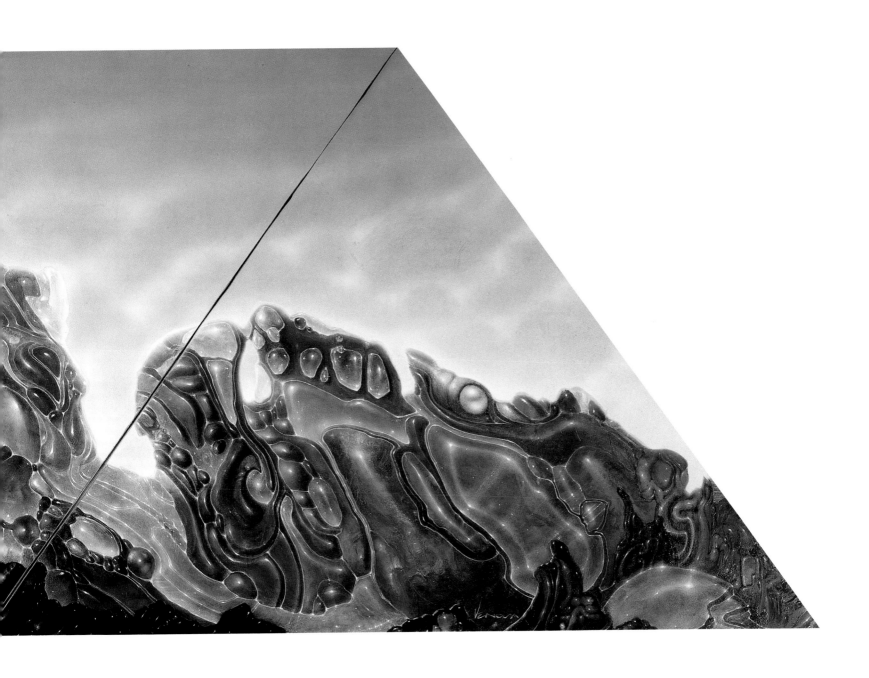

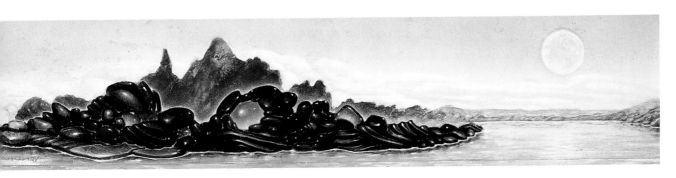

LUNA LLENA
1988, OIL ON MASONITE, 9 X 44 CM.
COLLECTION: PAUL KLAVER, TORONTO

Nature, jewel-like, opalescent with alchemical potential, surrenders eggs nascent and ambiguous. Visionary thought flows through these recollections and anticipations of past and future form. Thought that carries with it always an iridescence of both dream and self-reflection.

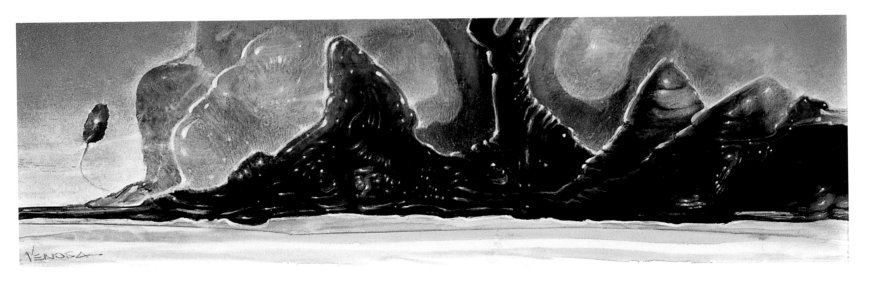

EMERALD BAY
1996, OIL ON MASONITE, 10 X 33 CM.
PRIVATE COLLECTION

DOZEN EGGS
1986, OIL ON CANVAS, 22 X 14 CM.
PRIVATE COLLECTION

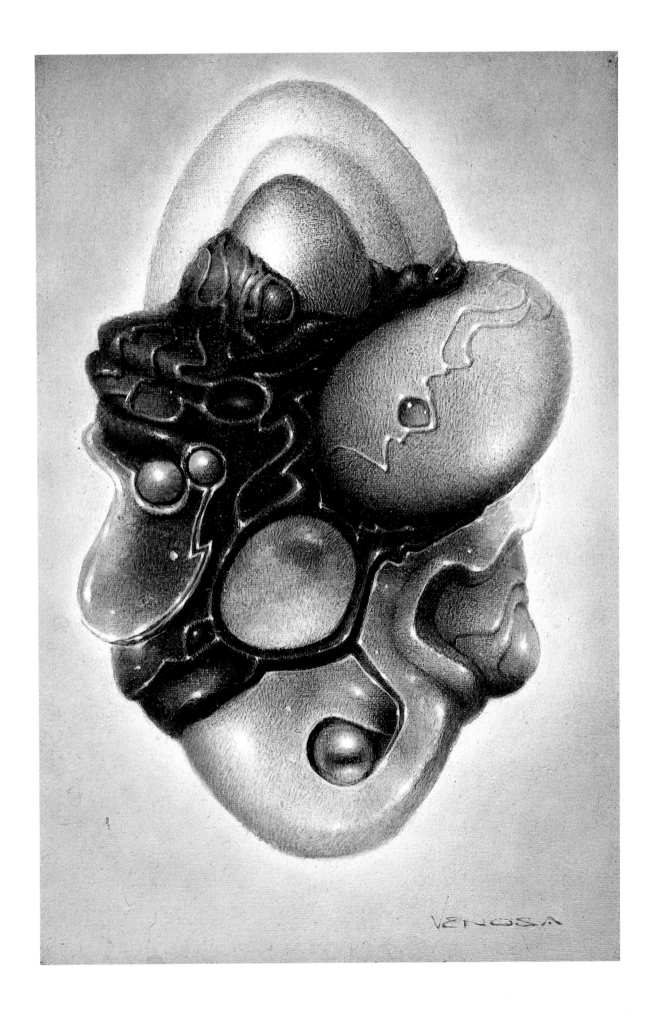

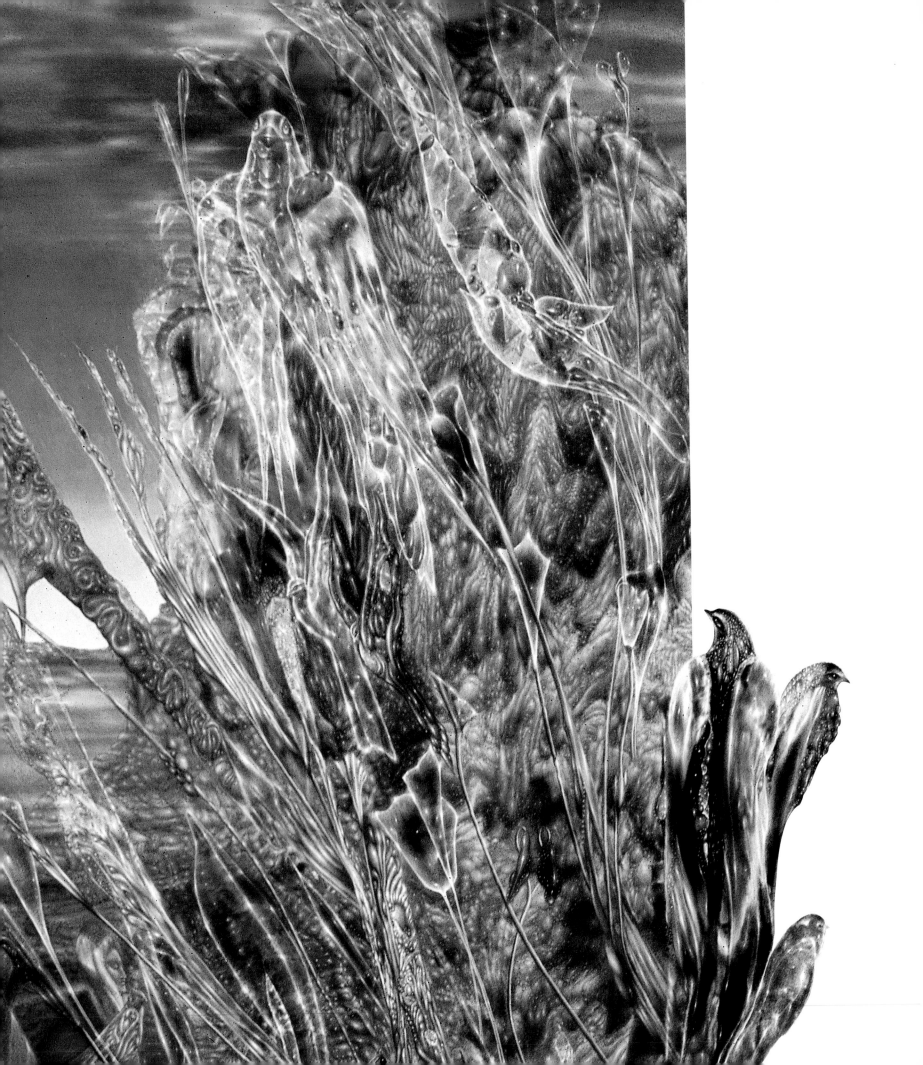

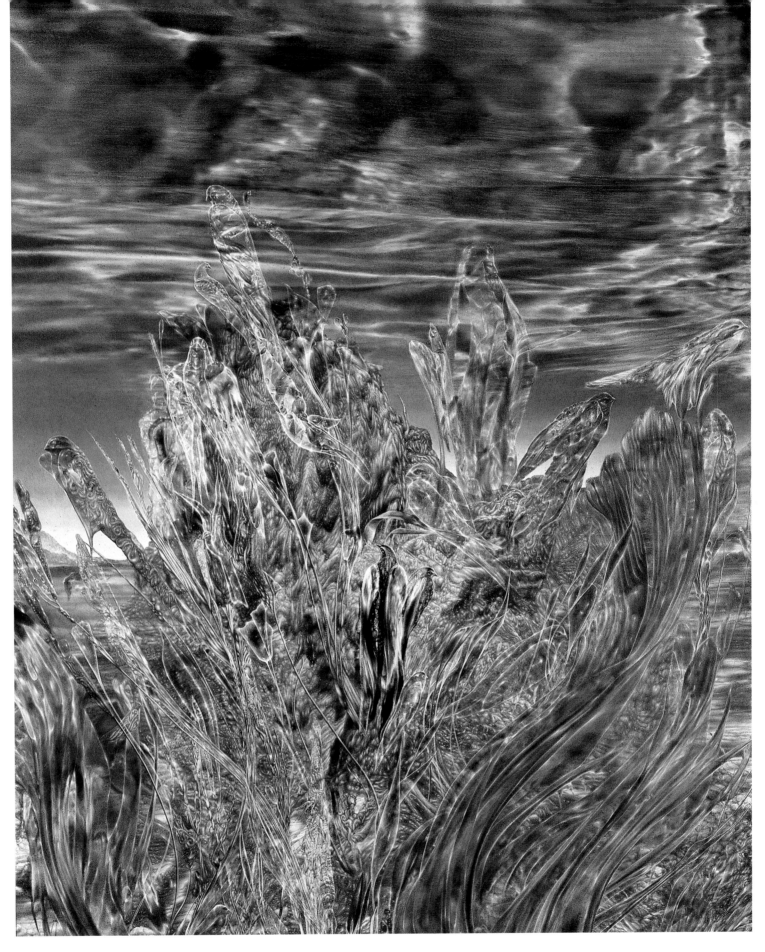

CRYSTALAVI
1976, OIL ON MASONITE, 100 X 80 CM.
COLLECTION: JASON McKEAN, SAN FRANCISCO

MANAS MANNA TREE
1975, OIL ON PAPER, 18 X 25 CM.
COLLECTION: PETER LEDEBOER, LONDON

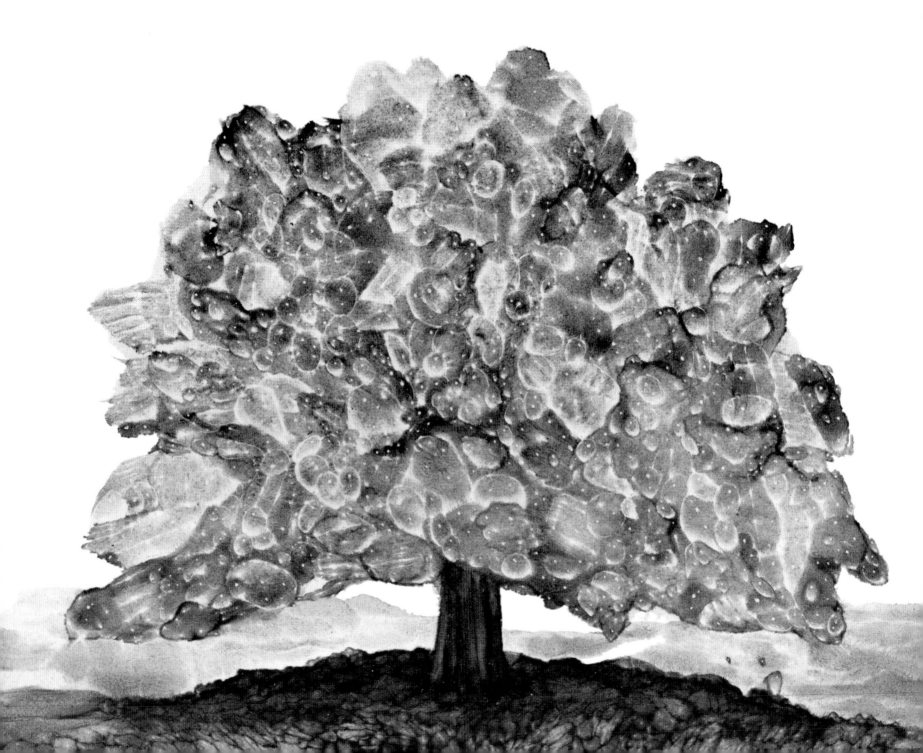

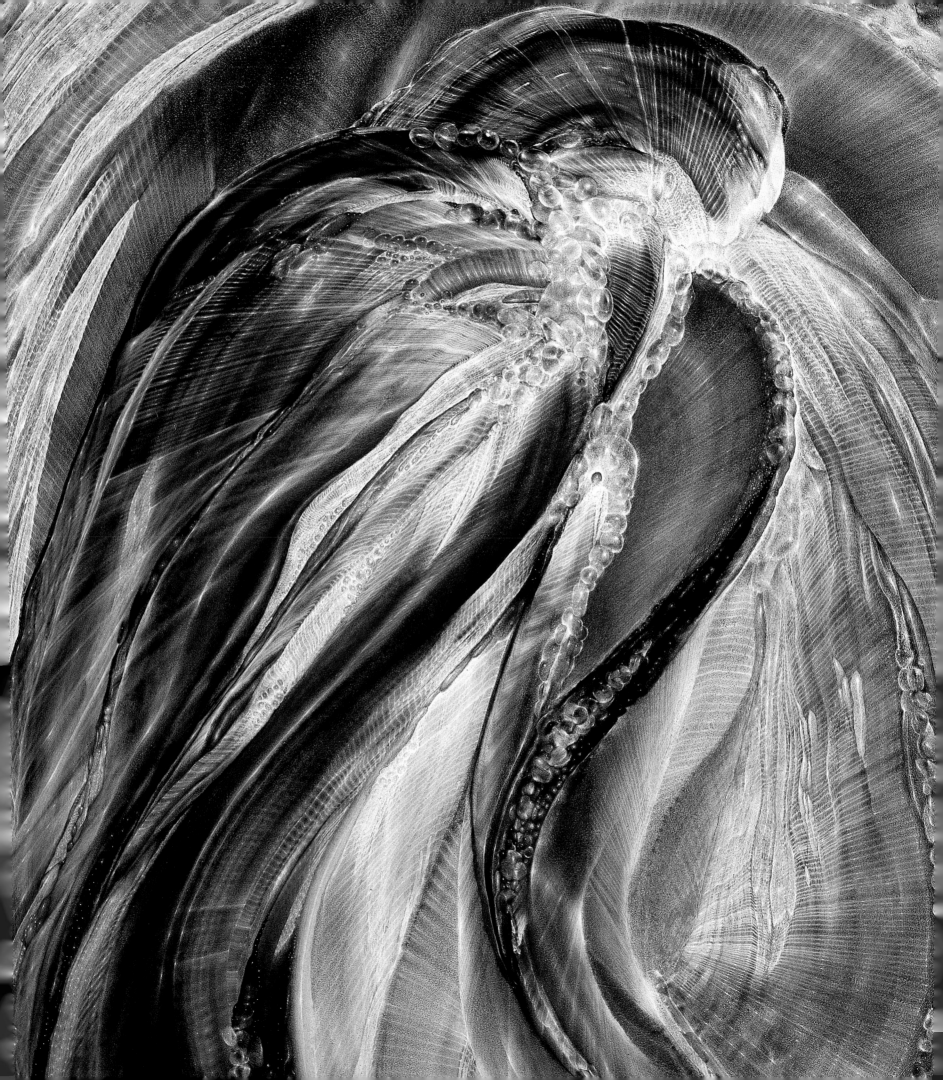

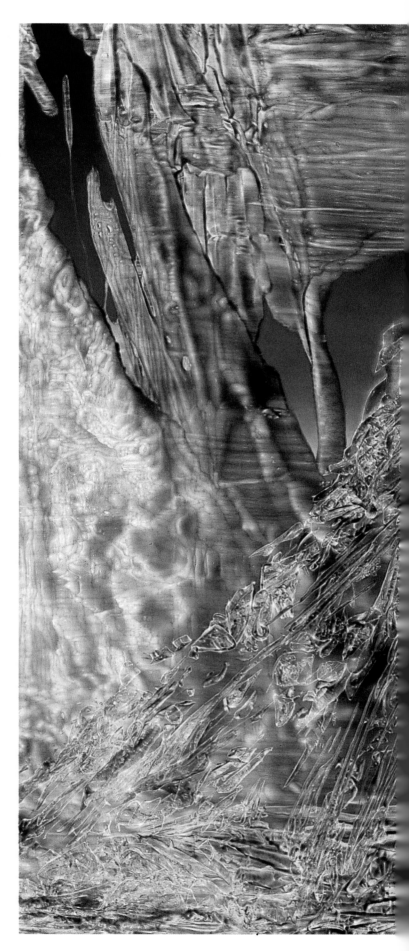

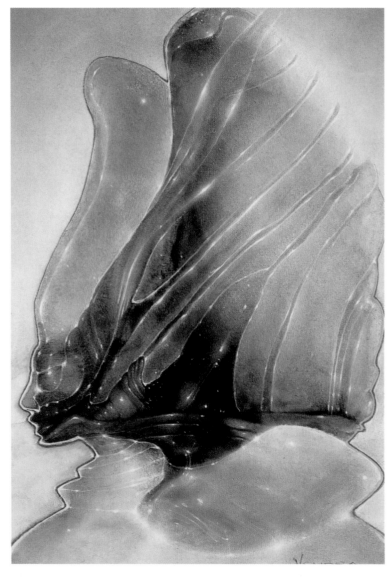

ANGEL HEAD II
1986, OIL ON MASONITE, 28 X 18 CM.
COLLECTION: MARK TRATOS, LAS VEGAS

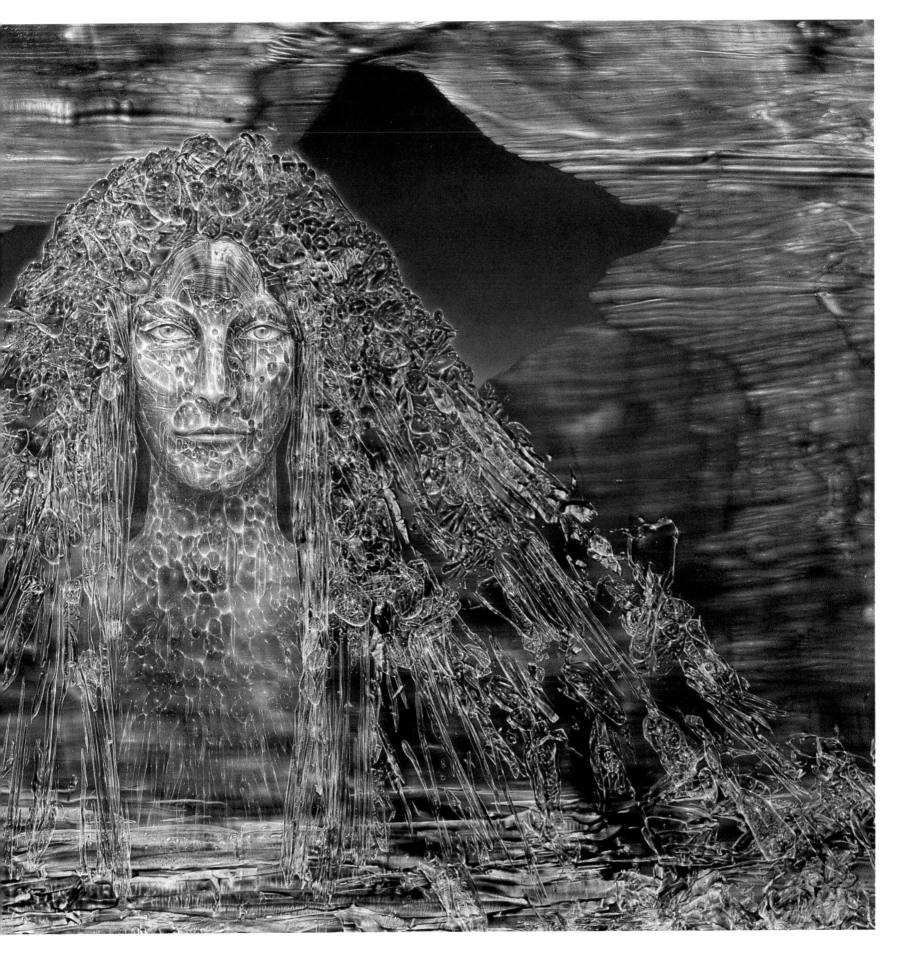

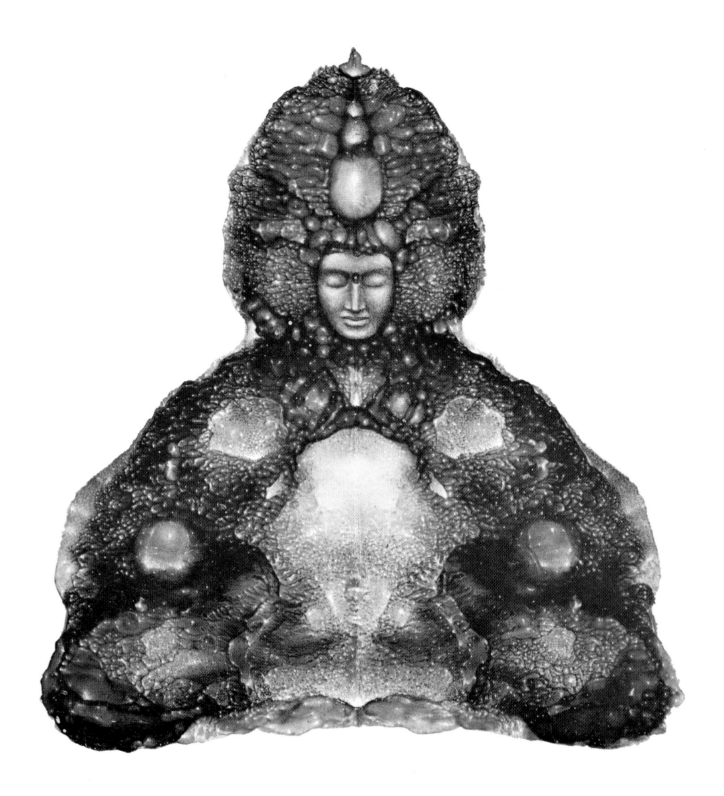

MANAS MANNA BUDDHA
1975, OIL ON PAPER, 20 X 18 CM.
COLLECTION: RONALD FORD, LONDON

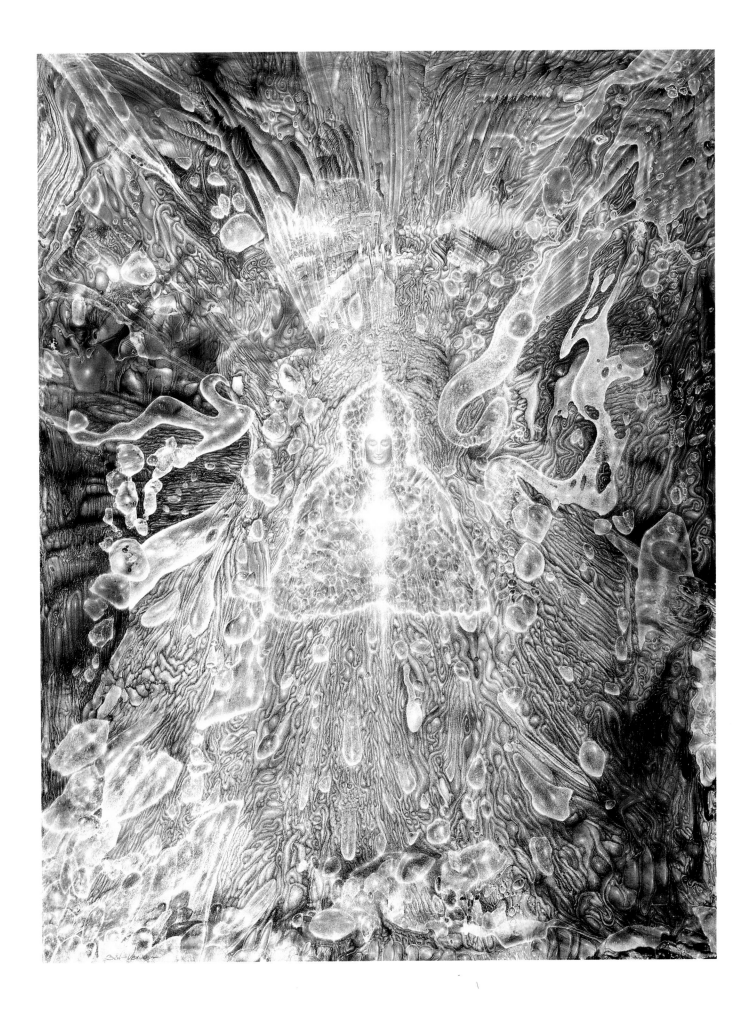

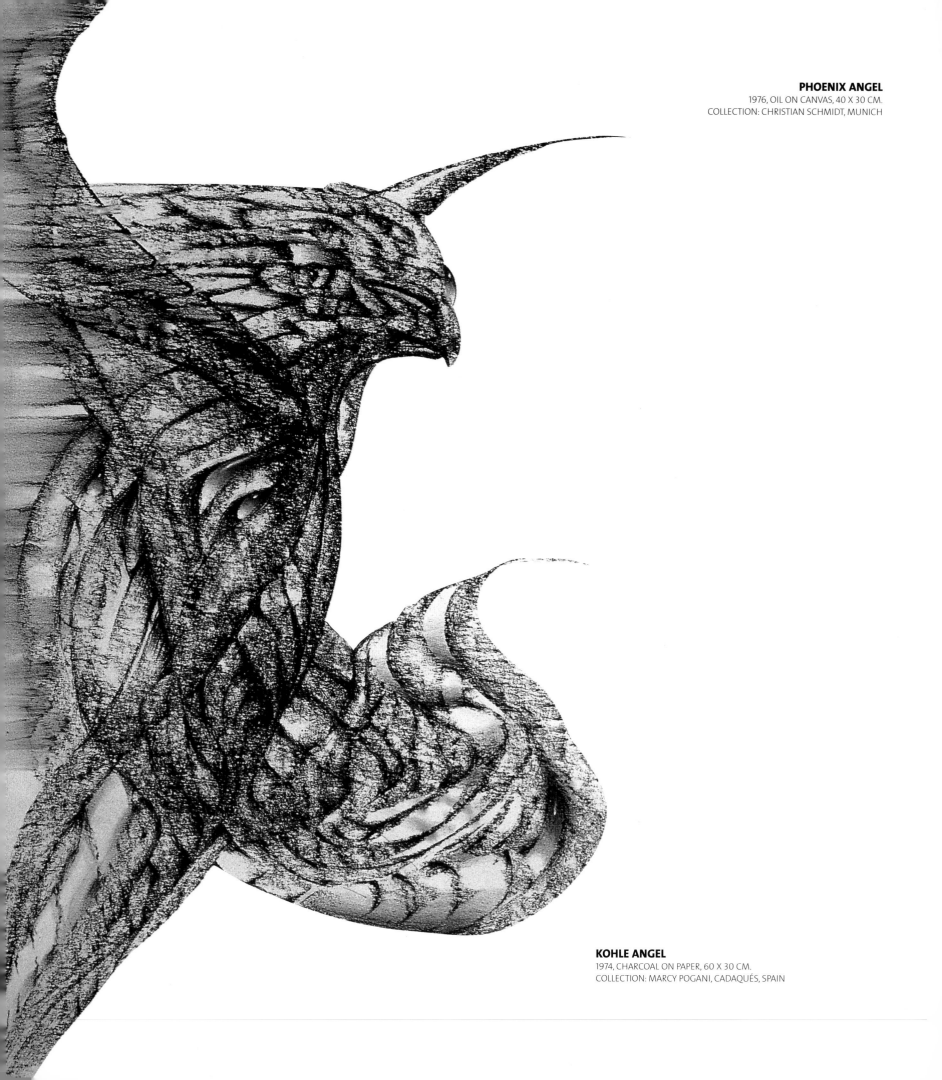

PHOENIX ANGEL
1976, OIL ON CANVAS, 40 X 30 CM.
COLLECTION: CHRISTIAN SCHMIDT, MUNICH

KOHLE ANGEL
1974, CHARCOAL ON PAPER, 60 X 30 CM.
COLLECTION: MARCY POGANI, CADAQUÉS, SPAIN

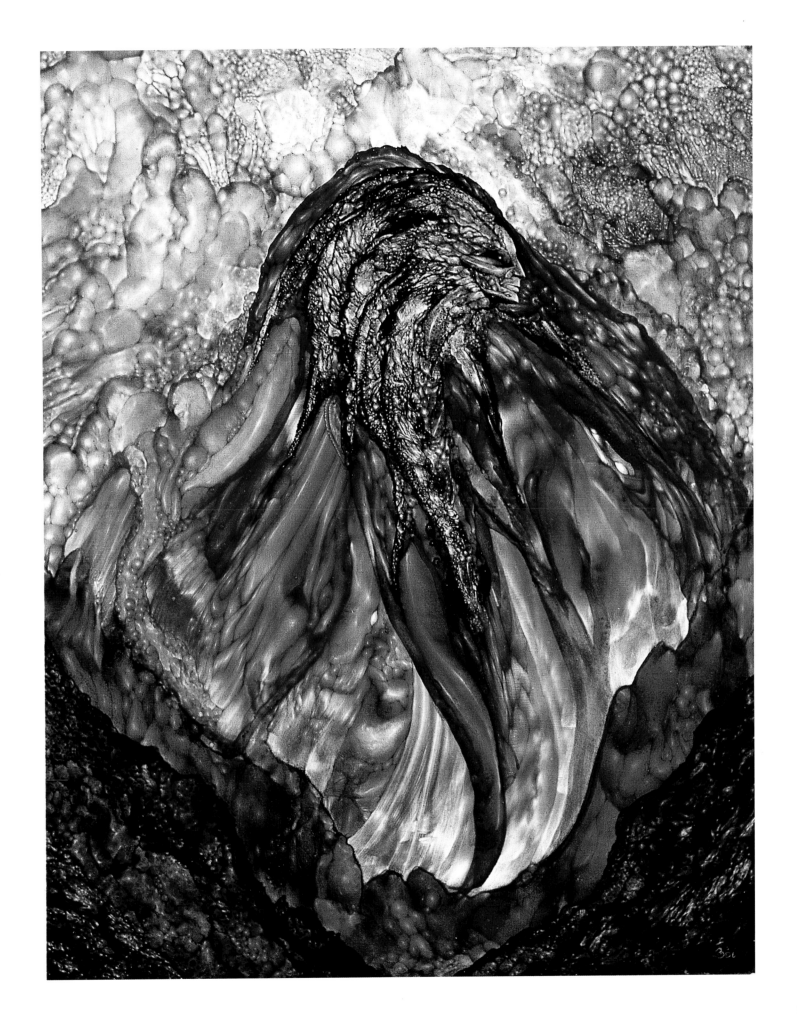

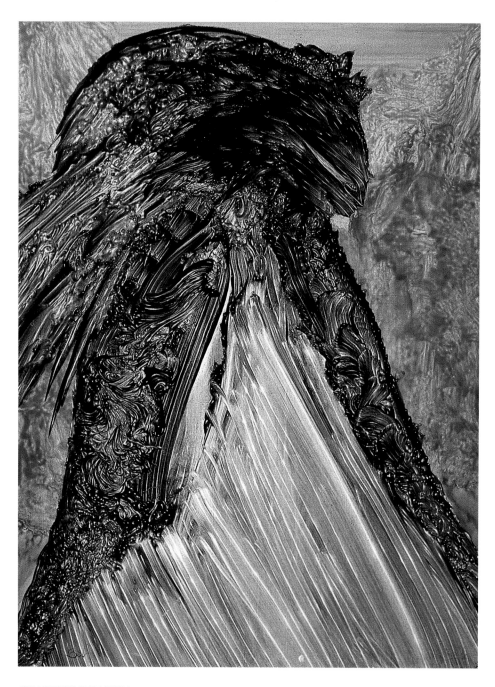

GUARDIAN SERAPHIM
1975, OIL ON MASONITE, 40 X 30 CM.
COLLECTION: SELMA BRANDL, FRANKFURT

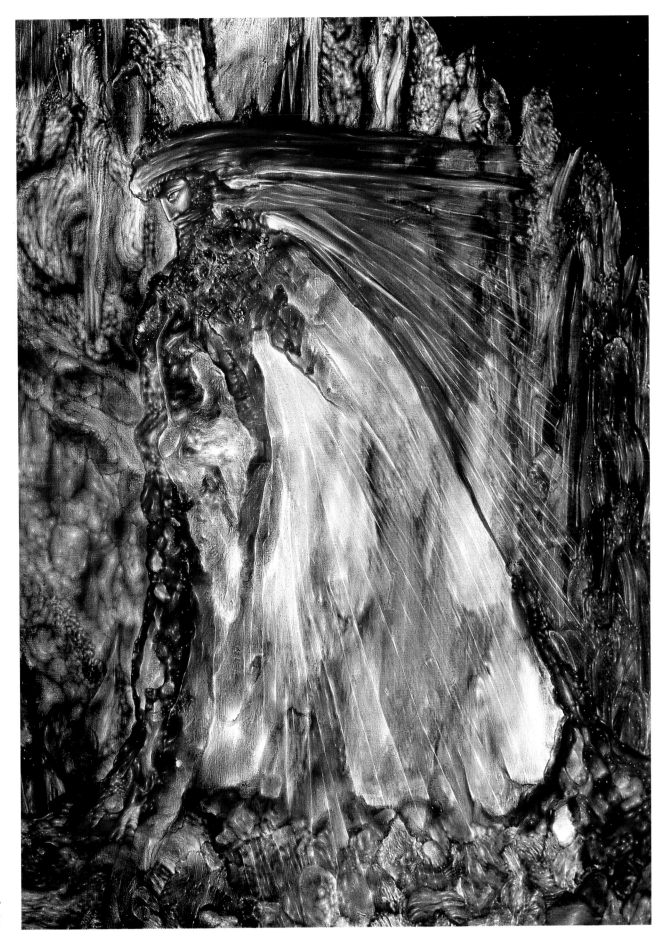

GUARDIAN OF CARMEL
1974, OIL ON CANVAS, 70 X 50 CM.
COLLECTION: MUSEO DE CADAQUÉS, SPAIN

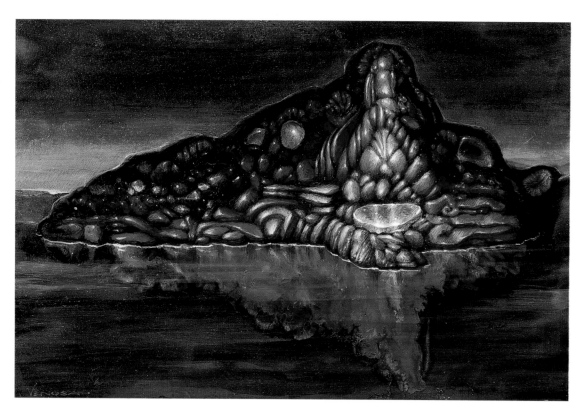

GOLDEN ISLE
1997, OIL ON MASONITE, 30 X 40 CM.
PRIVATE COLLECTION

The human image, impressed, distorted, sometimes surrounded by a halo of time, recollects experience as a journey into imagistic understanding. Understanding by visual association that manages eventually to microcosmically encapsulate all the worlds there are or may be.

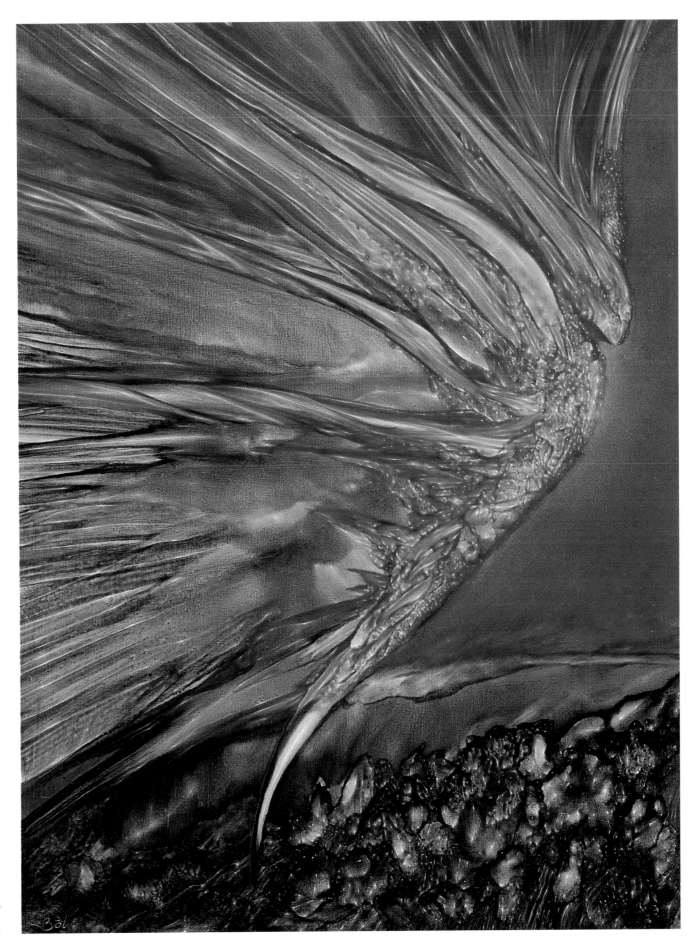

SECONAPHIM
1974, OIL ON MASONITE, 40 X 30 CM.
PRIVATE COLLECTION

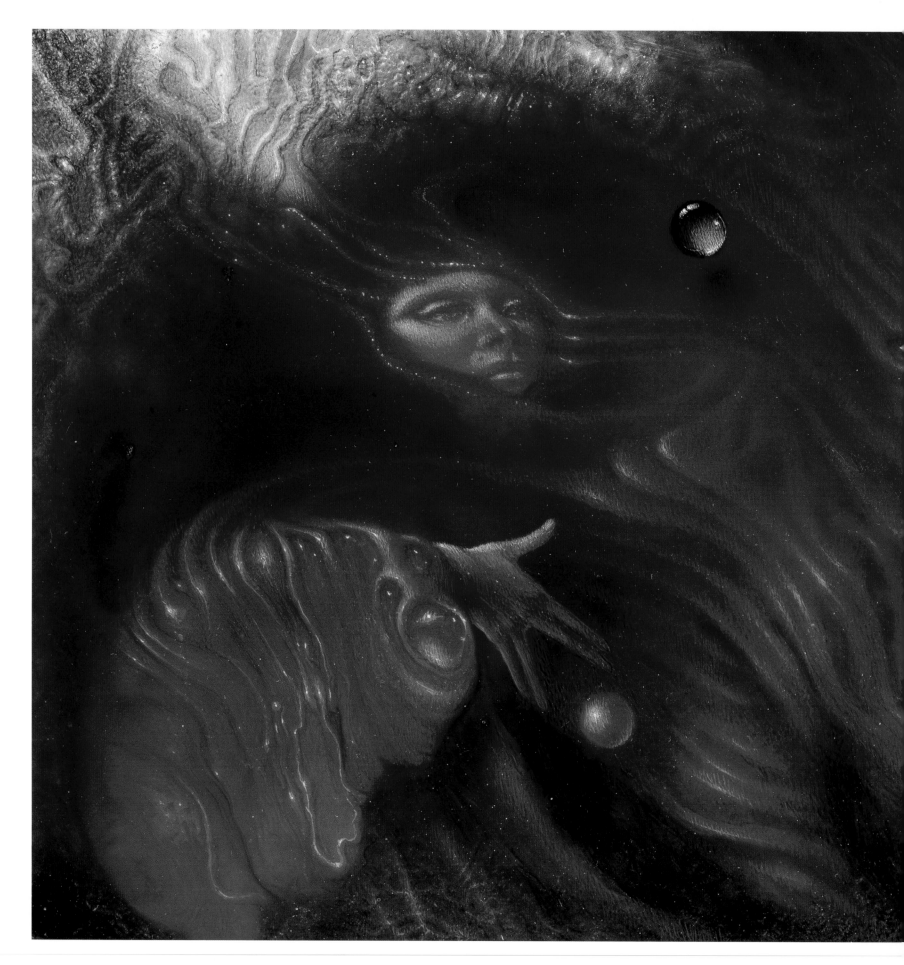

Fractal dust in the service of alien architectonic agendas. All objects partake of the surreal presence of the observer, who fulfills a parasitic mission by bringing undreamt-of images into existence. Images that are mysteriously alive.

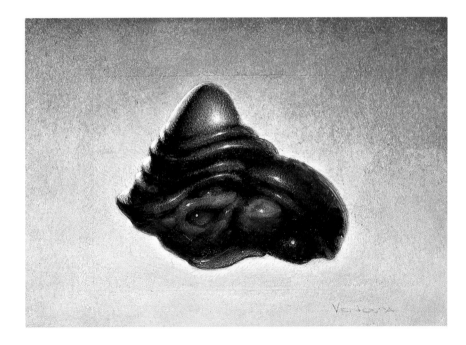

COSA MAGENTA
1986, OIL ON MASONITE, 8 X 10 CM.
COLLECTION: VERA MARTIN, SYDNEY

TWO SPHERES
1983, OIL ON CANVAS, 31 X 40 CM.
PRIVATE COLLECTION

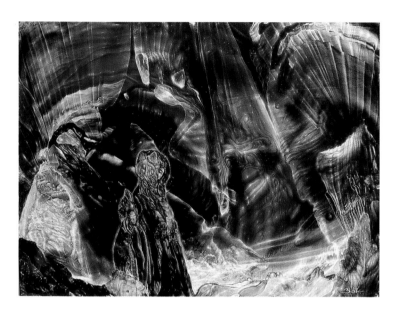

PILGRIMS
1977, OIL ON TILE, 30 X 40 CM.
COLLECTION: ANDREAS LESOWSKI, LOS ANGELES

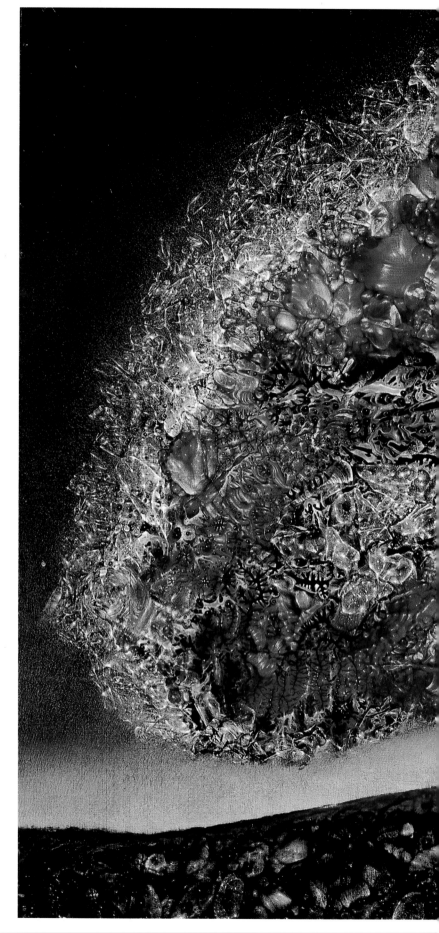

<div align="right">

ATOMIC BLOSSOM
1975, OIL ON CANVAS, 40 X 60 CM.
COLLECTION: CHRIS MURRAY, WASHINGTON, D.C.

</div>

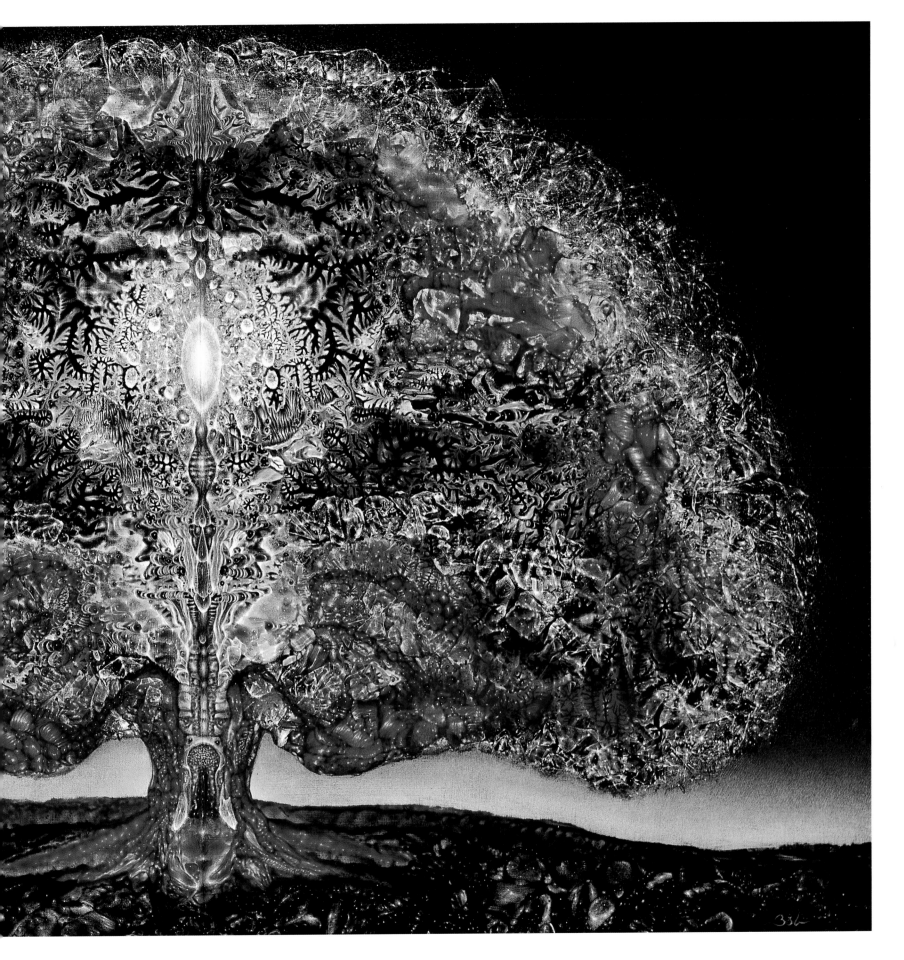

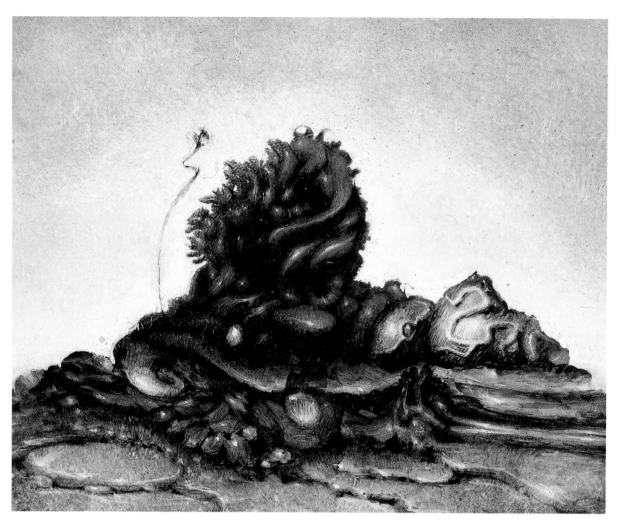

BURNING BUSH
1987, OIL ON MASONITE, 12 X 14 CM.
TERWILLIGER-THOMAS COLLECTION, CHICAGO

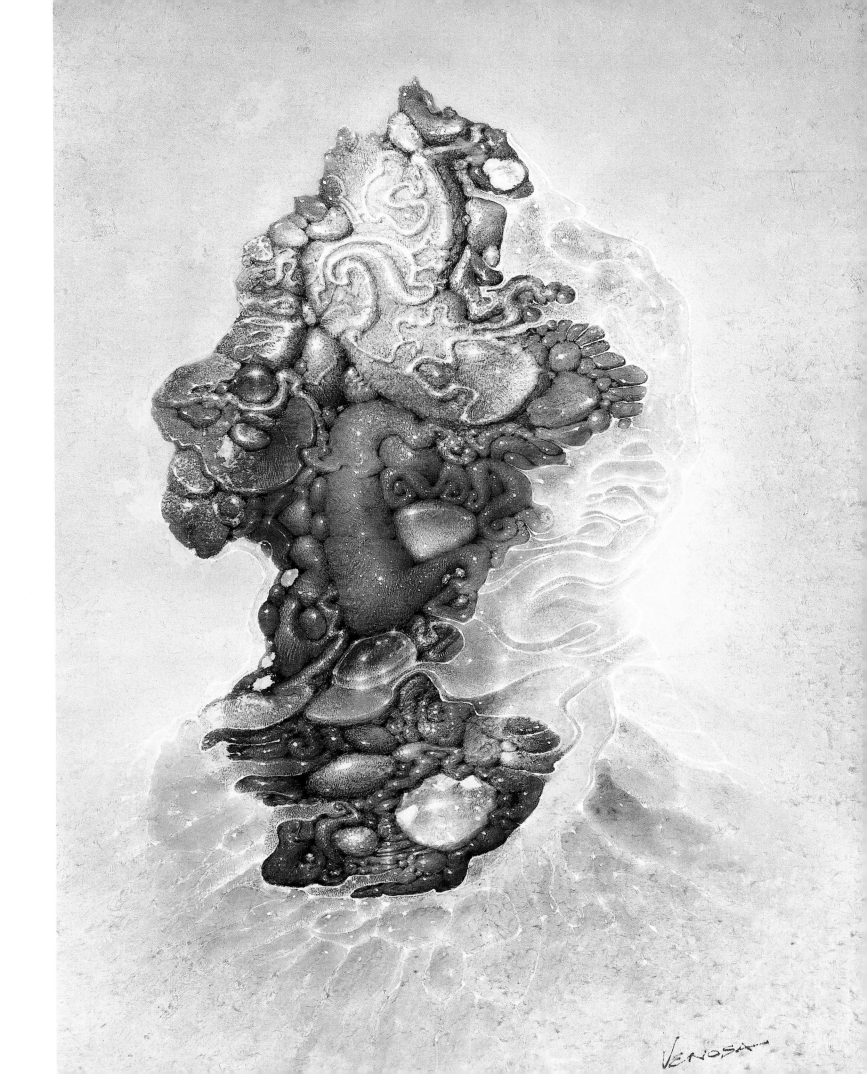

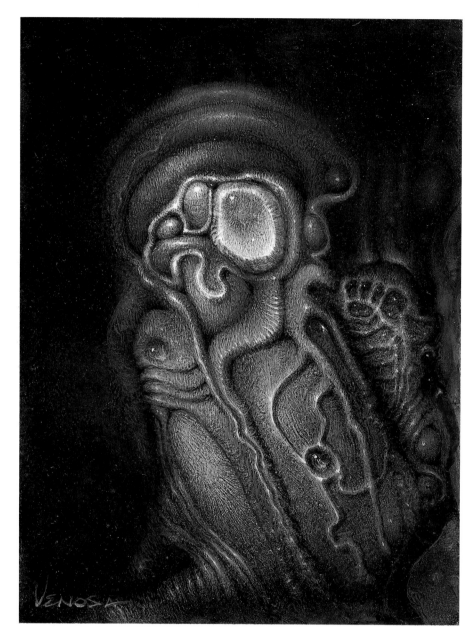

DREAMSCAPE
1983, OIL ON CANVAS, 26 X 22 CM.
PRIVATE COLLECTION

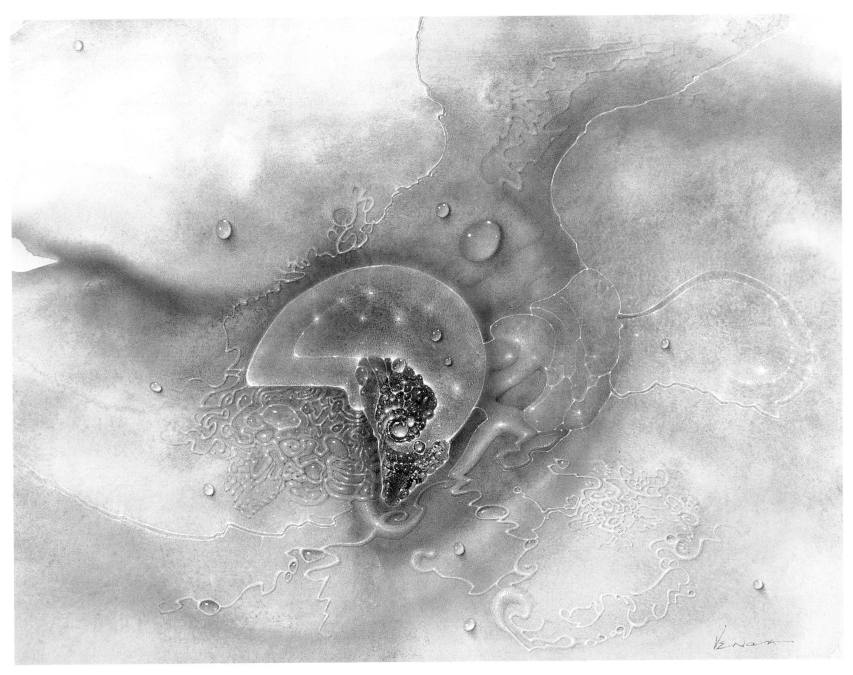

SIN TITULO
1986, WATERCOLOR, 41 X 51 CM.
PRIVATE COLLECTION

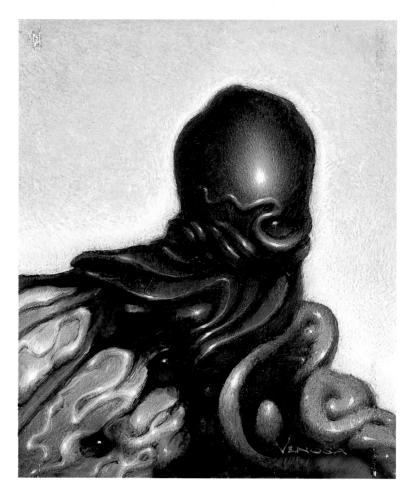

CORONA D'ORO
1987, OIL ON PAPER, 17 X 13 CM.
PRIVATE COLLECTION

ISIS
1977, OIL ON CANVAS, 30 X 40 CM.
COLLECTION: JOSE ANTONIO SALISACHS, BARCELONA

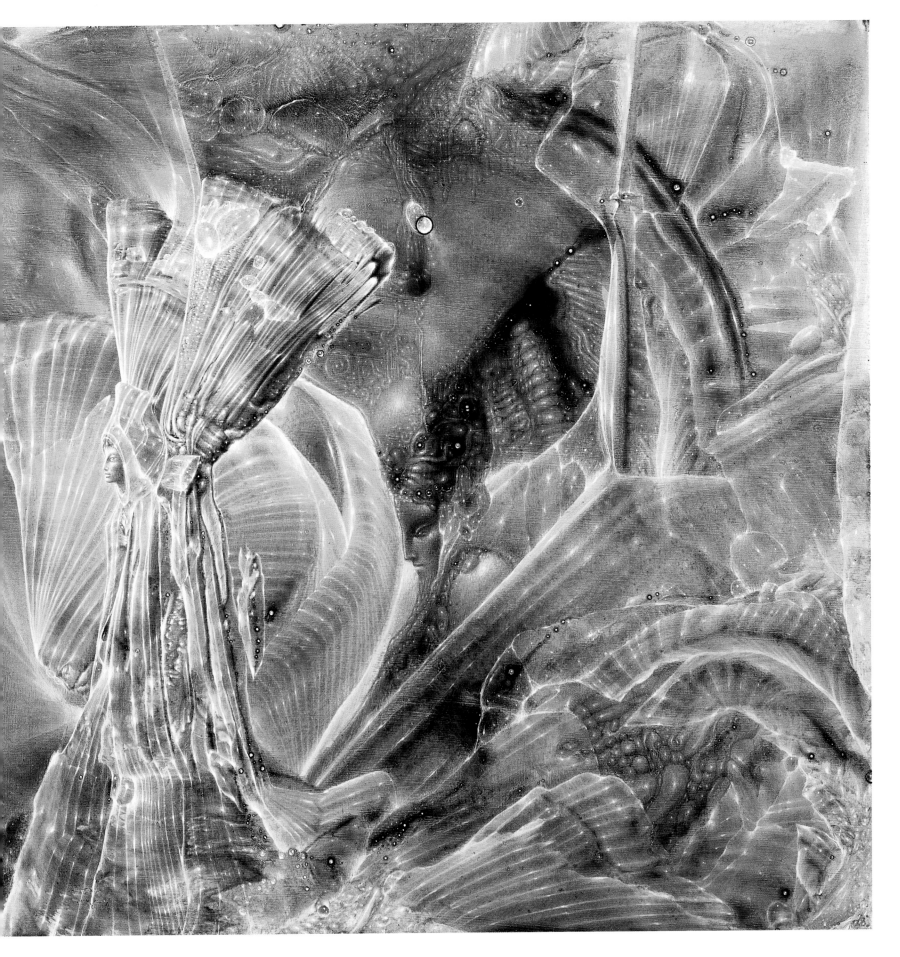

"Every angel is terrible," wrote Rilke. So too this dark angel, this iridescent messenger spawned by time's amberesque obsidian abyss. She is Mother Death, the genetrix of time and space and the motes that drift therein.

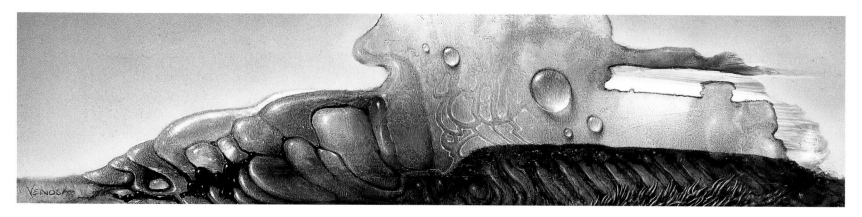

NOOSCAPE
1989, OIL ON MASONITE, 9 X 38 CM.
COLLECTION: PAUL KLAVER, TORONTO

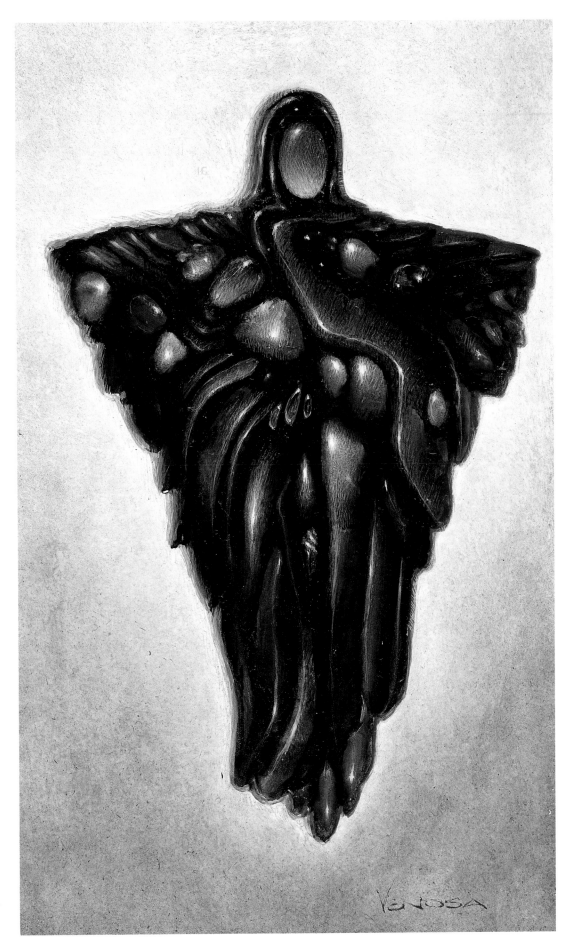

JEWEL ANGEL
1986, OIL ON CANVAS, 20 X 13 CM.
COLLECTION: JEFFERY BEARD, DENVER

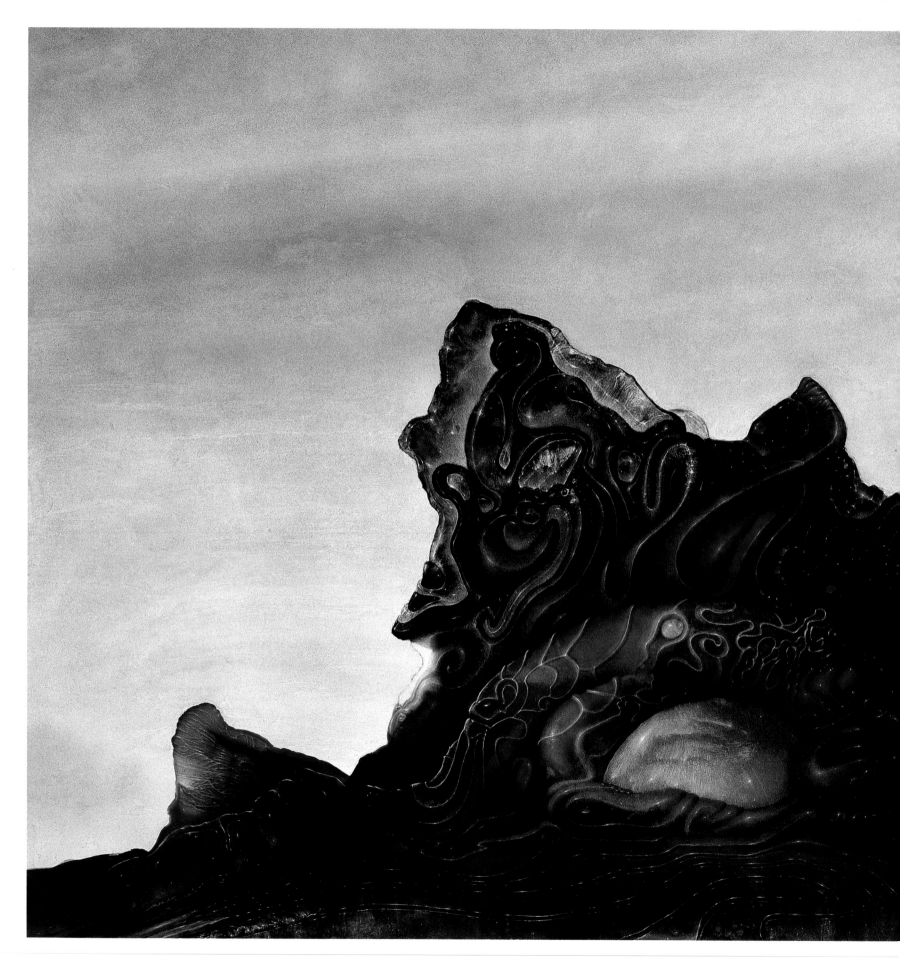

LANDESCAPE II
1981, OIL ON CANVAS, 68 X 98 CM.
COLLECTION: DR CHRISTIAN SCHMIDT, MUNICH

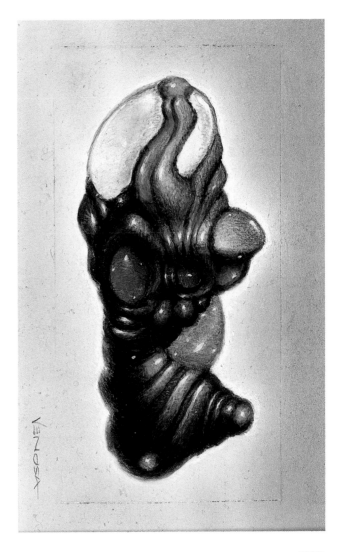

OVNI
1988, OIL ON MASONITE, 13 X 8 CM.
PRIVATE COLLECTION

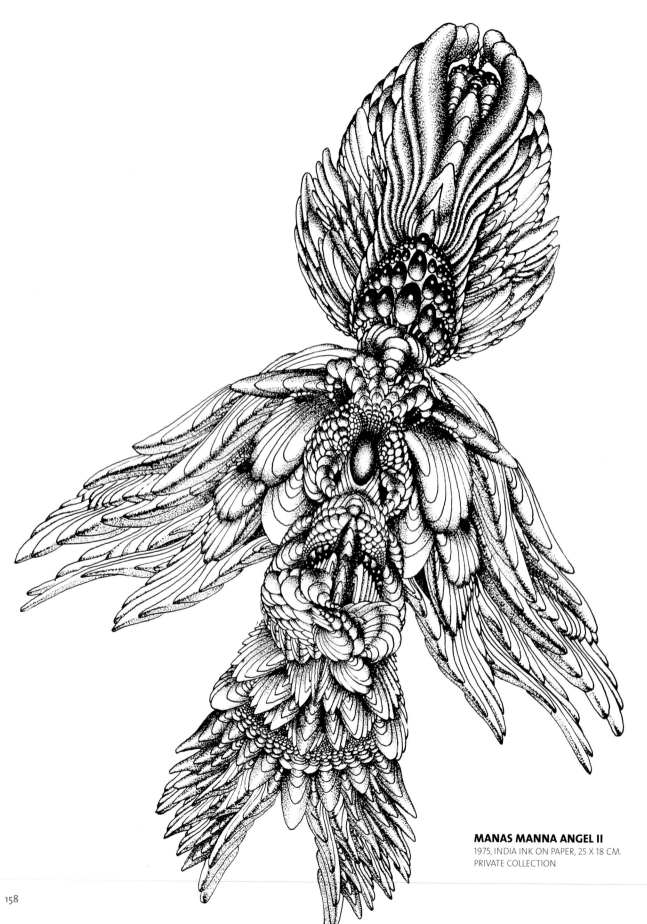

MANAS MANNA ANGEL II
1975, INDIA INK ON PAPER, 25 X 18 CM.
PRIVATE COLLECTION

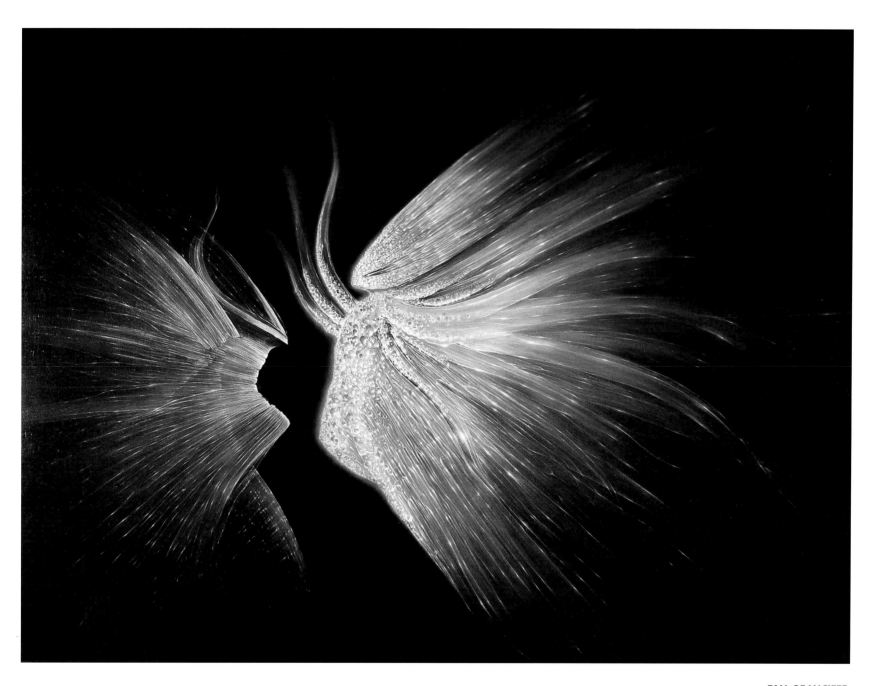

FALL OF LUCIFER
1972, OIL ON CANVAS, 75 X 108 CM.
COLLECTION: RUUD VAN DER NEUT, AMSTERDAM

The mythical land, shaped in service of the imagination, calls forth epic human figures, both ideal and individual, caught somewhere out in the billows of the ages, in their own unfolding dramas, some suspecting, some never guessing the dimension of canvas upon which they glow and think and move and live.

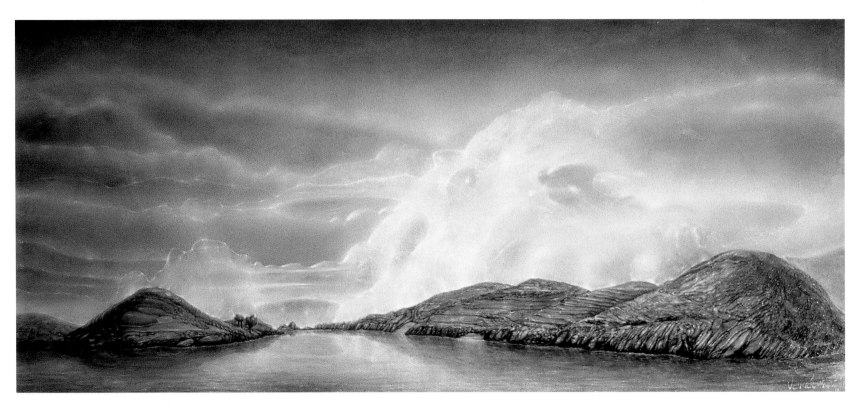

PORT LLIGAT
1980, OIL ON CANVAS, 45 X 76 CM.
COLLECTION: FRANCIS AND LUCIENNE GASC, PARIS

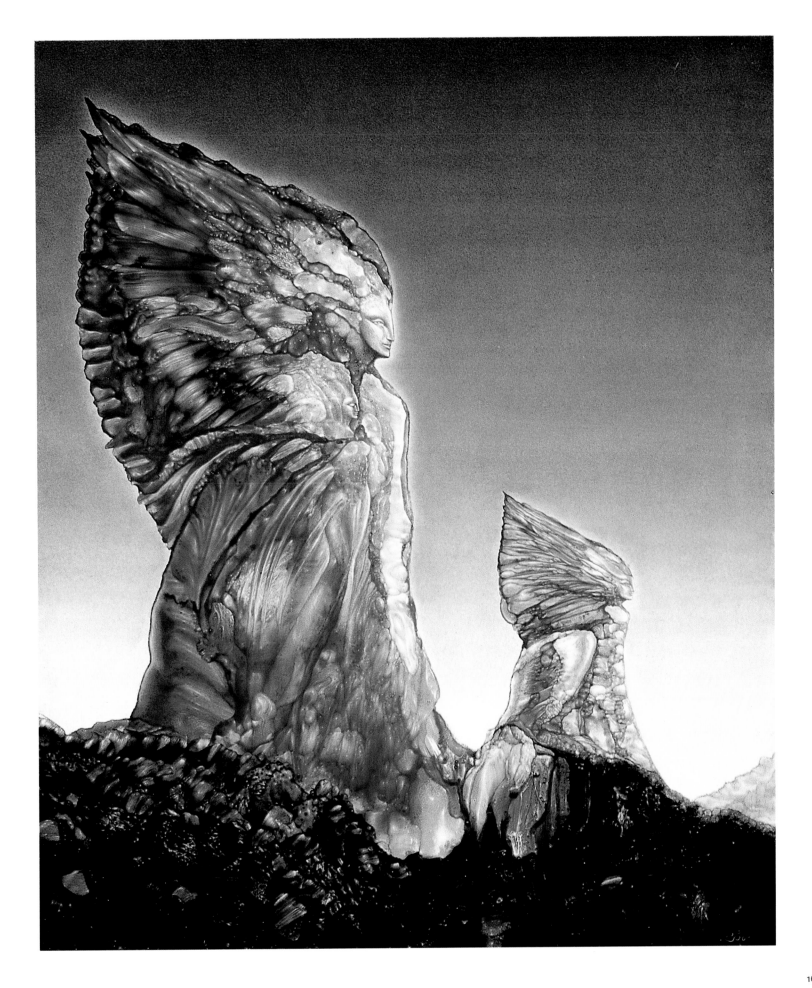

The eschaton, the final convergence of purpose on the last of all things, the transcendental object at the end of time. All matter is self-canceling, parity is conserved, and the final illusion is revealed to be made entirely of light.

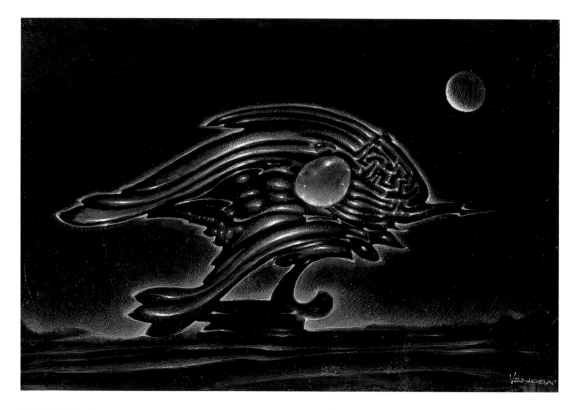

NEW MOON II
1997, OIL ON MASONITE, 30 X 40 CM.
PRIVATE COLLECTION

PARASAMGATE
1975, OIL ON CANVAS, 75 X 55 CM.
COLLECTION: H.R. GIGER, ZURICH

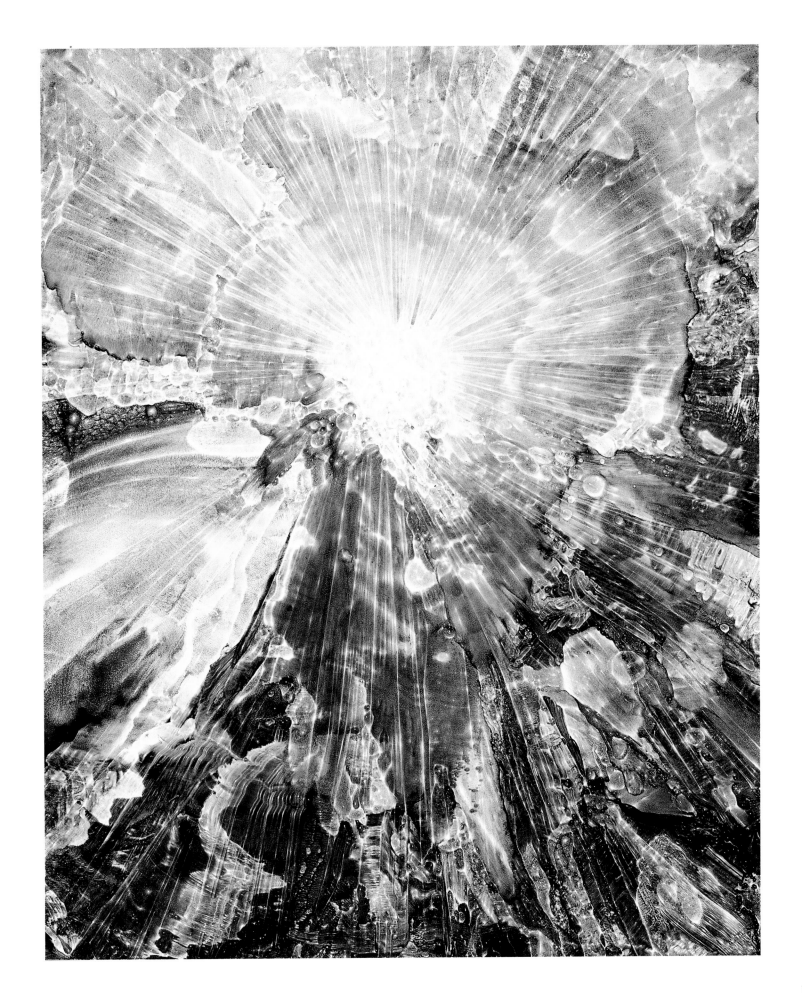

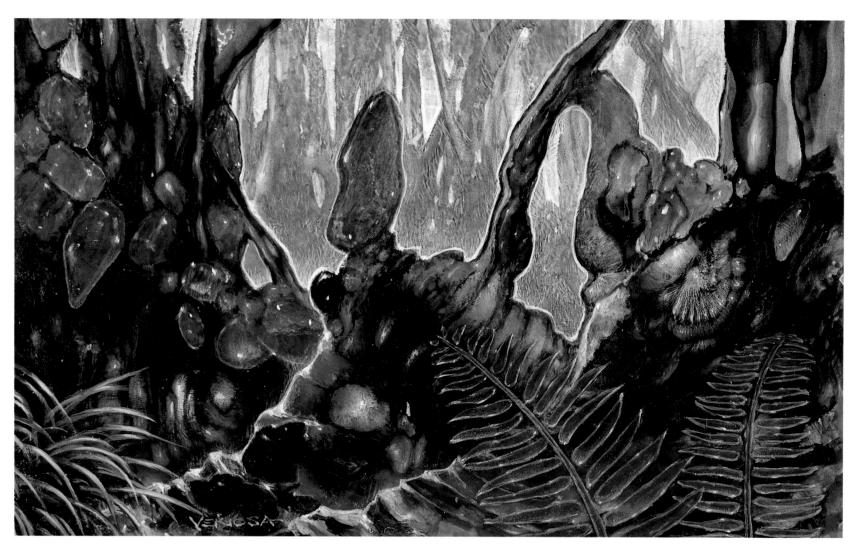

EMERALD FOREST
1989, OIL ON CANVAS, 13 X 20 CM.
COLLECTION: ABEND GALLERY, DENVER

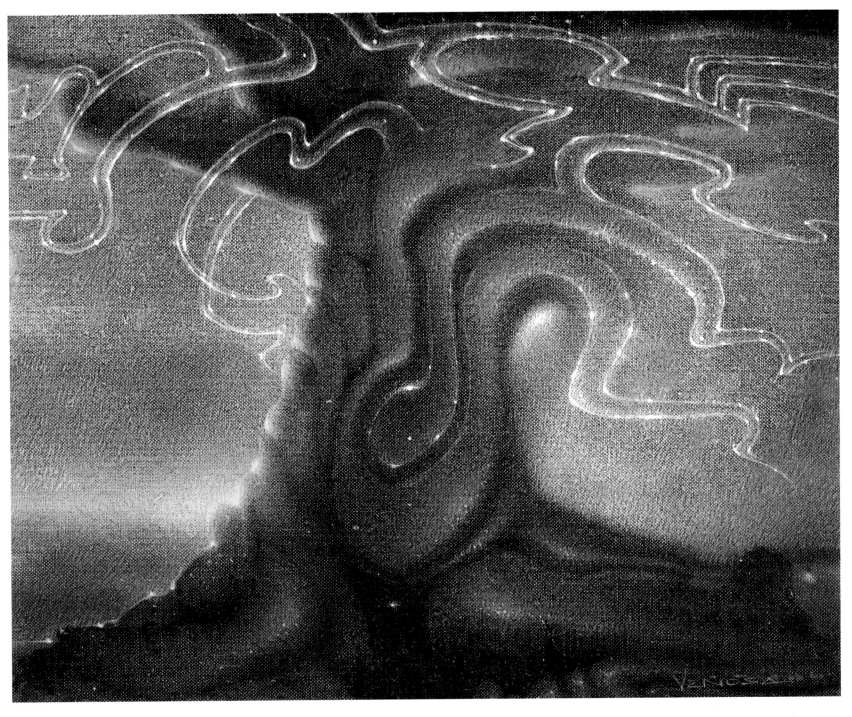

CRYSTAL TREE
1986, OIL ON CANVAS, 20 X 25 CM.
TERWILLIGER-THOMAS COLLECTION, CHICAGO

Protean forms, and forms mutating into other forms, flesh and landscape, jewel and water droplet, cloud and canyon. Everything in Venosa's vision is capable of eruption, of change. All is artifice which demands attention.

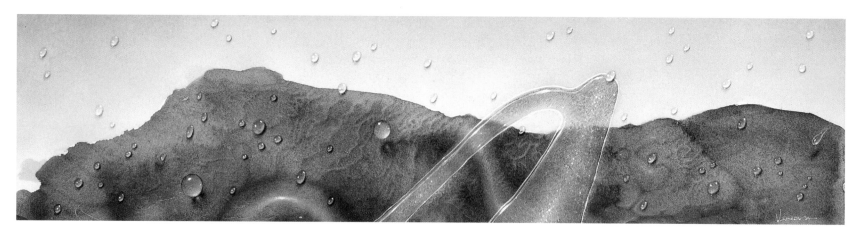

CRYSTALITH
1986, OIL ON MASONITE, 12 X 38 CM.
COLLECTION: MARK TRATOS, LAS VEGAS

MINDSCAPE II
1980, OIL ON MASONITE, 63 X 58 CM.
COLLECTION: JASON McKEAN, SAN FRANCISCO

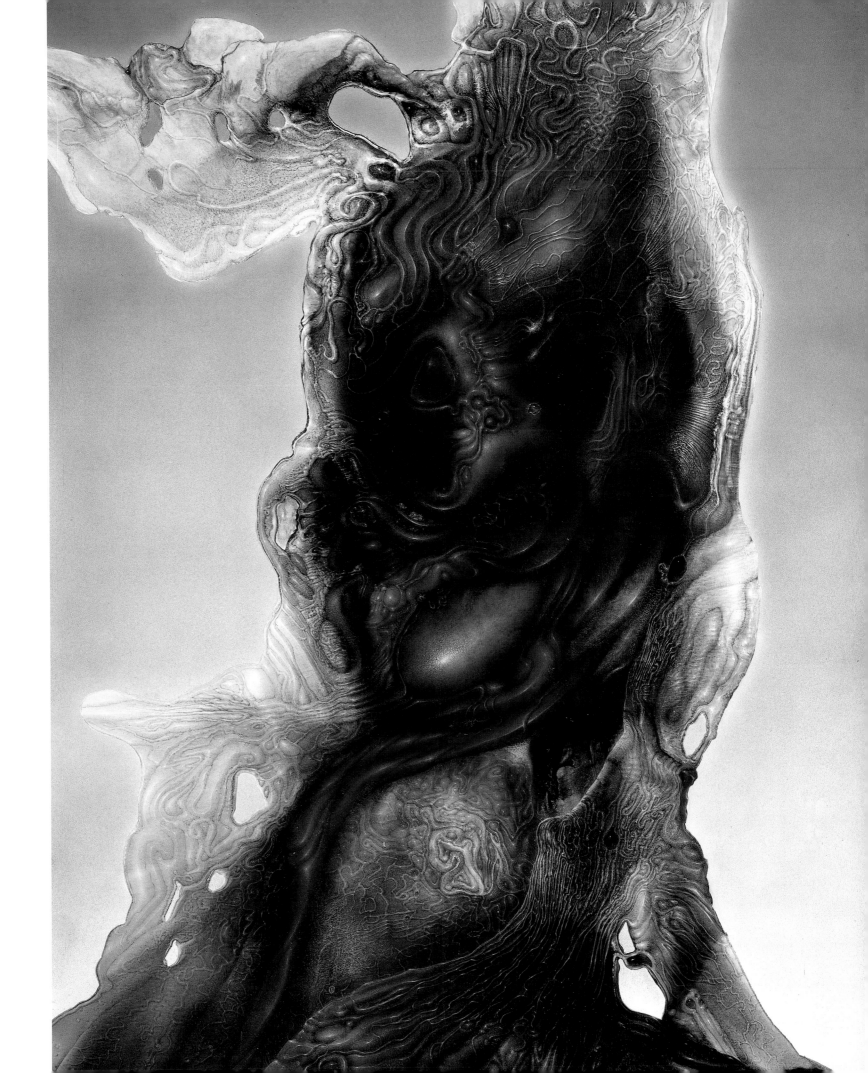

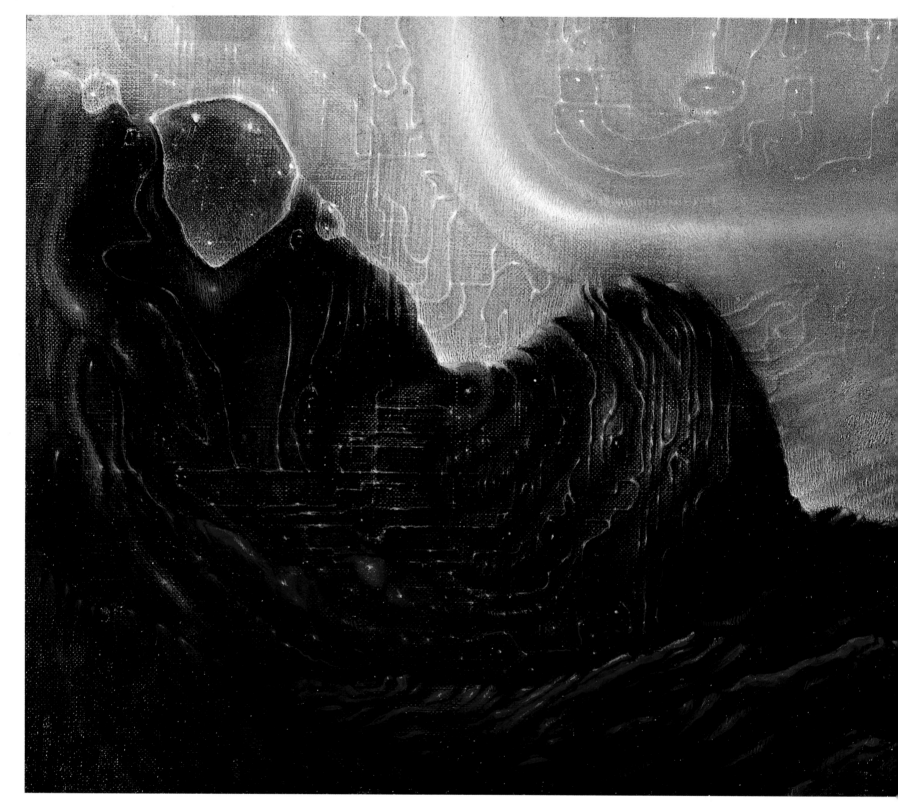

MINDSCAPE III
1981, OIL ON CANVAS, 21 X 38 CM.
COLLECTION: STEVEN VENOSA, MIAMI

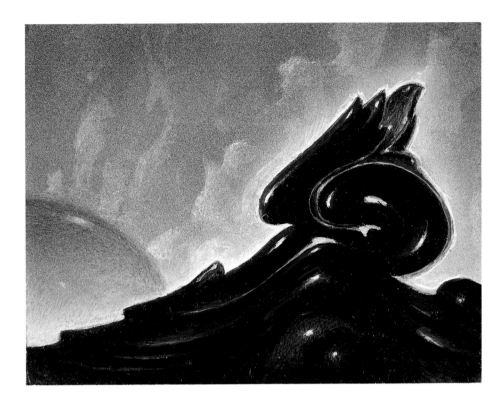

WAVE
1989, OIL ON PAPER, 14 X 18 CM.
PRIVATE COLLECTION

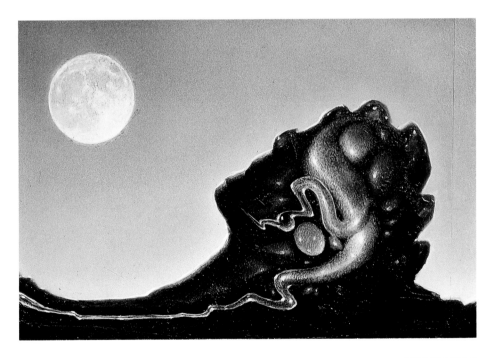

FULL MOON II
1988, OIL ON CANVAS, 13 X 18 CM.
COLLECTION: CAROL CHRISTENSEN, LOS ANGELES

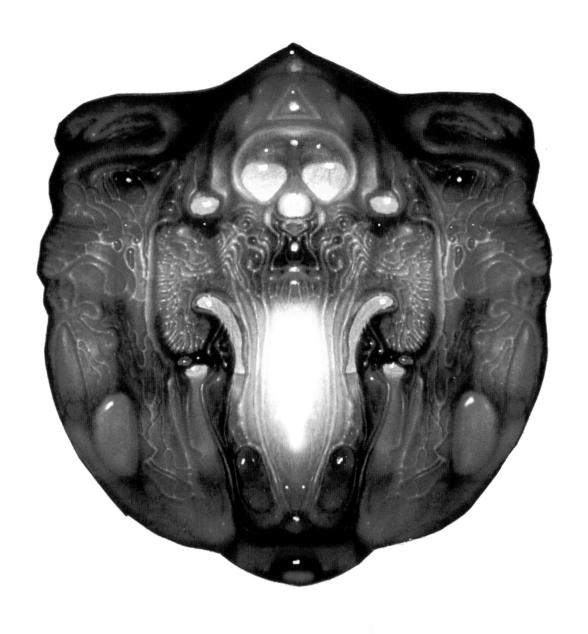

RED MOON
1996, OIL, MONTAGE, 38 X 38 CM.
PRIVATE COLLECTION

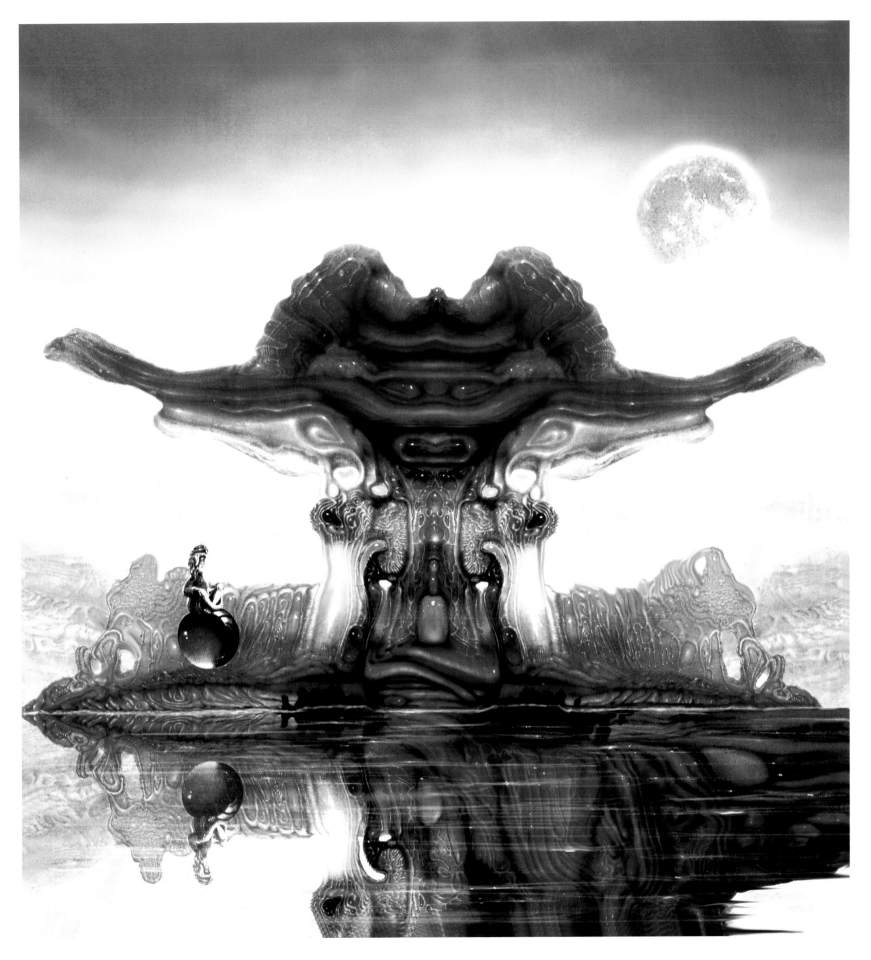

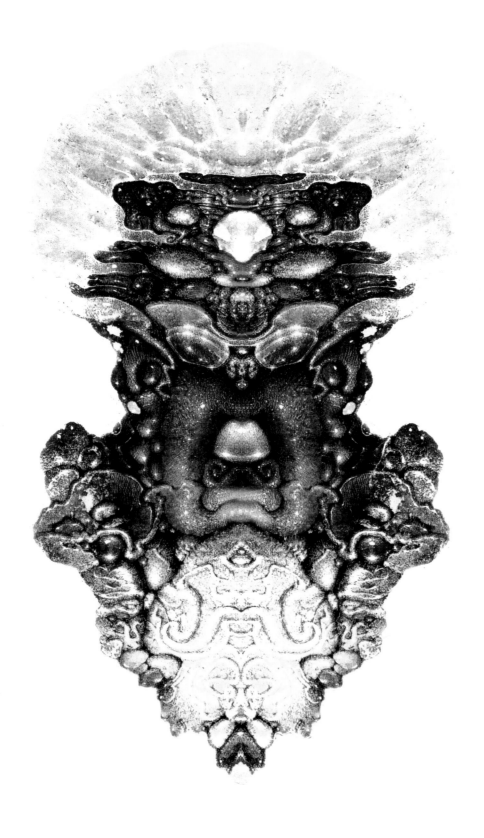

SHROOMGLOW
1996, OIL, MONTAGE, 38 X 38 CM.
PRIVATE COLLECTION

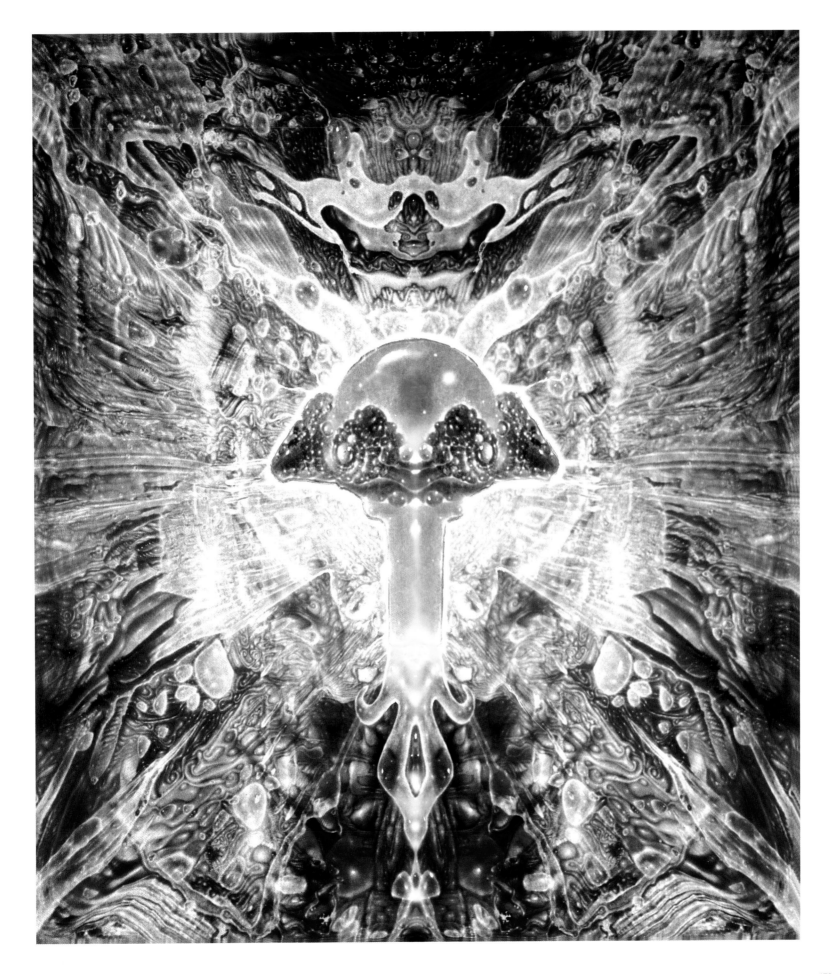

The disembodied eye, the Devic splendors in the grass, recall the radiation shed by the mushroom mind; entering, insinuating itself into the quiet stream of early human history. This is the river whose source is older than man and upon whose surface our ships are by time permitted to glide.

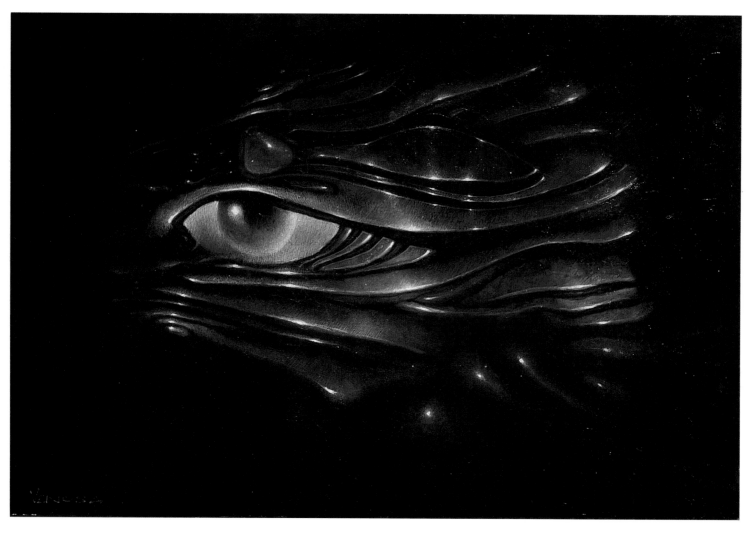

ANGEL EYE
1997, OIL ON MASONITE, 30 X 40 CM.
COLLECTION: STEVE SKELTON, DALLAS

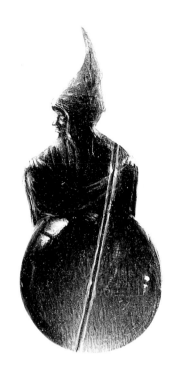

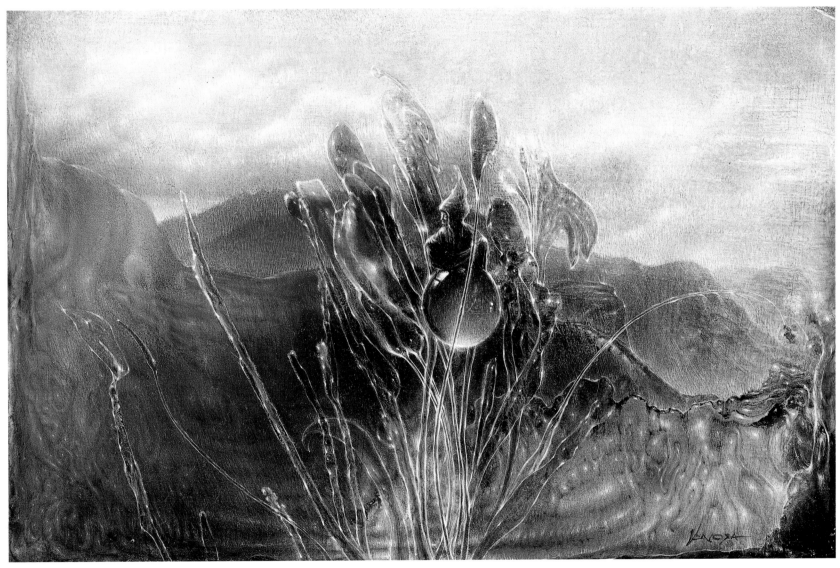

DEVA TRANSIT
1979, OIL ON CANVAS, 15 X 22 CM.
COLLECTION: GOVINDA GALLERY, WASHINGTON, D.C.

Primordial oceans and primal boundaries reveal the trembling, moving edge where the bow shock of encounter with an Other causes the definition of the self to emerge more clearly.

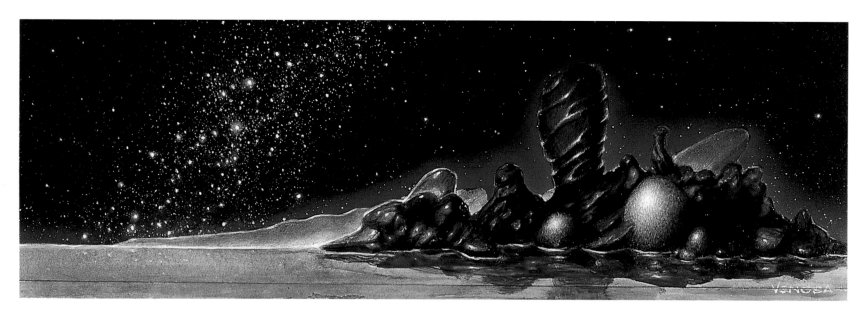

STARWAY
1988, OIL ON MASONITE, 10 X 28 CM.
COLLECTION: JASON McKEAN, SAN FRANCISCO

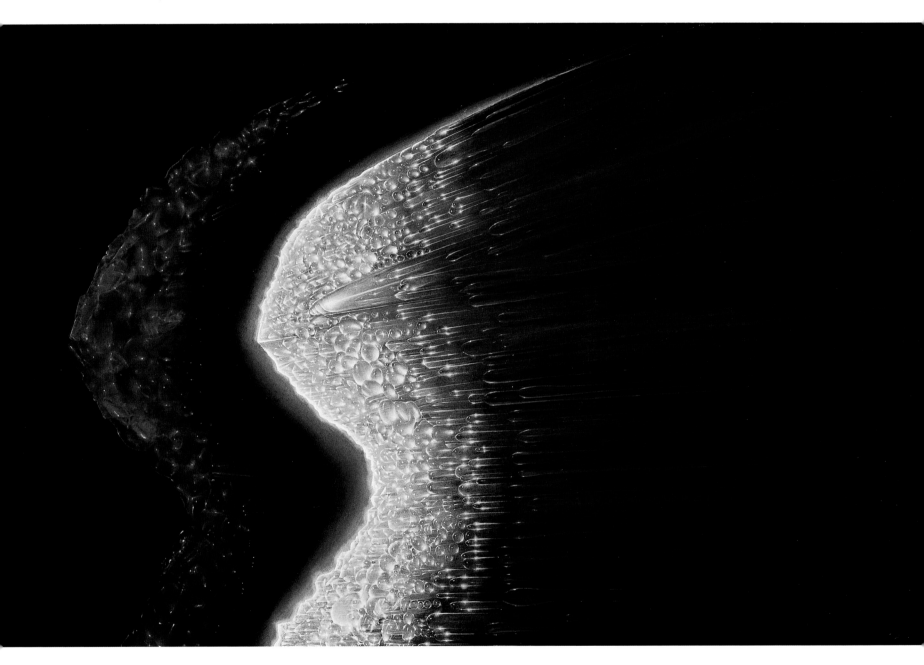

ANGEL HEAD
1973, OIL ON CANVAS, 35 X 65 CM.
COLLECTION: HANS WEWELKA, VIENNA

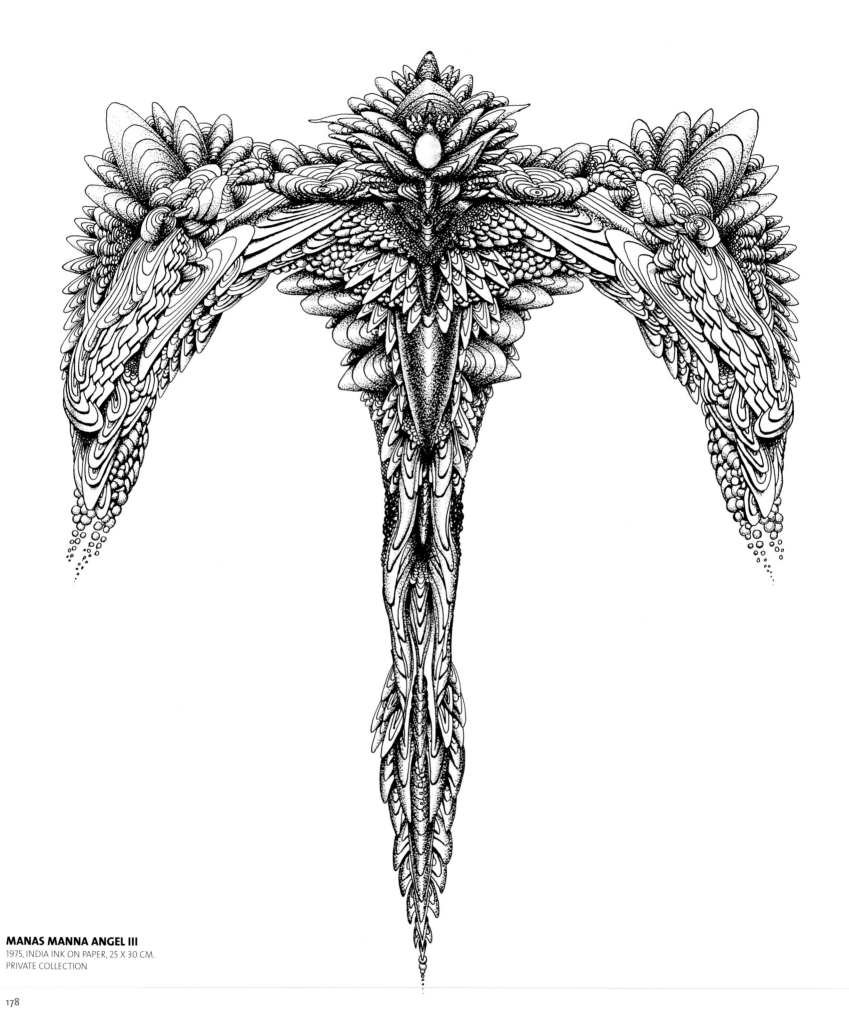

MANAS MANNA ANGEL III
1975, INDIA INK ON PAPER, 25 X 30 CM.
PRIVATE COLLECTION

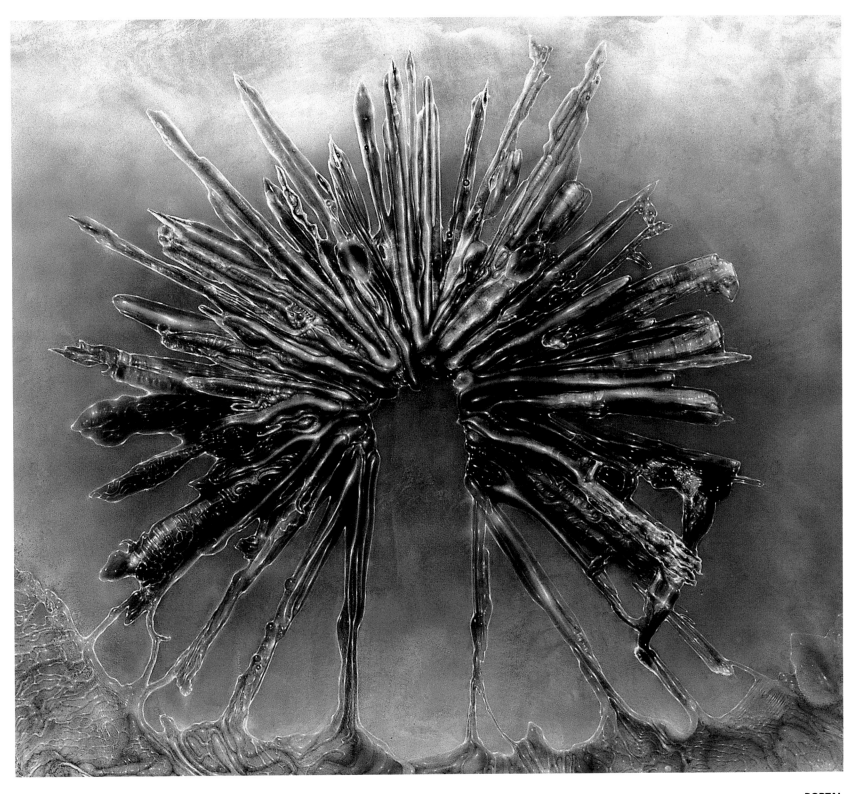

PORTAL
1980, OIL ON CANVAS, 62 X 72 CM.
COLLECTION: REGINE HOPPL, NEW YORK

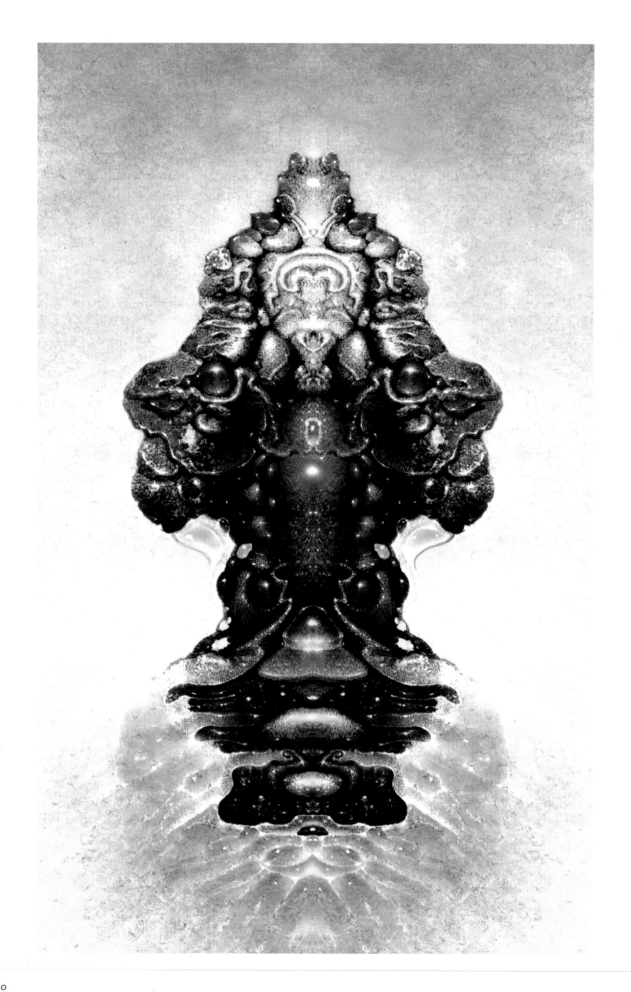

HALLUCINATORY SELF-PORTRAIT
1997, OIL, MONTAGE, 40 X 30 CM.
PRIVATE COLLECTION

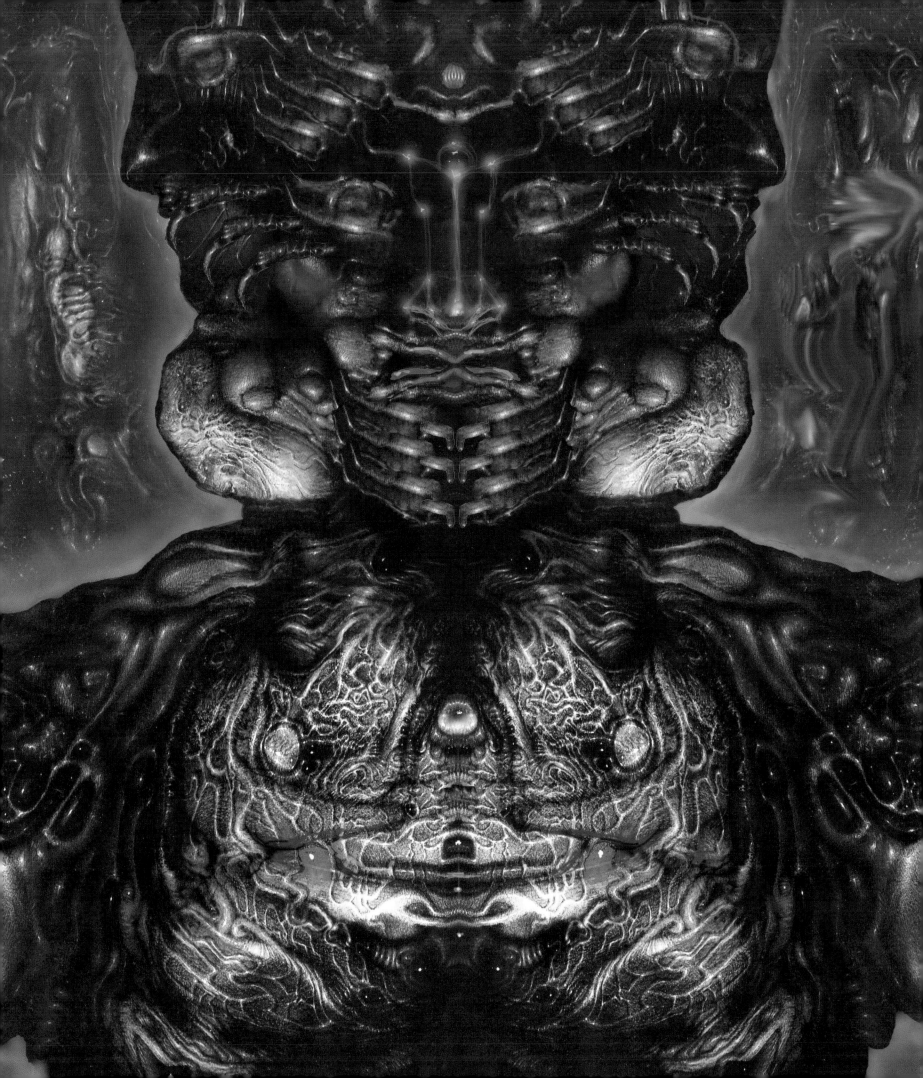

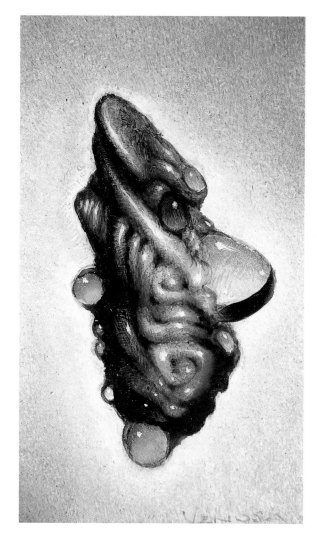

BEJEWELLED
1988, OIL ON MASONITE, 9 X 6 CM.
COLLECTION: VERA MARTIN, SYDNEY

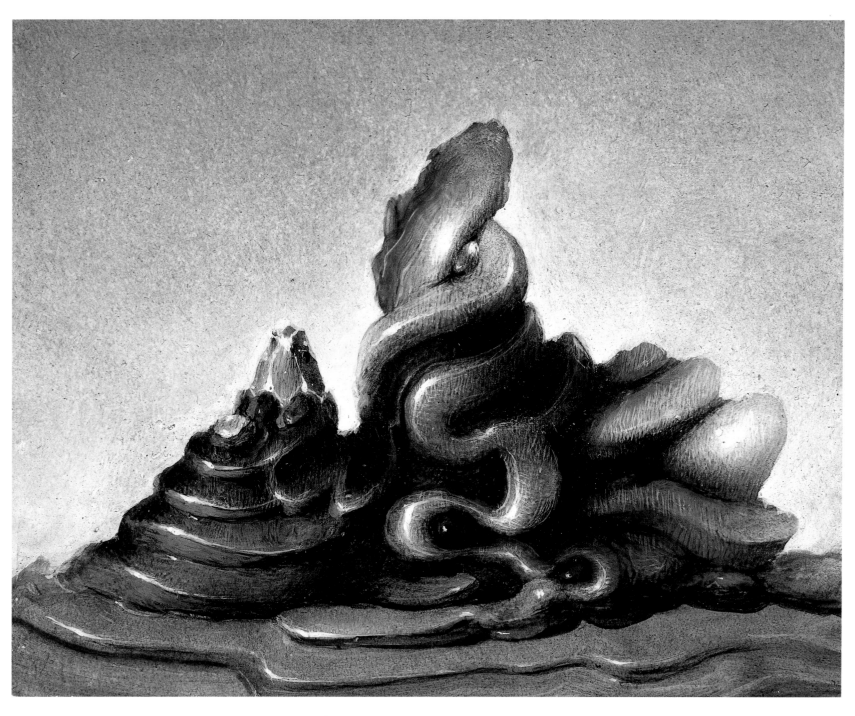

SMALLSCAPE
1987, OIL ON MASONITE, 12 X 14 CM.
COLLECTION: BERT BATES, DENVER

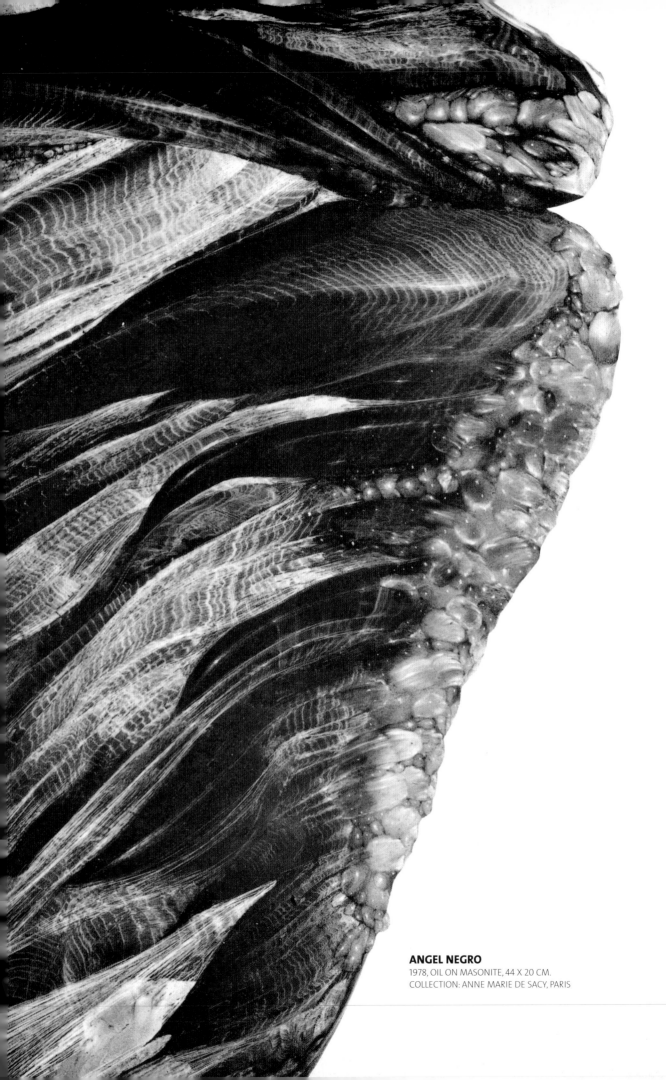

ANGEL NEGRO
1978, OIL ON MASONITE, 44 X 20 CM.
COLLECTION: ANNE MARIE DE SACY, PARIS

DREAM
1975, OIL ON PAPER, 30 X 25 CM.
COLLECTION: PETER LEDEBOER, LONDON

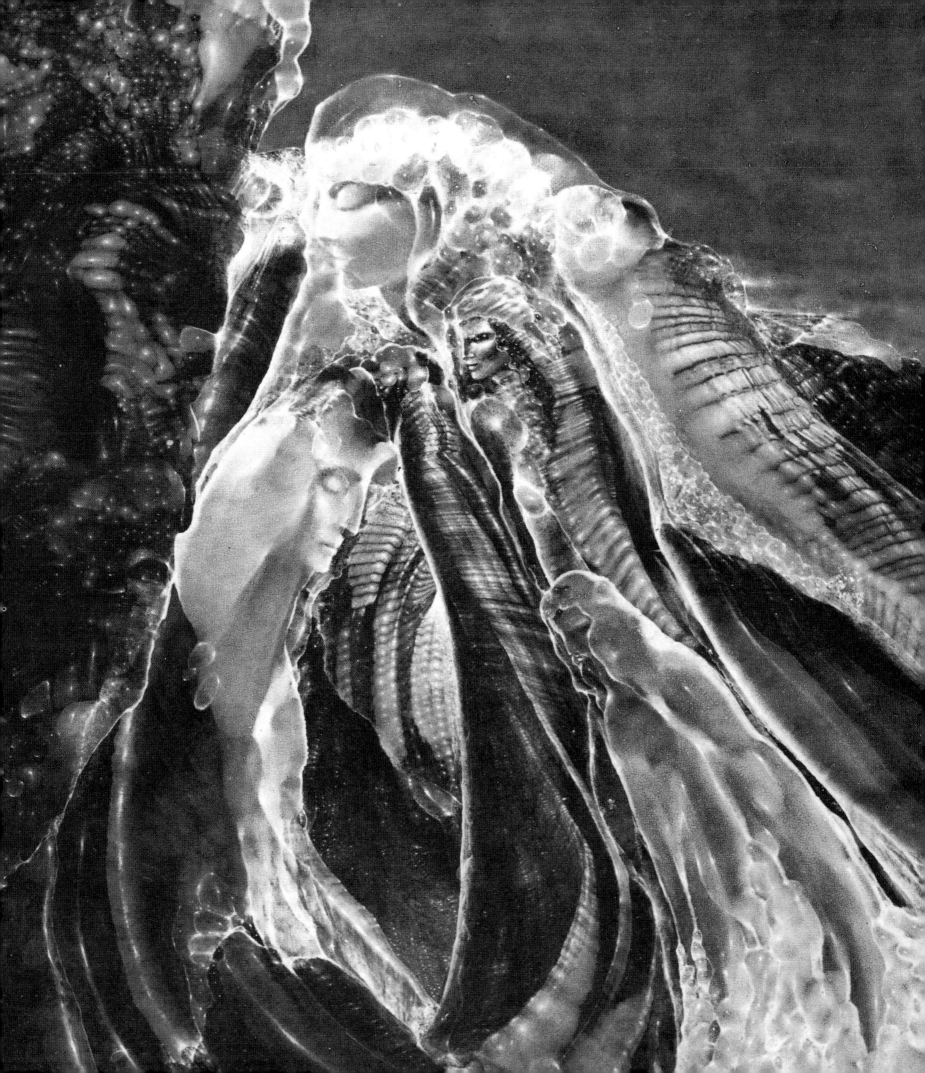

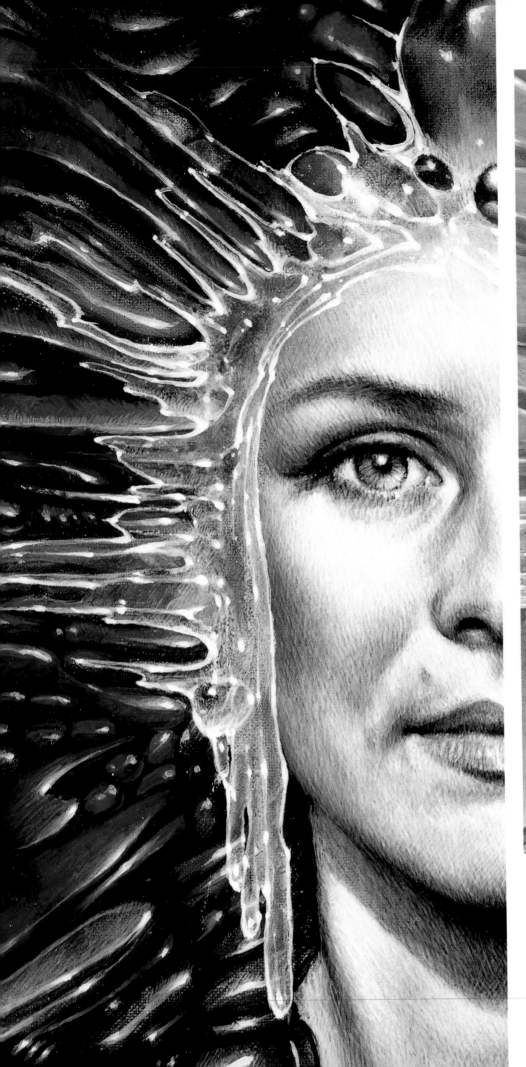
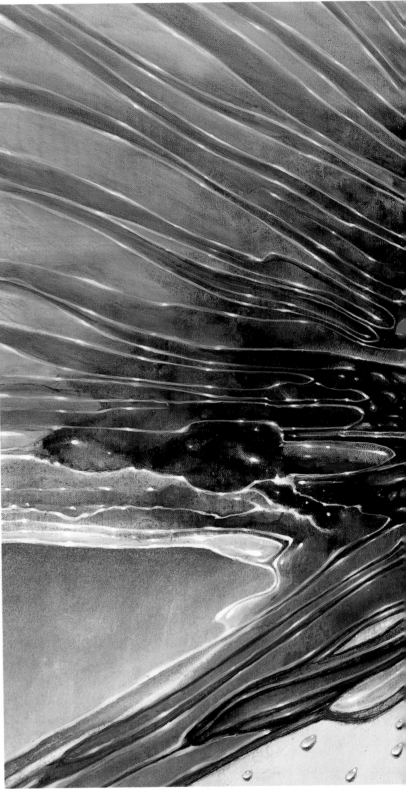

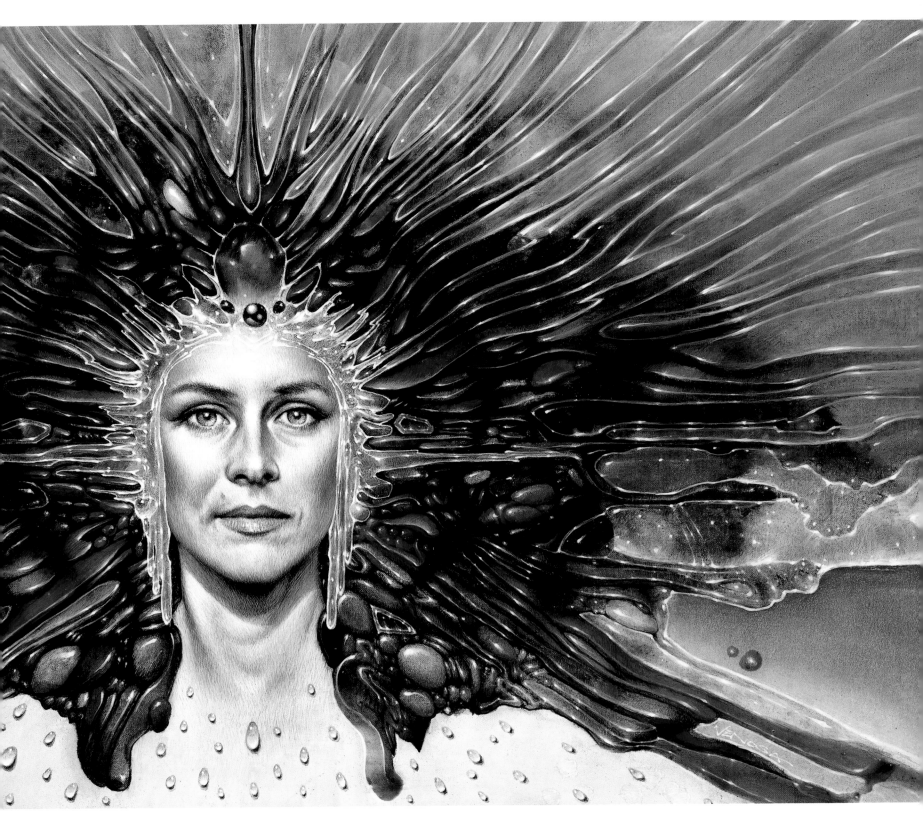

MARTINA IV
1997, OIL ON CANVAS, 50 X 92 CM.
PRIVATE COLLECTION

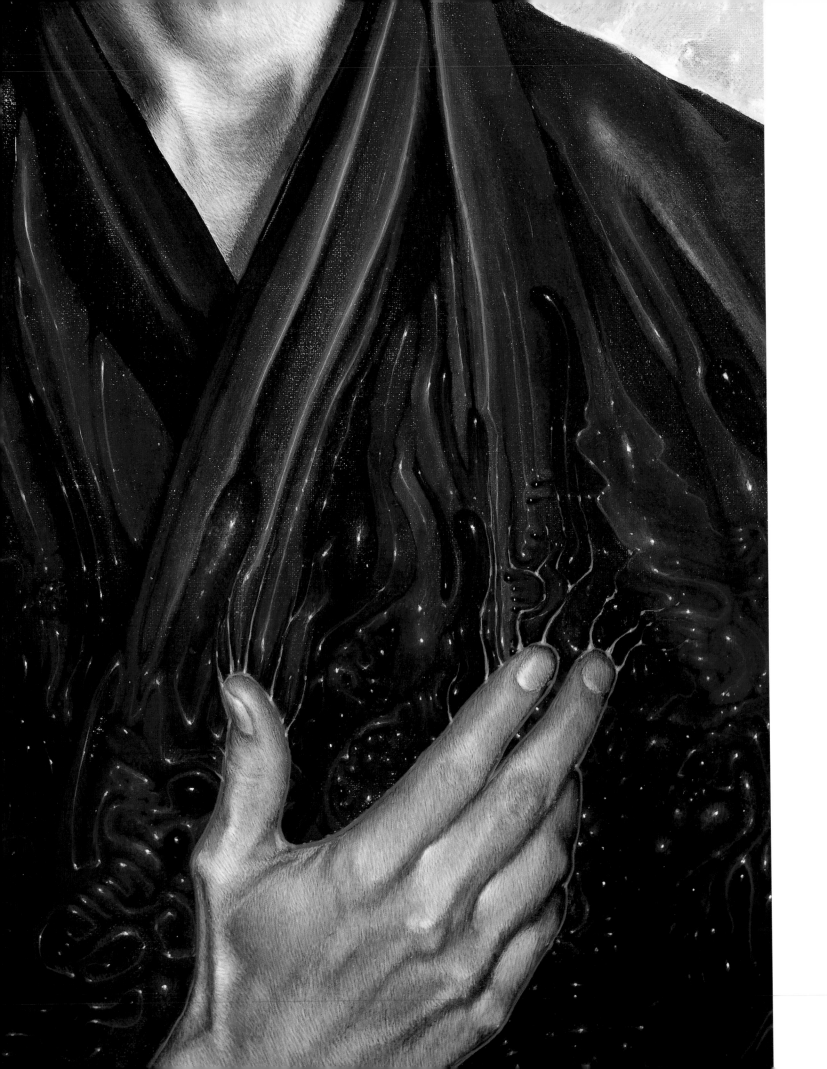

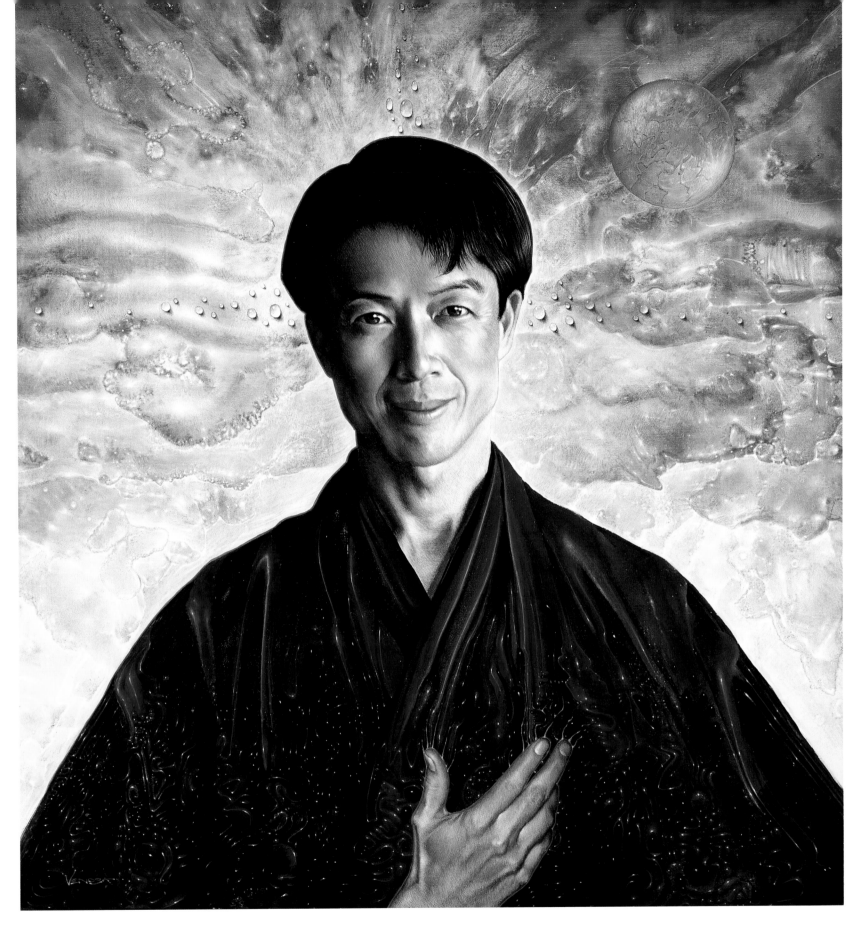

PORTRAIT OF MAKI SAN
1995, OIL ON CANVAS, 86 X 81 CM.
COLLECTION: MASEO MAKI, BOULDER, COLORADO

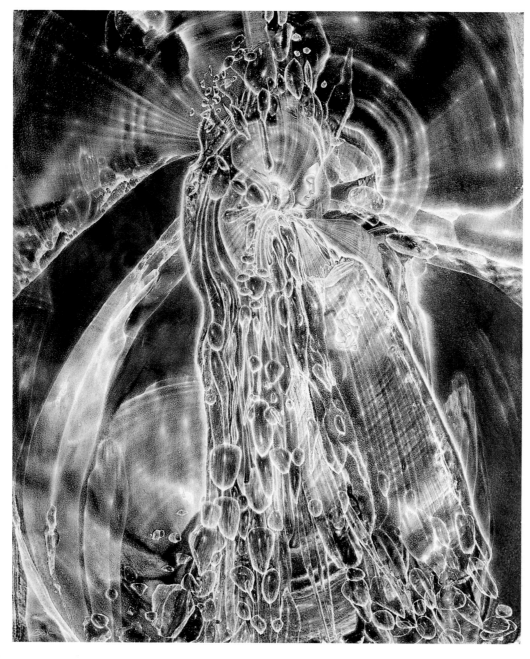

PERPETUATION
1977, OIL ON CANVAS, 75 X 65 CM.
COLLECTION: JOSEPH E. VENOSA, SAN FRANCISCO

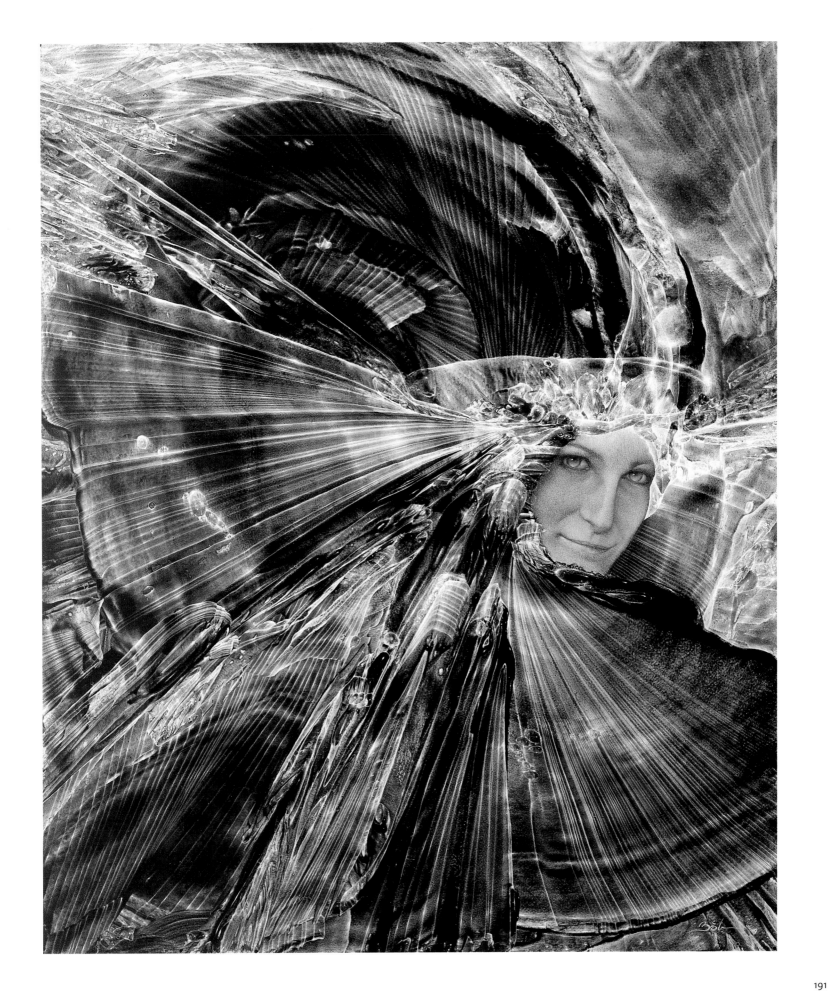

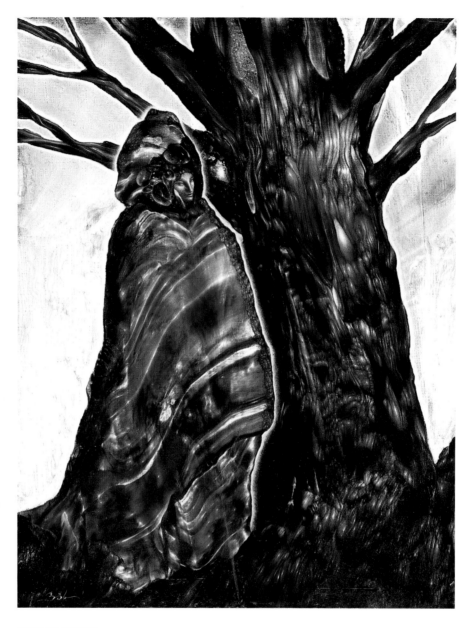

WINTER BODHI
1977, OIL ON CANVAS, 40 X 30 CM.
COLLECTION: CHRISTOPHER MURRAY, WASHINGTON, D.C.

JUTTA II
1980, OIL ON CANVAS, 72 X 70 CM.
COLLECTION: JACH PURCELL, PALM BEACH

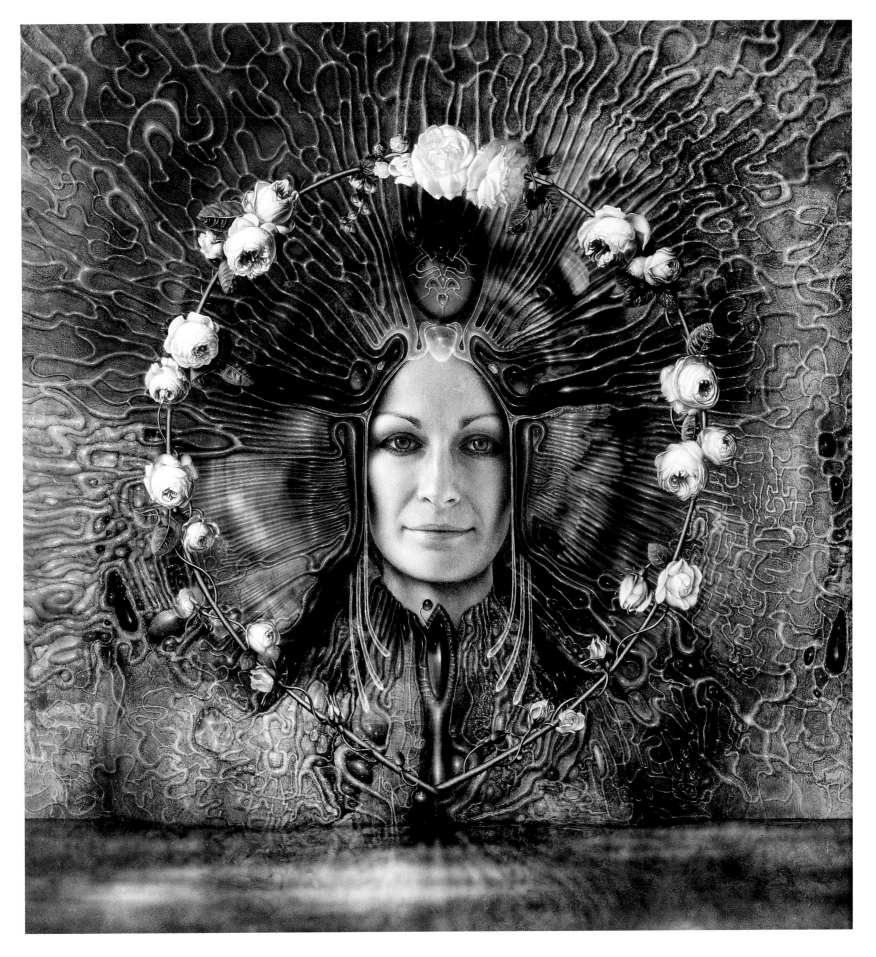

MARTINA
1981, OIL ON MASONITE, 64 X 61 CM.
PRIVATE COLLECTION

MARTINA
1981, PRE-SKETCH, PASTEL ON PAPER, 80 X 40 CM.
PRIVATE COLLECTION

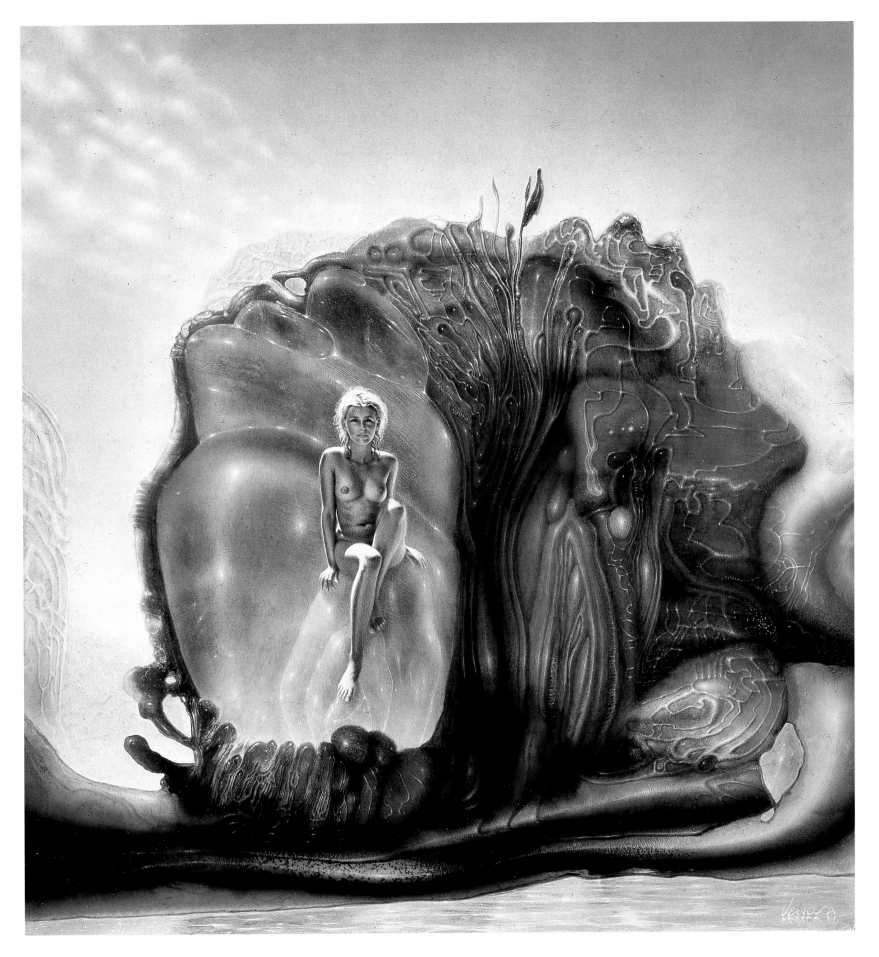

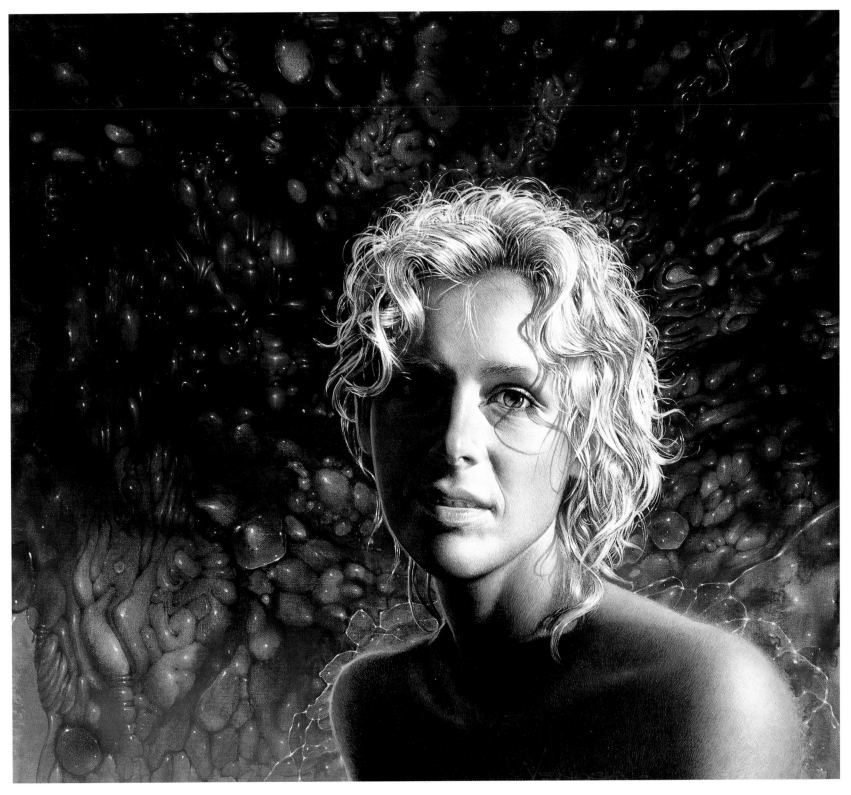

MARTINA DE DUORO
1990, OIL ON CANVAS, 58 X 58 CM.
PRIVATE COLLECTION

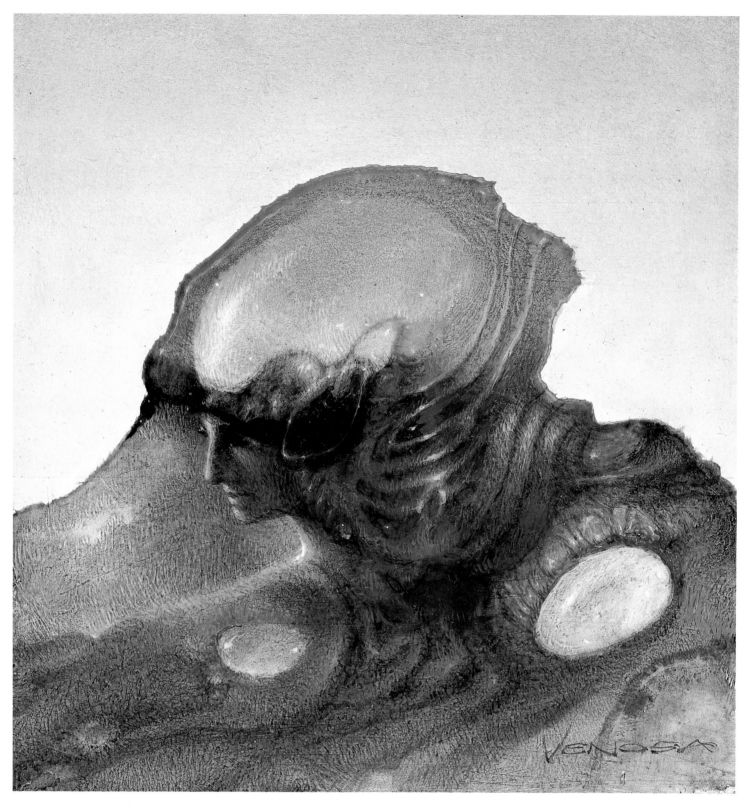

HEADSCAPE
1983, OIL ON CANVAS, 18 X 18 CM.
PRIVATE COLLECTION

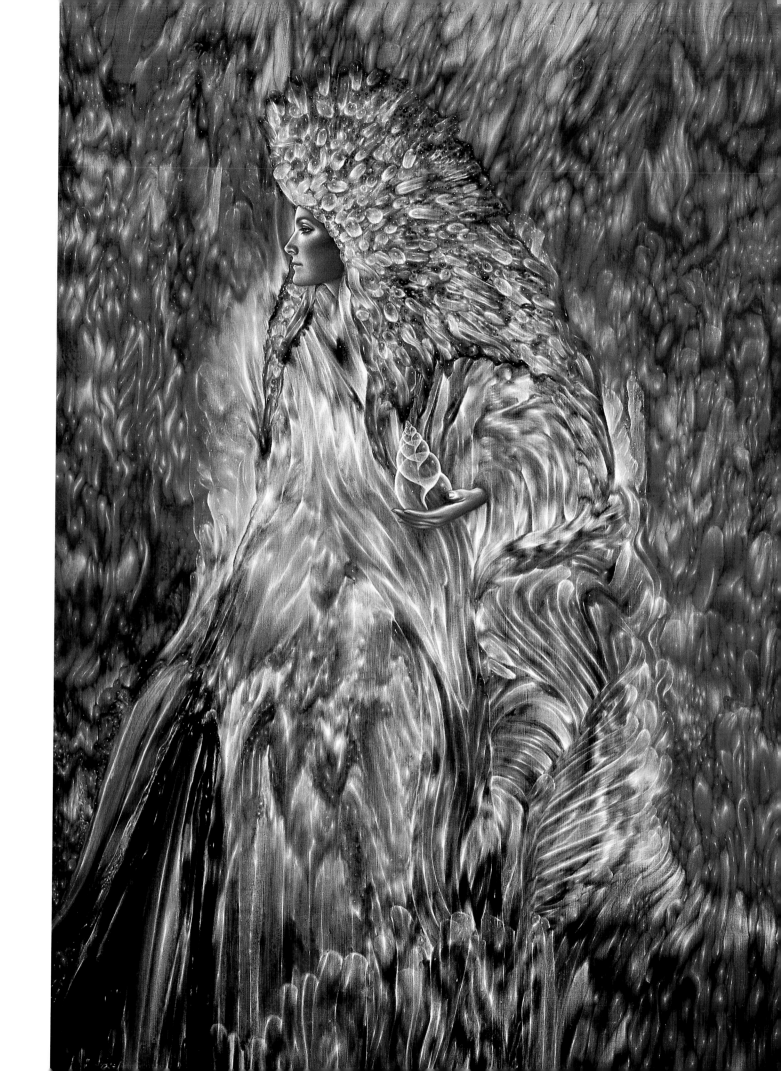

SATCHIDANANDA
1975, INDIA INK ON PAPER, 25 X 25 CM.
PRIVATE COLLECTION

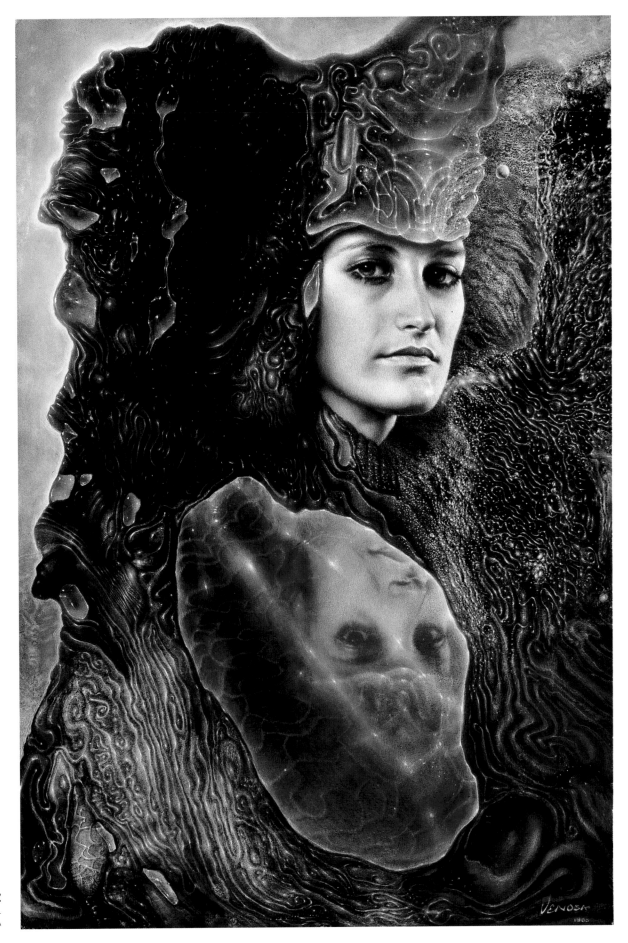

ISABEL SANZ
1980, OIL ON CANVAS, 55 X 38 CM.
COLLECTION: DR LUIS SANZ, BARCELONA

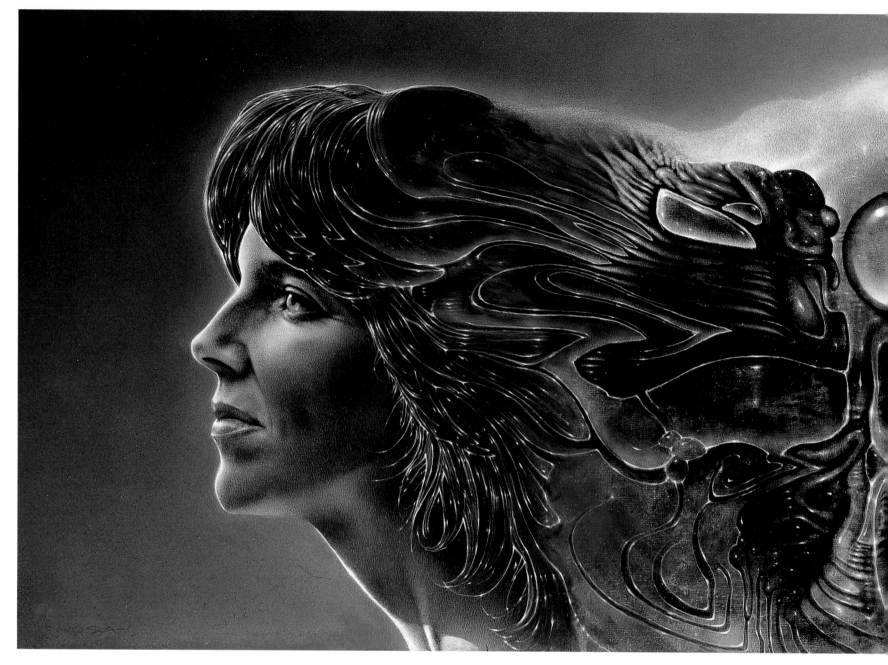

PORTRAIT OF JANET KRUZE
1986, OIL ON CANVAS, 34 X 96 CM.
COLLECTION: JANET KRUZE, KANSAS CITY

A Janus-like symmetry reminds us that the Goddess stares both into the past and the future, and that the reconciliation of these domains of understanding yields the jewel-like condensation of concentration. An iridule, the quintessence of intent, manifests at the pivot of time.

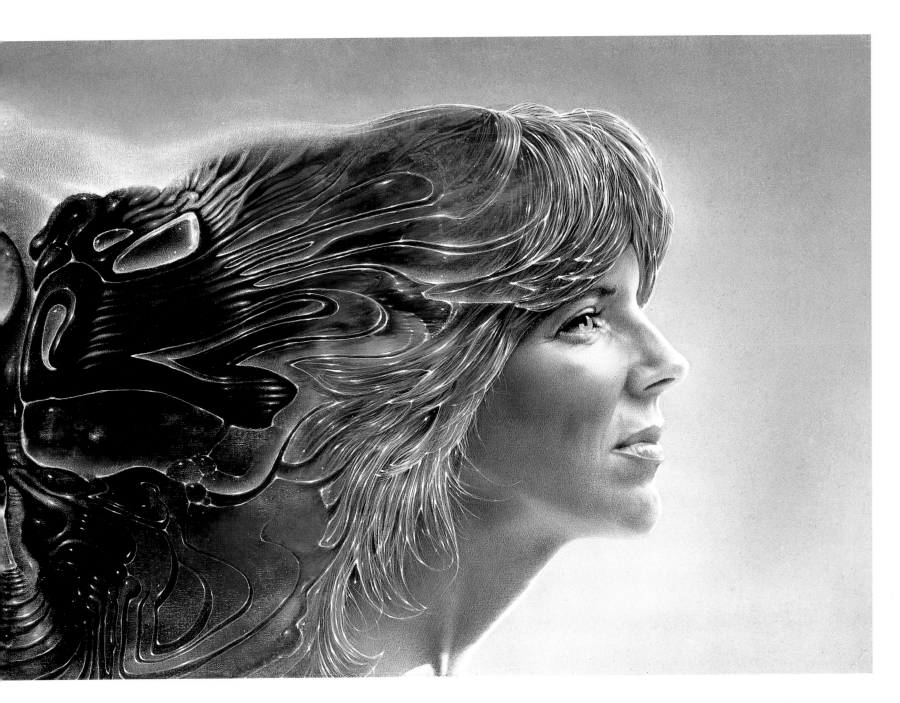

Summation comes with the coalescence of attention on the human form. From the archetype of ideal humanness to the fact of great and real persons; women, cast by chance into being. They are the many faces of Venosa's muse. His vision is moved by the real presence of a female spirit, who reveals and initiates the painter's eye into the arcana of the Mysteries.

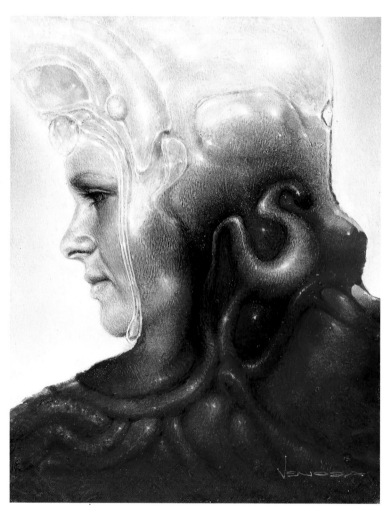

MARTINA II
1983, OIL ON CANVAS, 22 X 17 CM.
COLLECTION: CAROL TRATYN FISHER, WASHINGTON, D.C.

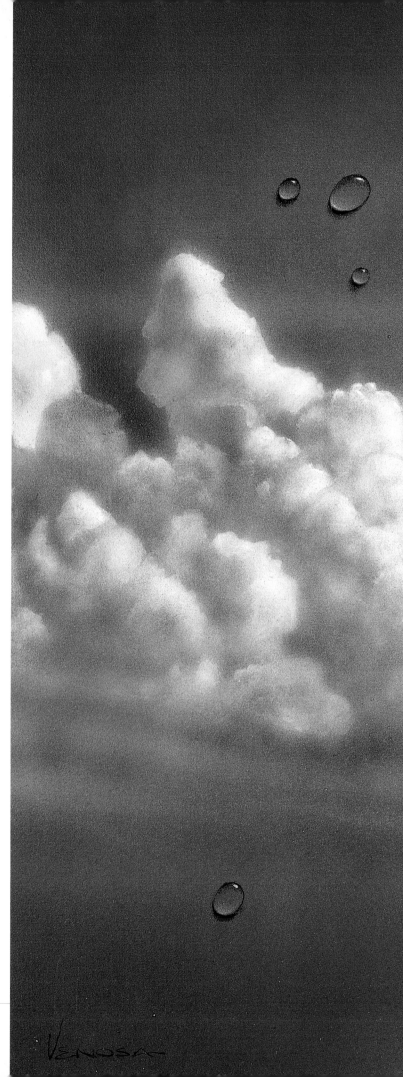

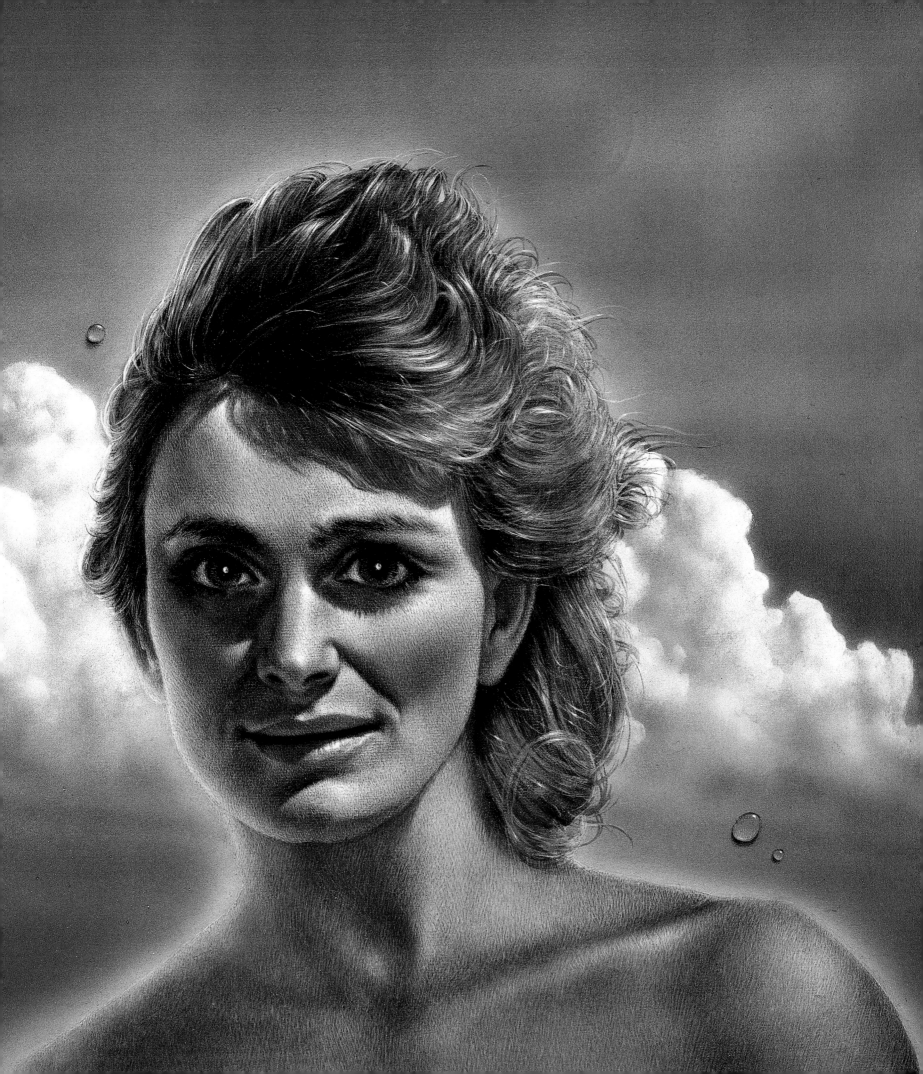

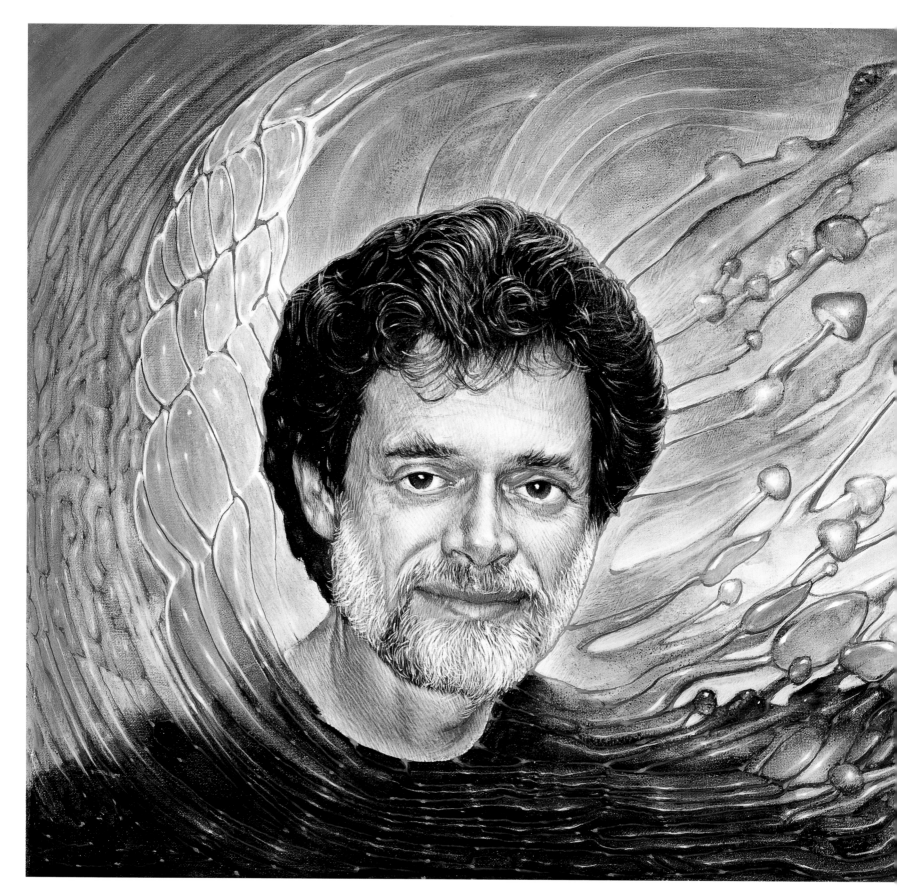

PORTRAIT OF TERENCE McKENNA
1999, OIL ON CANVAS, 40 X 64 CM.
COLLECTION: TERENCE McKENNA, KONA, HAWAII

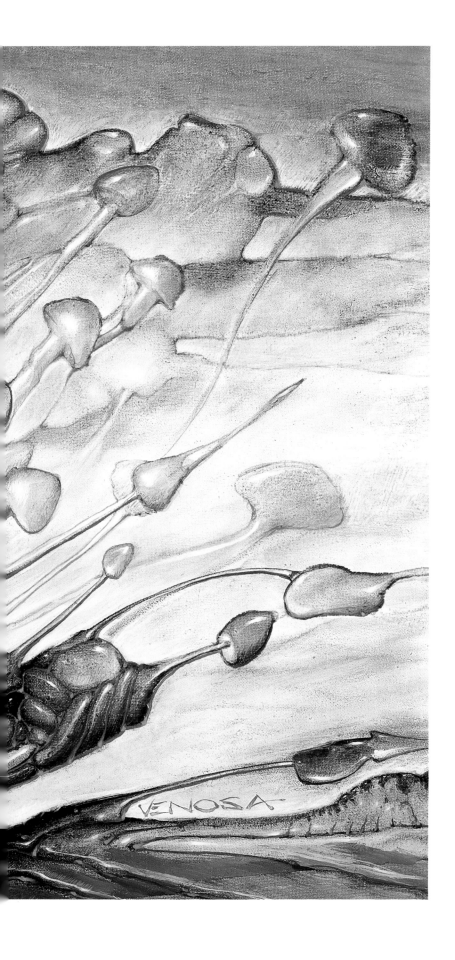

The last and sixty-fourth hexagram of the I Ching is *Before Completion*. The cornucopia of images is infinite. And the life of a painter a brief epiphany unnoticed by the slowly burning stars. To make art is to draw even with the aspirations of divinity. To make art well is to call spirit into being. Magicians, like Venosa, know this.

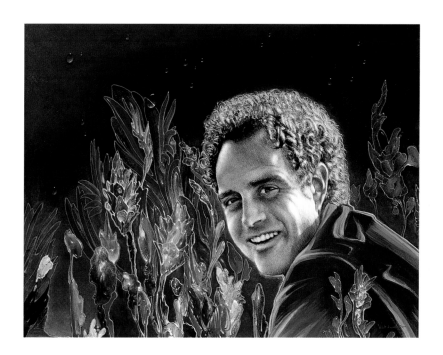

PORTRAIT OF JOHN D. HAY
1990, OIL ON CANVAS, 50 X 76 CM.
COLLECTION: JOHN HAY, BOULDER, COLORADO

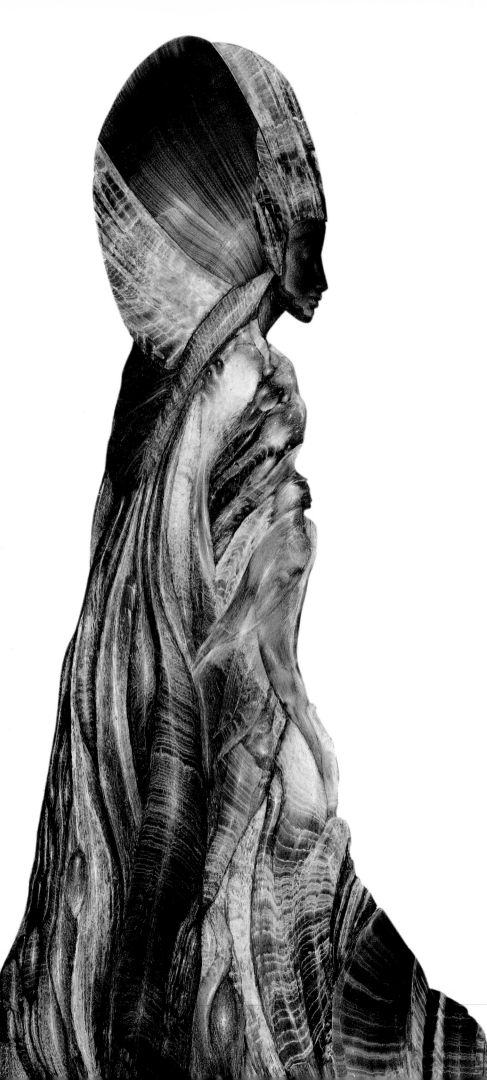

film design

The transcendent, otherworldly quality of Venosa's art fits perfectly into the sci-fi genre of film design. *Dune* (Universal, 1982), *Fire in The Sky* (Paramount, 1993), and *Race For Atlantis* (IMAX, 1998), are three movies for which Venosa created his unique style of conceptual design.

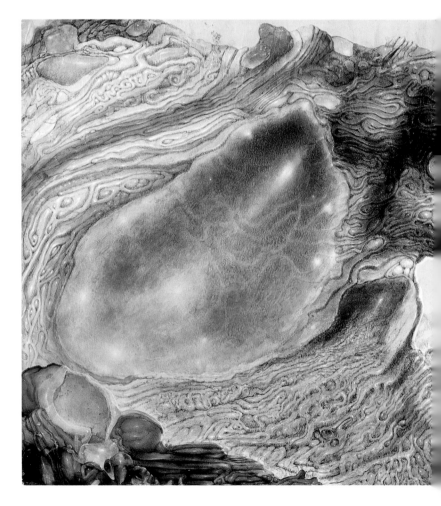

BLAQUEEN
1980, FILM DESIGN FOR **DUNE**
OIL ON PAPER, 30 X 17 CM.
PRIVATE COLLECTION

The exquisite landscapes and character design executed by Venosa for *Dune* are incomparable visions of the fantastic. Frank Herbert's masterpiece, as interpreted through the dreamlike art of Venosa, promised an inspired collaboration that would have translated magically onto the screen. However, as often happens in Hollywood, the production staff changed hands in mid-stream and Venosa's work was sacrificed to the gods of banality. H.R. Giger was another whose designs on the project were also scrapped. One can only imagine what might have been ...

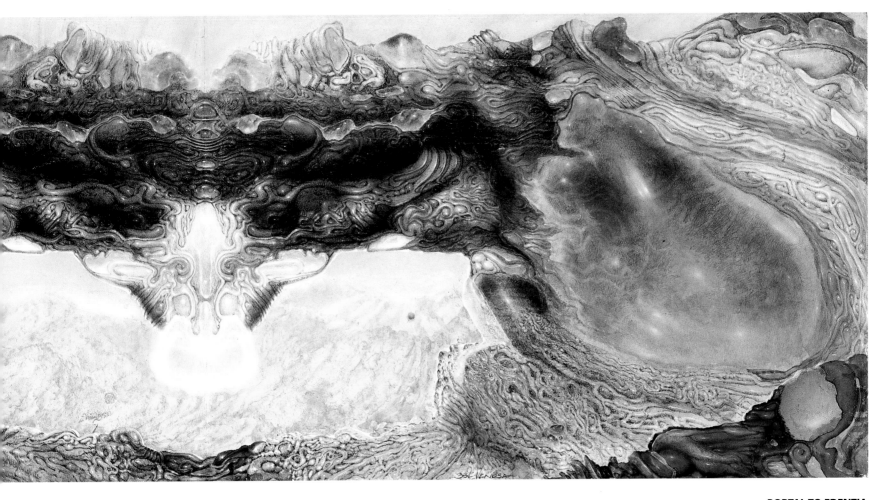

PORTAL TO EDENTIA
1980, FILM DESIGN FOR **DUNE**
OIL ON CANVAS, 42 X 118 CM.
PRIVATE COLLECTION

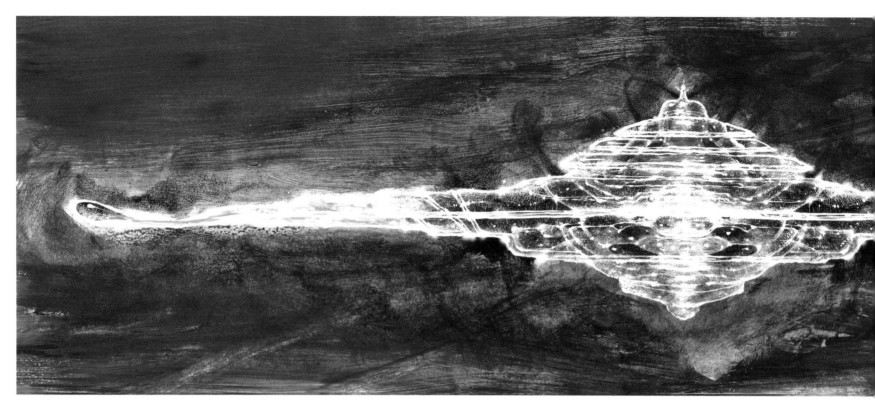

SPICE SHIP
1980, FILM DESIGN FOR **DUNE**, OIL ON PAPER, 10 X 38 CM.
PRIVATE COLLECTION

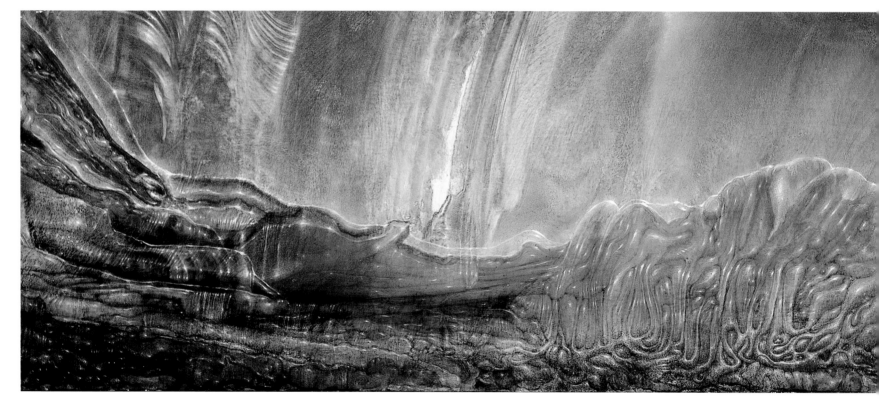

MORONTIA LANDSCAPE
1980, FILM DESIGN FOR **DUNE**, OIL ON CANVAS, 18 X 58 CM.
COLLECTION: JEAN JACQUES BROCHIER, PARIS

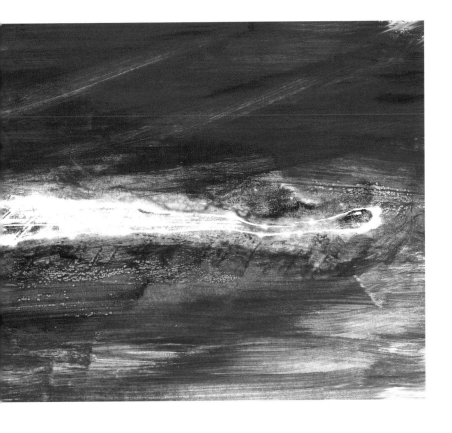

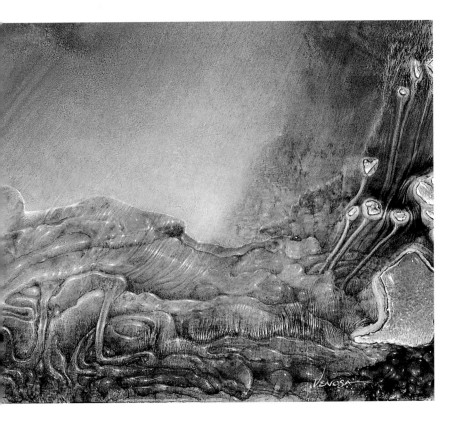

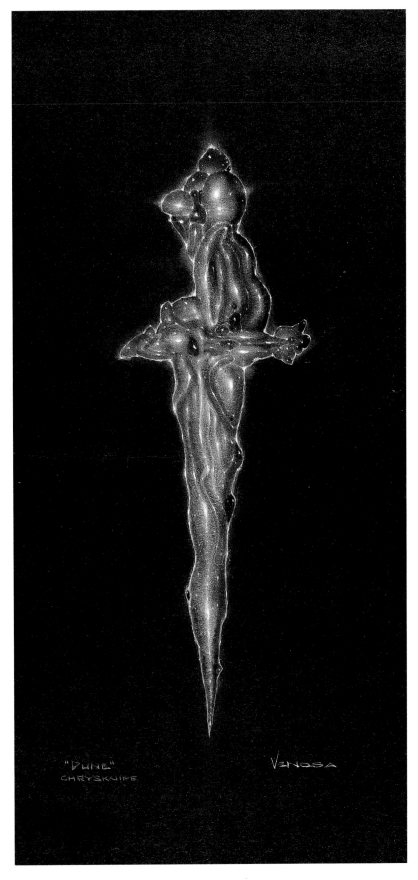

CRYSKNIFE
1978, FILM DESIGN FOR **DUNE**, OIL ON PAPER, 38 X 23 CM.
TERWILLIGER-THOMAS COLLECTION, CHICAGO

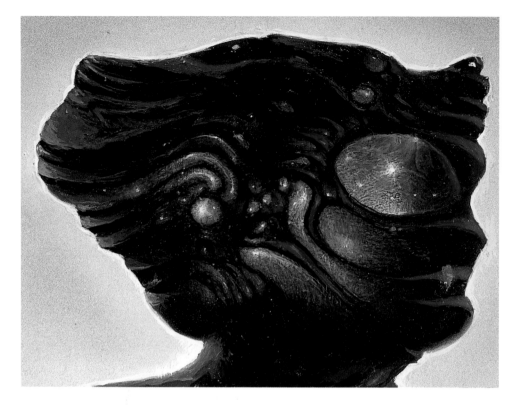

Rob Lieberman, the director of *Fire in The Sky*, contacted Venosa after seeing his work in *Noospheres*. Their visions of the otherworldly coincided, and Lieberman felt that Venosa was perfect for the movie's design work, some examples of which are shown on the next four pages.

ALIEN HEAD
1991, OIL ON MASONITE, 9 X 14 CM.
PRIVATE COLLECTION

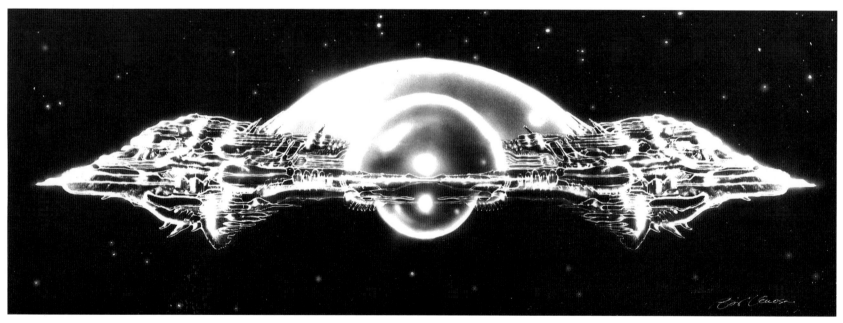

UFO
1991, OIL ON PAPER, 23 X 46 CM.
COLLECTION: VITTORIA BRAGA, LAGO, ITALY

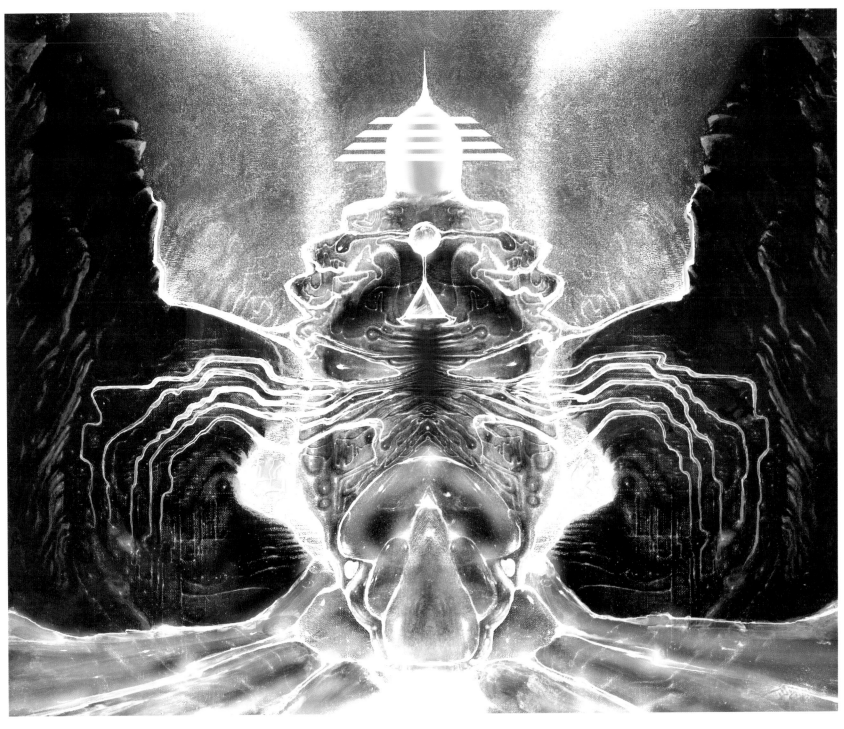

UFO CONSOLE
1991, OIL ON PAPER, 35 X 40 CM.
PRIVATE COLLECTION

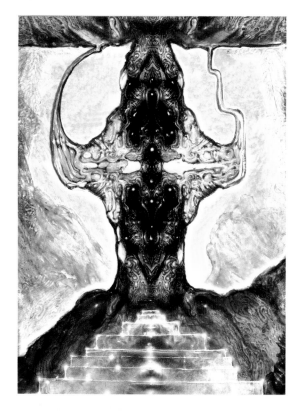

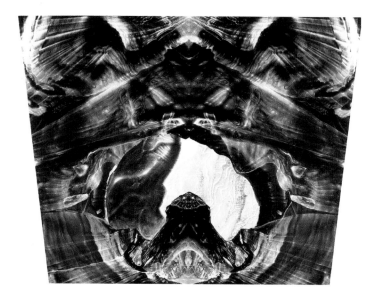

UFO INTERIOR
1991, OIL, MONTAGE, 30 X 28 CM.
PRIVATE COLLECTION

UFO INTERIOR III
1991, OIL, MONTAGE, 40 X 30 CM.
PRIVATE COLLECTION

UFO COLUMN
1991, OIL, MONTAGE, 30 X 25 CM.
PRIVATE COLLECTION

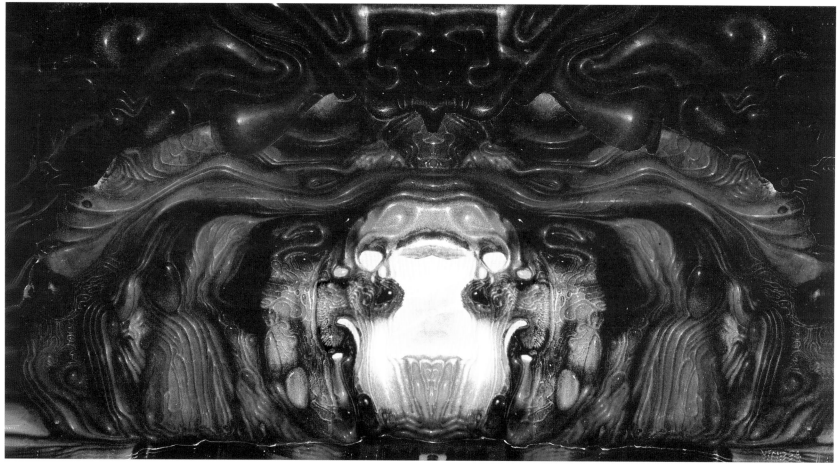

UFO INTERIOR II
1991, OIL, MONTAGE, 30 X 45 CM.
PRIVATE COLLECTION

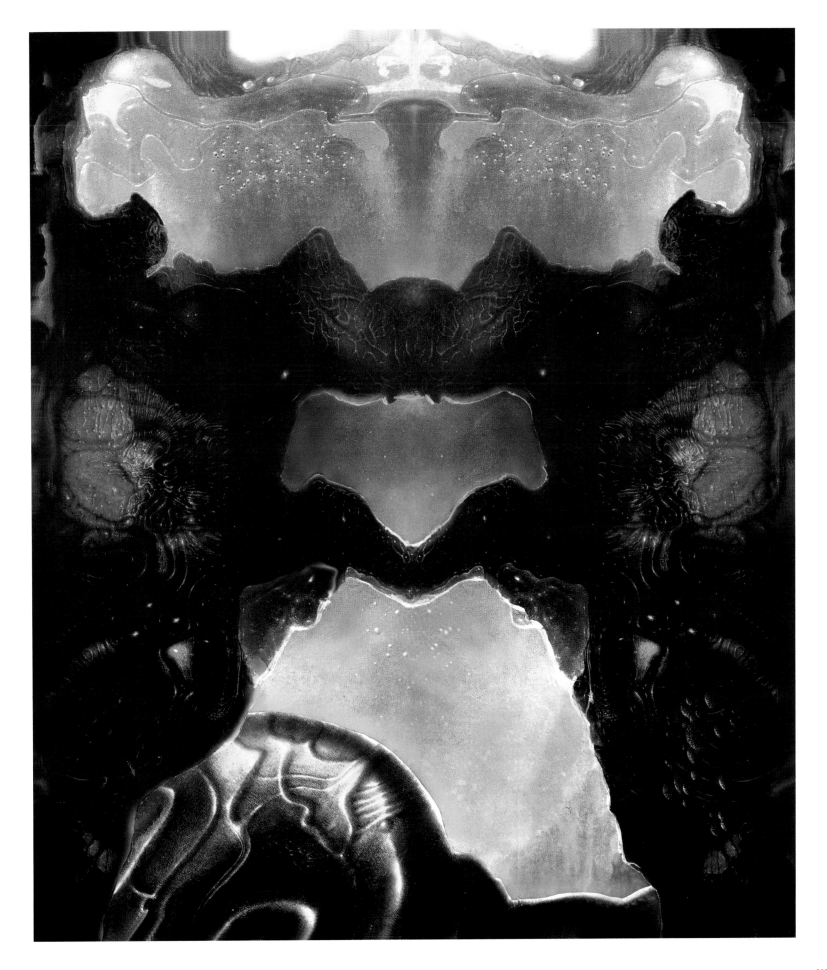

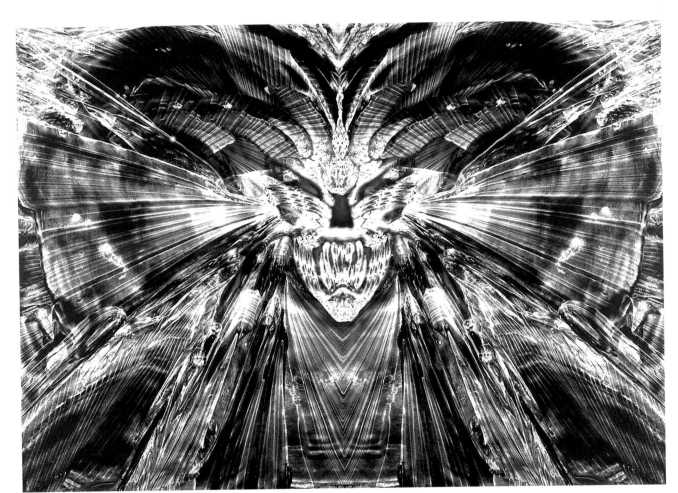

GHASTLIUS
1996, OIL, MONTAGE, 35 X 50 CM.
PRIVATE COLLECTION

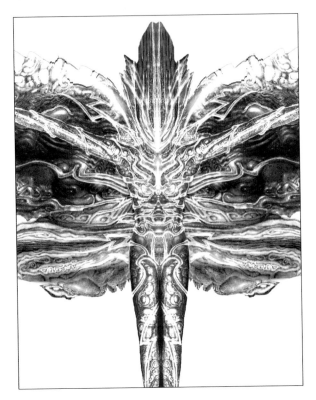

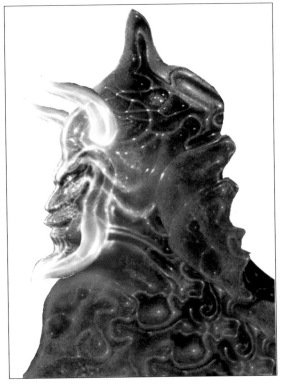

Race For Atlantis is an animatronic, 3-D adventure projected onto an 85-foot high screen in a custom-built theater at Caesars Palace in Las Vegas. Venosa was asked to design the protagonist of the film, a creature called "Ghastlius."

GHASTLIUS II
1996, (DETAIL), OIL, MONTAGE, 25 X 33 CM.
PRIVATE COLLECTION

GHASTLIUS III
1996, OIL, MONTAGE, 35 X 25 CM.
PRIVATE COLLECTION

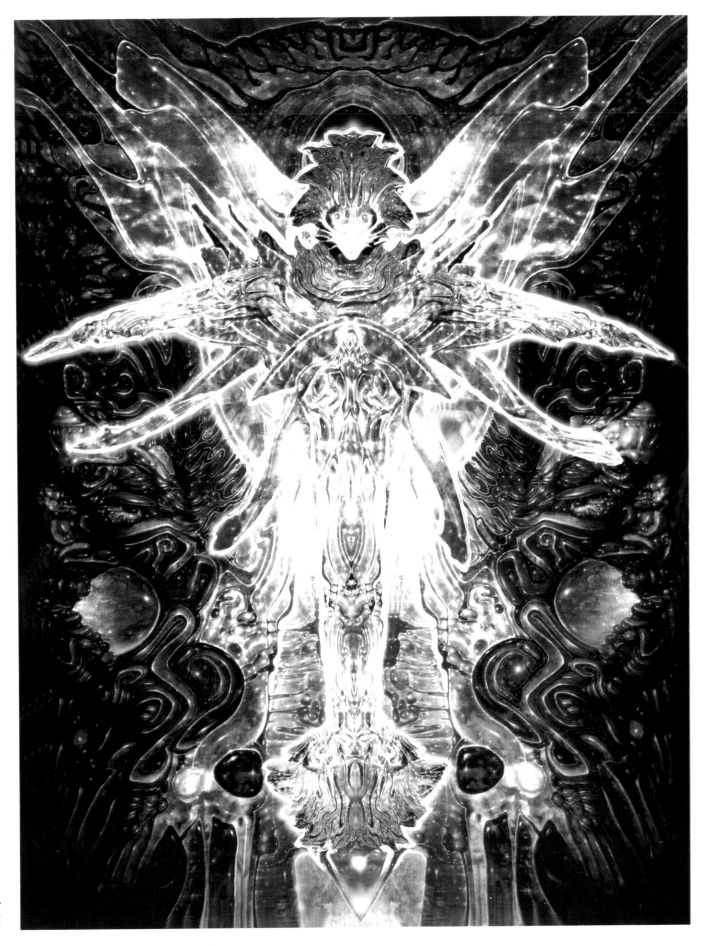

ATLANTIS ANGEL
1996, OIL, MONTAGE, 80 X 50 CM.
PRIVATE COLLECTION

Venosa arriving upon Pegasus, New York, 1946

"The paintbrush is the key that allows entry into the divine mysteries," states Robert Venosa, whose journey to the paintbrush, however, is another mystery altogether, the divinity of which is left up to the observer of his life and work.

Born in New York City on a snow-swept January night, Venosa resisted entry and had to be forcibly extracted. Forceps tracks on his head attest to that event. The isle of Staten in New York Harbor offered the ideal environment in which to start the planetary excursion. Just forty-five minutes from mid-town Manhattan, the island's steep hills and lush green woods were just two blocks from the active streets and tenements of Stapleton, the ebullient town where Venosa spent a good deal of his youth. Typical of New York, the population at that time was a melting pot in the extreme. Friendly stoop gangs, classmates and sports teams were composed of just about every earthly national and racial group, every one of which hadn't the slightest clue or interest in the "higher arts." EC comic books were about as close as one got to the creative fine line. Walt Disney and Basil Wolverton reigned supreme. As true today as it was then — pitiful to say — movies and comic books were the American visual-culture entities. But, for Venosa, there was one particular piece of art — El Greco's painting *View of Toledo* — which hung on his classroom wall and which was the initial lure and bait that touched upon what was then a consciousness in deep sleep. 1940s America was not exactly the Greece of Euripides — the Eleusinian mystery at the time was: how many home-runs would Joe DiMaggio hit?

As has been true through the ages, being a juvenile delinquent was *de rigueur* for the teenager of that place in time, and Venosa excelled in that discipline. He and a few associates, however, crossed one line too many and ended up spending a year in the beautiful countryside of upstate New York, compliments of the powers that were. It was there, at the Lincoln Hall (rebellious) Boys' School, that Venosa started to awaken to his artistic abilities by sketching — on request and for a small fee — the erotic fantasies of his mates, while at the same time discovering the pleasures and empowerment of creating art. The gift, however, would remain dormant for the next fifteen or so years until the mid-1960s, at which time, thanks to lysergic acid (LSD), Venosa's mind and consciousness were psychotropically — and forever — altered.

Venosa directing music video, New York, 1968.
Photograph: Charles Keddie

Up to this point Venosa had been commercially creative, working first as an art director at CBS/Columbia Records, and then as the creative director and owner of a New York advertising agency. But the deeper Venosa wandered into the highly experimental counterculture of that time — 1965 — the further away he drifted from the socially correct reality in which he had been sleepwalking. In any event, there was no looking back. The banal, small-change life-view would give way to the higher elementals which demanded a courageous insistence in the search of *truth* and all the eternal, temporal, momentary, and confounding possibilities that the word encompassed.

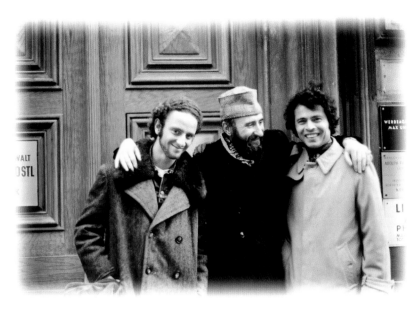

Michael Fuchs, Ernst Fuchs and Venosa, Vienna, 1969. Photograph: Uta Hille

Walking away from the extremely comfortable lifestyle offered by a multimillion-dollar-a-year agency to pursue a path of existentialist struggle and near poverty would seem, in the eyes of many, to be reaching towards the heights of lunacy. And, to add a deeper tint of incredulity, imagine that this sacrifice will assure your exclusion as a respected member of the community and brand you forever as a social misfit. Such were the demands made by an expanded consciousness in conjunction with the Muse of Painting. Any and all of the psychedelic pilgrims of that time were confronted with a phantasmagoria of sensory overload, as well as being entrapped within a cyclonic, directionless maze — the door of which slammed shut on all previous realities.

It was during this dross-burning rebirthing that the perceptions and values of art took on a dimensional change for Venosa. Having had little or no previous experience in the finer arts, he quite suddenly became attracted to oil painting, especially as exemplified in the works of the visionary artists such as Ernst Fuchs, Mati Klarwein, William Blake and Gustave Moreau, as well as the art of the Pre-Raphaelites: Lord Leighton, Sir Lawrence Alma-Tadema and Richard Dadd in particular. (It was Dadd's painting *Fairy Feller's Masterstroke* that inspired Venosa's *Astral Circus*, 1976–78, pages 44–49.) But above all, it was Fuchs' work, with his otherworldly seraphic images, that resonated most forcefully with Venosa, and which approached the

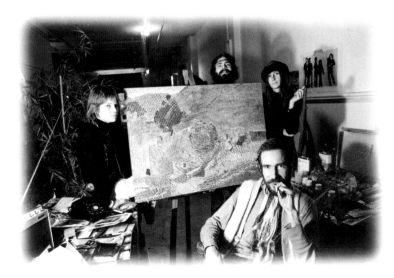

Mati Klarwein's 17th Street studio, New York, 1970.
From left: Babette, Venosa, Cathy Ainsworth and Mati Klarwein.
Photograph: Caterine Milinaire

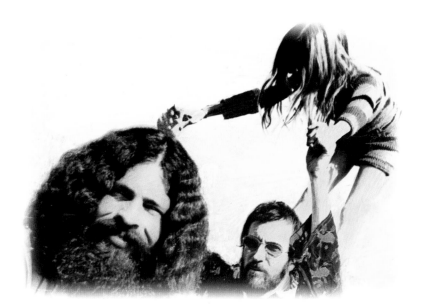

Venosa with Mati and Eleanor Klarwein. Boulder, Colorado, 1971. Photograph: Terence Toole

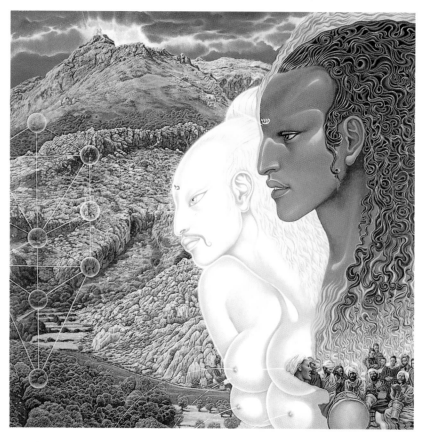

Mati Klarwein, Moses and Aaron, 1970, oil on canvas, 75 x 75 cm

psychedelically induced ephemeral visions that he was attempting to sort out and apply some understanding to.

A ski trip to Austria in 1969 led to a meeting with Fuchs in Vienna and, subsequently, three months of studying painting technique with the master in 1971. And then, strangely coincidental, a chance meeting with Mati Klarwein in New York, also in 1969, presented, in the following year, the same golden opportunity to apprenticeship.

During the summer of 1970, while in California, Venosa had the first of two profound, defining visions which were to compel him to start painting forthwith. Heading into a siesta, he was shocked out of the hypnagogic state as he saw the image of Christ integrated as part of an atomic pattern. Heeding some sort of transcendent message, he cut his trip short, returned to New York and, attempting his first painting, struggled to transpose the vision onto canvas. The result was *Atomus Spiritus Christi* (page 109). It was upon seeing this painting, and the technical struggle that obviously ensued, that Klarwein decided to take Venosa on as a student — something he rarely, if ever, did.

Here was Venosa not only meeting, but being able to spend time studying with, the two artists he admired above all others, actually learning their techniques and secrets, in their studios, under their personal guidance! These were experiences that transcended Venosa's wildest dreams.

Klarwein's studio presented much more than just the opportunity to learn the ways of painting: it was a veritable pit-stop for the *haute volée* of New York and beyond. At any given time one could listen to, or partake in, a conversation with the likes of Tim Leary, Jimi Hendrix, Jackie Kennedy, Miles Davis, Peter Beard, and a host of other luminaries who continually appeared at all times of the day

and night looking to provide and/or refuel on the high energy that therein vibrated non-stop.

In between, Mati found time to teach Venosa his updated version of the "Misch Technique," discovered by Hubert and Jan Van Eyck in fifteenth-century Holland. This technique utilizes applications of tempera underpainting and oil glazing, allowing for the dimensional, transparent effect Venosa was searching for in order to give life to those crystalline worlds bubbling in the psychotropics of his superconscious. Even though it was ever put to the test, discipline was one of the more important necessities that Klarwein emphasized and — through his own adherence — strongly impressed on Venosa. In the midst of all the ongoing activities Venosa learned to make the gesso for his canvases, lay the paint down properly, and the manner in which to wash his brushes. Mati taught well the techniques of painting and, even more relevant, personified a vibrant, wit-filled, quality-laden lifestyle. It was also during this time that Venosa and Klarwein collaborated on the Santana *Abraxas* record album cover design, which utilized Klarwein's painting, *Annunciation*, and Venosa's logo, which is now an instantly recognizable music icon.

It was directly after his studies with Klarwein that Venosa was afforded the opportunity to go to Vienna and spend time interning with Fuchs. Vienna, at that time, presented a lifestyle diametrically opposed to that of New York. The somber, deeply serious atmosphere of traditional classicism would replace the fun-filled flash of New York. Fuchs' method of teaching was significantly more formal than that of Klarwein's, and the eerily silent studio sorely missed the cacophony of Mati's 17th Street madhouse. But

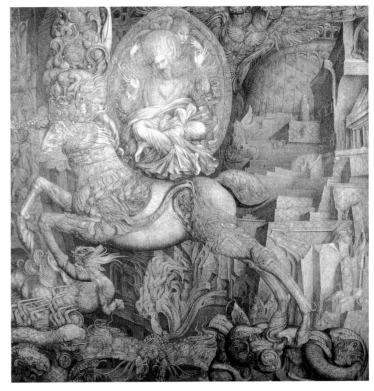

Ernst Fuchs, The Triumph of Christ, *1965, pencil on canvas, 200 x 200 cm*

Jutta Cwik on Sausalito houseboat, California, 1971. Photograph: Alan Watts

Fuchs' environment had its own attractions, with Romy Schneider, the Prince of Liechtenstein, Placido Domingo and other notables coming to visit the maestro and, as a respectful gesture, checking out what crimes the interns were committing on canvas.

It was during this time, January 1971, that Venosa met Jutta Cwik, who was also present at the Marokkanergasse studio, assisting Fuchs in the underpainting on certain of his larger canvases. Having studied with Wolfgang Hutter, Jutta was an exceptional artist in her own right,

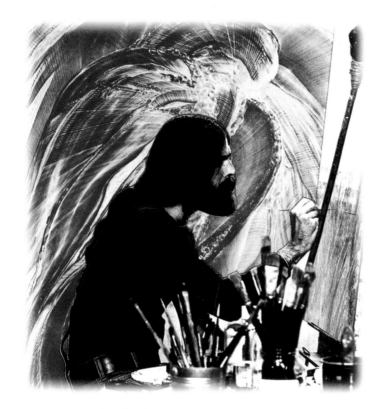

Venosa in Cadaqués studio, Spain, 1976. Photograph: Moses Tibau

and helped Venosa, both as constructive critic regarding painting progress, and — being of outstanding beauty — as a model for his paintings during his three-month stay in Vienna. The relationship extended, however, beyond the academic— leading eventually to marriage and three children: Marcus, Celene and Christan. This was the second marriage for Venosa, who had been previously wed to Edith Strofield in New York, with whom he had Laura and Steven, the first two of his five children.

As with Klarwein, Venosa's studies with Fuchs lasted about three months and, as with most masters, the inspiring driving factor was not what they technically taught so much as the high energy that one could absorb by being in their presence.

At this point Venosa felt supercharged and sufficiently confident to enter the world of survival-by-art. However, not having saved nor invested anything from his high-rolling New York business days, he would be left in a financial dilemma as his insufficient bankroll slowly dwindled away. He nevertheless felt that the same guiding forces and spirits which had led him to this radical juncture in his life would also take care of the banking, feeding and housing of his liberated soul. In time, with the tightening of his belt and the necessity of having to live in his van, these beliefs would slowly dwindle away as well.

After his studies with Fuchs, Venosa returned to the United States where he and Jutta would spend some months, first in Santa Fe, New Mexico, sharing a house with Klarwein, and then on to California, living in the houseboat community of Sausalito with Alan Watts — advisor of all things Zen and educator in the discipline of meditation — as his next-boat neighbor. It was during one of his meditative states that Venosa experienced his second transcendent vision. As he relates it:

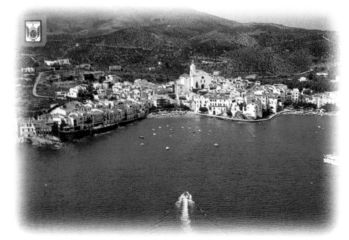

Cadaqués, Spain

> *It happened in a nanosecond. A brilliant, jewel-encrusted, overwhelmingly beautiful, angelic-looking being flashed in my mind's eye, shocking me out of my meditation and compelling me to attempt a rendering of this astonishing vision. Certainly that was far beyond my abilities then, as well as now, and I have been chasing that vision ever since.*

The painting inspired by this experience, *Fall of Lucifer* (page 159), was the first of many that Venosa attempted over the years, including *Seconaphim*, 1974 (page 143), *Angelic Manifestation*, 1974 (page 67), *Seraphim*, 1975 (page 133) and, more recently, *Angelic Awakening*, 1992 (pages 56–57) and *Dos Angeles*, 1993 (pages 60–61). Visions of otherworldly beings are by no means a new or unique experience. Aldous Huxley in one of his letters to Dr Humphrey Osmond talks of seeing crystal- and jewel-bedecked creatures during one of his experiences with mescaline. Ernst Fuchs devoted much of his early work to the depiction of angelic creatures and celestial architecture that he envisioned during dreams.

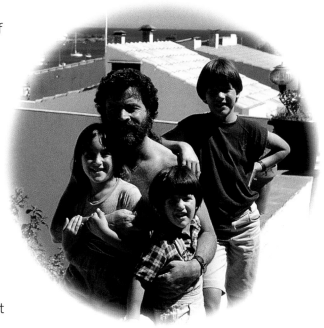

From left: Celene, Robert, Christan and Marcus Venosa, Cadaqués, Spain, 1986

In April 1972 Venosa packed up his pants, paints, and palette, put his Dodge van on a boat, and headed back to Europe where he would spend the better part of the next seventeen years. The first of those years was spent travelling about, mostly skirting the radiant Mediterranean where, eventually, Venosa discovered the small, renowned Spanish fishing village of Cadaqués — renowned as the home of Salvador Dali. Robert and Jutta immediately fell in love with this magical place, with its centuries of history and the most interesting looking people imaginable filling every seat in the smoke-filled, conversationally vibrant coffee houses. Home at last!

They found a studio, and for the remainder of the year went about painting, partying and happily integrating into the magical vortex of Cadaqués. But, for Venosa, funds suffered their final dwindle and, in early 1973, it was back to Vienna and his first sour taste of the age-old artist's struggle to survive. The custom-made suits and shirts of his New York days were now a hazy dream.

Cold flats, dim lights, empty pockets and a nasty, arrogant populace, forced Venosa to stay at his easel overtime and helped enlighten him to the fact that a starving, pained artist truly *does* create inspired, emotion-directed work. His was an exercise in maturity as he experimented with extruding vision, while perfecting his technique. Paintings such as *Birth of a Nebula* (pages 74–75), *Towards Edentia* (pages 34–35) and *Crucifixion* (pages 104–105), poured out as Venosa found his stroke and confidence.

It was also during 1973 that meetings took place, and friendships

Dali in his Port Lligat garden, Cadaqués, Spain, 1978. Photograph: Alex Kayser

were struck, with H.R. Giger, DeEs Schwertberger, Gottfried Helnwein, Wolfgang Hutter, Eric Brauer, and a number of the other Fantastic Realist artists who, at the time, abounded throughout Austria, Germany, and Switzerland. The School of Fantastic Realism, founded in Vienna in 1949 and primarily composed of Ernst Fuchs, Rudolph Hausner, Eric Brauer, Wolfgang Hutter, and Anton Lehmden, was now blossoming into a full-blown movement of dedicated purists holding their own in counterpoise to the mainstream, commercialized art mills that were selling the collectors on, and polluting the market with, Abstract, Pop, and other McArts.

Having established a presence of sorts on the strength of these new paintings, Venosa found his work gaining acceptance and being sought after by a number of the more prestigious galleries, as well as becoming part of Vienna's important collections,

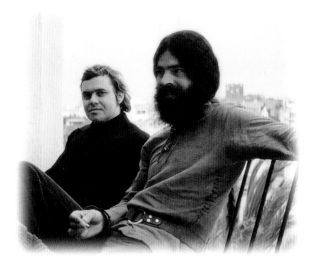

H. R. Giger and Venosa, Cadaqués, Spain, 1985

hanging alongside Fuchs, Hausner, and other Fantastic *obermeisters*. The gallerists Gerard Schreiner in Basel, Geneva, and Lisbon, and Peithner-Lichtenfels in Vienna, among others, took on Venosa's work, providing entry into the collections of aristocrats, industrialists and entertainers, including those of Countess Maria Mautner-Markov, Lenz Moser, and singer/actor Miguel Bosé.

Exhibitions in Basel and Munich followed, then in Amsterdam, London, Frankfurt, Monaco, and, in unquestionably the most beautiful setting one could wish for, the castle of Perelada in Spain. The economics involved enabled Venosa to return to his beloved Cadaqués in 1974.

One is absolutely captivated the moment one enters Cadaqués, a small fishing village surrounded by the Mediterranean's most romantic bay. Besides Dali, practically every artist of note in the twentieth century has been lured by the pueblo's siren song of inspiring vistas, as well as its deep-blue waters and hard-core hedonism into which one lustily dives. Picasso, Marcel Duchamp, Man Ray, Garcia Lorca, René Magritte, Joan Miró, David Hockney, Walt Disney — even Albert Einstein! — have all sipped a little absinth, skinny-dipped, and most assuredly sensed a different flow of joy there where the Pyrenees slide into the sea.

Contrary to what one might imagine, Dali was quite accessible, especially to his

Venosa and Martina Hoffmann, Boulder, Colorado, 1993

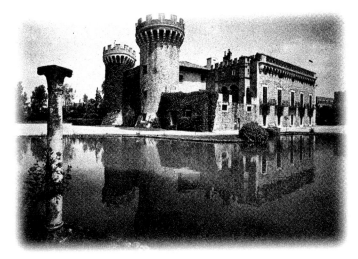

Castillo de Perelada, Spain

fellow artists. Over time, Venosa cultivated a close friendship with the maestro, and spent many memorable evenings in the Port Lligat casa, enjoying the spectacle that surrounded Dali: aristocrats, musicians, Flamenco singers and dancers, vagabonds, charlatans, and the King of Spain! All would come to bask in Dali's prodigious energy and pay homage to "El Rey Del Arte."

Dali paid Venosa what he considers his most memorable compliment and critique when, upon seeing the artist's painting of *Seraphim*, 1975, the maestro turned to him and said, "Bravo Venosa! Dali is pleased to see spiritual madness painted with such a fine technique."

As Dali's enormous intellectual appetite was forever seeking out the new, exciting and interesting, he enjoyed the visits of Venosa who on most occasions would present the maestro with gifts of books, catalogs and information regarding those new and unique artists whom he knew Dali would enjoy. One of those was H.R. Giger who, as a consequence of his meeting with Dali, was directed to the producers of the *Alien* movie for which he did the overall conceptual design, winning an Oscar in the process.

Dali, *el Gran Maestro*, was true to form right to the end, departing this realm in the wake of the scandal, chaos, and confusion that he so enjoyed subjecting critic, collector, and appreciative public to while he was alive. He is dearly missed by many, but most of all by those who had the experiential pleasure of witnessing his surreal theatrics and accompanying wink of the eye. His lesson was always clear: the road of genius is paved with wit.

In the mid-1970s Mati Klarwein introduced Venosa to Peter Ledeboer of Big O Publishing in London who, at the time, was producing a number of visionary oriented books and reproductions on such artists as Klarwein, Giger, Helnwein, Vali Myers and Rudolph Hausner. After seeing Venosa's work, he immediately included him in the Big O catalog, producing a series of prints, posters and other mass-market reproductions which would significantly expand the international audience and recognition of his work. But most importantly, Ledeboer published Venosa's first book, the now-classic *Manas Manna*, in 1978.

1981 was to be another of those years that brought about unexpected,

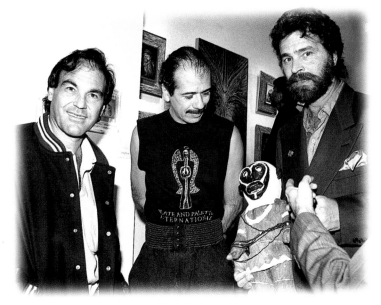

Oliver Stone, Carlos Santana and Venosa at a Los Angeles exhibition, 1990.
Photograph: Shelly Gazin

significant change. On Beltane Eve (April 30th) Venosa met the German sculptress Martina Hoffmann who, like so many before her, was making her pilgrimage to Cadaqués, *el sanctorum del artistas*. Being of such a fresh, exquisite beauty and intellect, she captivated a goodly portion of the male population of the village — Venosa being no exception. But the captivation was mutual, love crashed the gates, and the dyadic cyclone that followed brought about major emotional turmoil and irreversible changes for all involved. One relationship would transmute into another, and in the alchemical fire some would get burned. With Venosa moving out of his home and into his studio, and Martina ending her own protracted relationship and moving down from Paris, their spurned spouses made life difficult. But the forceful insistence of fresh love and re-invigorated passion

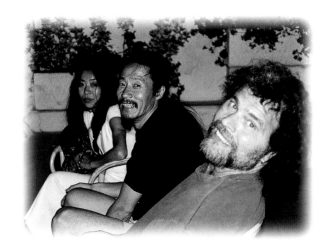

Kitaro and Venosa, Cadaqués, Spain, 1995.
Photograph: Stefano Romizi

was not to be denied and, eventually, rancor grudgingly gave way to the inevitable, and an uneasy peace settled over the emotional battleground. Robert and Martina have been together ever since, sharing a vibrant, inspired relationship as well as a deep-seated love for art and the creative life.

The following years in Cadaqués proved highly inspirational for Venosa, as he expanded his color range and his approach to putting imagery onto canvas. Through a series of what he calls "holy mistakes," Venosa discovered his "Serendipitic Exploitation" technique in which the artist attempts to become more of an instrument instead of the conductor. As Venosa explains:

It's a superconscious process. I try not to impose my ego on the forms and colors that manifest; I let the painting dictate to me what it wants to be, and I sculpt out with my brushes the sacred language within. I've learned to let the initial expression flow onto the canvas as it so desires, allowing the creation to come through me, not from me, and I simply work it out in detail later.

Throughout the 1980s Venosa was extending his reputation to the United States, thanks in no small part to his exposure in *Omni* magazine, which had been using his art both on the cover and throughout the magazine on a continual basis. Venosa's good friend, author Ed Rosenfeld, had become an editor in the early days of the magazine and, being an aficionado of the art and artists of Fantastic Realism, used his influence in getting the magazine to utilize their art. Venosa comments:

Omni was the first to give the artist equal credit with the author, something that to this day is still not seen in any other magazine. Omni also put Fantastic Realism, Surrealism, Visionary, and every other type of "Fantasy" art square into the public's eye. My colleagues and I owe Omni a large measure of gratitude for their uncompromising stance and visionary concepts.

In 1982, due to a number of commissions, commercial allurements, and a burgeoning recognition of his work through its extensive exposure in *Omni* and on compact disc covers, Venosa began to travel more frequently to the United States, dividing his time between New

York and Boulder, Colorado. It was time to make the shift from Europe and, enjoying the mountains, clean air and active consciousness of its populace, Venosa and Martina settled on Boulder to re-position their easels.

Compared to the raucous, colorful activity of Cadaqués, Boulder appeared somewhat anorexic, but the siren of success, along with the lure of mammon, wailed a seductive tune, irresistible in its promise but demanding in the changes deemed necessary if Venosa were to sing along: the merry Mediterranean mirage would have to give way to the aggressive American kindergarten for a season or two. There would be exhibitions to arrange, press releases to disseminate, collectors to romance, critics to confuse, and an entirely new sense of art to cultivate. The admiration and aristocratic respect accorded the artist in Europe is

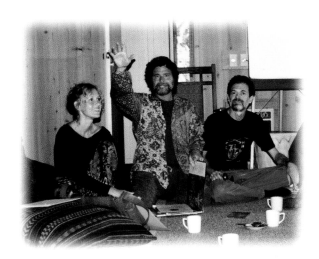

Martina, Venosa and Terence McKenna, Esalen, California, 1995

stripped clean upon arrival in the United States as these stalwart visionary architects of culture are transmogrified into novelty items and entertaining curiosities, to be looked upon as outlaws nevertheless. The centuries-old tradition of perfection, dedication, and contemplative approach to art is left at the gates of the rapid-fire, non-stop, instant sensual gratification American sitcom culture. Trying to compete in the fast lane of the high-velocity illusions and banal delusions of movies and television, offers a daunting challenge to the fine artist.

Although often homesick for Europe, the dynamics and opportunities in the United States were not to be resisted. Exhibitions, collectors, commissions, film design, interviews, compact disc cover design, publishers: all of these confronted Venosa on a non-stop basis and led to a melange of creative output which, most notably, included compact disc covers for Santana and Kitaro, film design for *Dune* and *Fire in the*

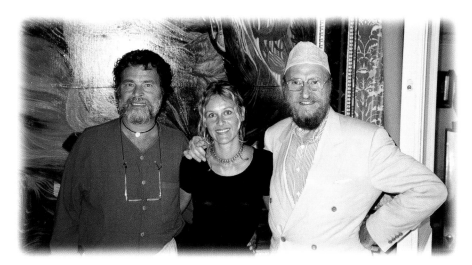

Venosa, Martina and Ernst Fuchs, Vienna, 1997. Photograph: Celene Venosa

Sky, and, in 1991, the publication of his second monograph, *Noospheres*. Never being able to cut the cord completely, Venosa and Martina have returned to Cadaqués every year for the summer months. Apparently, for those hooked on Cadaqués, the addiction is incurable.

Fuchs once mentioned to Venosa that it takes at least ten years for an artist — if worthy — to gain recognition. And now, after twenty years of running from country to country, from gallery to gallery, from collector to publisher, painting with one hand while attempting to keep the wolves from the door with the other, Venosa is finally

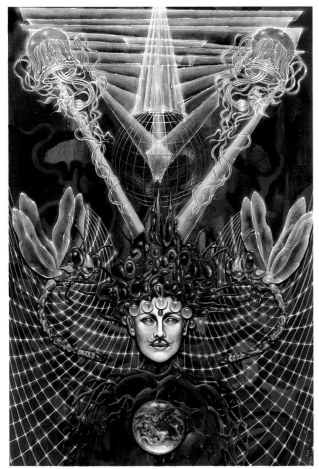

Martina Hoffmann, *The Messenger*, 1995, oil on canvas, 112 x 60 cm

enjoying his recognition and sense of worth and now understands what Fuchs meant — even though the estimate had been somewhat conservative.

Venosa's experiments with hallucinogens abated after his shift to Europe in 1972. It wasn't until the early 1980s when, wishing for Martina to have her own sacramental experience, he opened up once again to the transpersonal wonderment and phantasmagoria that one can only gain admission to through psychedelics. Although his paintings never showed a lapse in inspiration, it was his consciousness that he felt needed re-awakening. It was shortly thereafter that Martina herself turned to painting, attempting to transpose, in her own manner, her visual interpretations of the experience. It would be another ten years or so before the hallucinogenics would enter either of their spiritual diets again.

The act of painting, in itself, had become a form of meditation for Venosa as he would lose all track of time, space, and himself while at his easel. He talks of his art as being a transcendent language of form and color which contains enigmatic symbols and glyphs that, although undecipherable to the finite viewpoint, nevertheless resonates within the superconscious of all who confront it. Once, during a vernissage of his paintings in Amsterdam, a gentleman in the party fell to his knees and, with clasped hands, started praying quite fervently in front of one of the paintings! When later asked what had compelled him to do so, he replied that he had no memory of the incident. During the occasion of another of Venosa's exhibitions, one of the crowd came nose to nose with Venosa, screaming at the top of his lungs in some sort of babble that no one could understand, and had to be constrained until his aggression subsided. Once again, the person later admitted to being at a loss for his actions.

In 1991 Venosa started reading the works of author Terence McKenna, the renowned ethnopharmacologist/cybernaut/shaman whose own academic experiences with various hallucinogens spoke of visions that appeared to encompass the same otherworldly realms where Venosa occasionally ventured. They eventually met in 1993 and, upon being invited to the studio and seeing Venosa's work, McKenna felt he was standing before the same imagery that one might expect to see in those borderland realms. Their worlds were strikingly akin and, with the formation of an

Martina and Venosa, Santa Fe, New Mexico, 1995.
Photograph: Lisa Law

immediate friendship, they discussed the various possibilities of combining their visions, with one eventual manifestation being their collaboration on the book you hold in your hands — *Illuminatus*.

It was also during this period that Venosa was introduced to the sacred Amazonian hallucinogen, *Banisteriopsis caapi*, better know as ayahuasca ("vine of the soul"), and holy healer of body, mind, and soul. The experiences that followed exceeded in breadth and depth of vision, and liberation of spirit, all that came before. A new dimension entered Venosa's work, leading to such paintings as *Angelic Awakening* (pages 56–57), *Dos Angeles* (pages 60–61), *Ayahuasca Dream* (pages 26-31) *Oothoon's Palace* (pages 18–19) and *Sanctum Caelestis* (pages 24–25) — all the largest and, arguably, most dynamic of his works to date.

Martina's paintings have also shown a shift, resulting in work touching upon the fantastic, as exemplified in *The Messenger* (page 228), and she shares these thoughts:

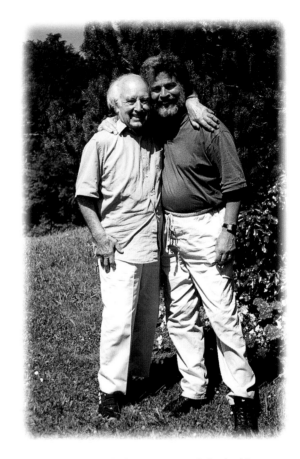

Dr Albert Hofmann and Robert Venosa, Burg, Switzerland, June 1999.
Photograph: Martina Hoffmann

If we consider different entry ways into the creative process, the psychedelic experience can certainly be considered one of the more accessible gateways to free association painting.

As a re-entry way to the superconscious, the sudden mind expansion on this path will provide an automatic opening of all channels, therefore allowing an unlimited abundance of images, otherworldly images, without limitation in form and content, to imprint the artist's mind, forever providing him with an inexhaustible well of images materializing on canvas in time.

As the messenger between the worlds, the artist acts as the translator for those who haven't seen into the shapeless abyss or the infinite possibilities of worlds beyond our imagination. Intelligent life forms, gaseous and amorphous, inhabiting other-dimensional landscapes, will test one's ability to adapt to the unexpected and unknown.

As we freefall into the new millennium, Venosa's visions vividly and holographically encapsulate our metamorphosis from three-dimensional, cosmically static beings to awakening inter-dimensional vessels of light. In this process, his paintings illuminate the corridor of our collective rebirthing canal, inciting spiritual and aesthetic euphoria. The mind is silenced by this strange, otherworldly beauty.

In the evolutionary scheme of things, Venosa seems to have inherited the creative genetics from the extensive family of supernatural artists that have enlightened us through the ages, starting with Hieronymus Bosch, through to Gustave Moreau and Ernst Fuchs. By teaching and

Salutation by Salvador Dali, 1974

writing about their techniques and traditions, these artists have been passing the malstick from one generation to the other, and Venosa is no exception as he shares his gifts and knowledge with those who exhibit the passion and talent to enter this exceptional realm. For the past five years, Venosa and Martina have given workshops on painting technique, with participants from all over the globe attending these sessions at such locales as Skyros Island, Greece; Tobago in the Caribbean; Esalen Institute in Big Sur, California; Kona, Hawaii; and Boulder, Colorado.

Perhaps it would be fitting to close with a statement by Michel Peissel, explorer, author and neighbor of Venosa in Cadaqués:

To let the spirit take control of the hand, to capture the message and form of spirit; this has been the mission of most prophets. Their writings are considered revelations of realities from beyond the field of normal experiential knowledge. But the attempt to portray on canvas the spirits themselves, and to some extent their message, is another consideration. It is also Robert Venosa's rationalization of his art. If Hieronymus Bosch let us look at hell, Venosa with his transparent, luminescent world gives us a preview of higher worlds, harmony, and ethereal beings that incarnate light. If Paradise, the Absolute, and Nirvana are considered beyond the grasp of the senses, and therefore of a painter's brush, one cannot help but feel that Venosa's paintings are somewhat similar to those pre-Nirvanic states reached by meditation, yogic practices, hallucinogens, and other paths used by the spiritual aesthete. With an art that transcribes a feeling beyond the habitual grasp of vision, Venosa opens a window onto the soul; a window you can look through onto a real picture. Like Bosch he sets us dreaming with that same sense that no doubt what he paints must exist.

David Joseph

acknowledgments

I want first and foremost to thank Nevill Drury for his appreciation, belief and productive investment in my work, without which this monograph would still be a wish pursued. Martina — renaissance goddess and *compañera* — is a continual source of inspiration and love. Much gratitude to Mati Klarwein and Ernst Fuchs for opening my eyes to the Fantastic and passing along the magic. And to H.R. Giger as well, for his collegial support. Terence McKenna helped immensely with the birth of this book and the rebirthing of my superconscious. Certainly Laura, Steven, Marcus, Celene and Christan should know that their father takes pride in their precious existence. Momma Rose knows my love only grows. And to Hanna Kay, a big *toda raba* for making contact. Thanks to David Joseph as well, for his wonder words.

Some of those who have helped make this book technically possible include Hari Ho, Grig Bilham, Ron Ellis, Lewis DeAngelis, Ken Sanville, Eric Bazarnic, Caroline de Fries, Claire Armstrong, Craig Peterson, and my Power Mac for holding up under the strain. Thanks to Kim Hunter for her exuberant promotional energy. Absolute gratitude goes to the collectors of my art — known, private and anonymous — and to those who have paid me the honor of exhibiting it in gallery, museum and home.

Most of all, I must acknowledge the blessings of my muses and guiding spirits who have quickened my eye and guided my hand, helping me translate in form and color the roadmap to the source and center of our being and to the heart of our Divine Creator.

index of plates

Distributed in Australia by Craftsman House,
Tower A, 112 Talavera Road, North Ryde, Sydney, NSW 2113
in association with G+B Arts International:
Australia, Canada, France, Germany, India,
Japan, Luxembourg, Malaysia, The Netherlands,
Russia, Singapore, Switzerland

ISBN 90 5703 272 4

Design: Robert Venosa and Craig Peterson
Colour Separations: Digital Pre-Press Imaging Pty Ltd, Sydney
Printer: Stamford Press, Singapore

Front Cover: Robert Venosa, *Scheherazade*, 1997 (detail), oil on canvas, 44 x 55 cm. Private collection
Back Cover: Robert Venosa, *Raw Shock*, 1999, oil and computer collage, 54 x 30 cm. Private collection
Frontispiece: Robert Venosa, *Blaqueen*, 1980 (detail), film design for *Dune*, oil on paper, 30 x 17 cm. Private collection

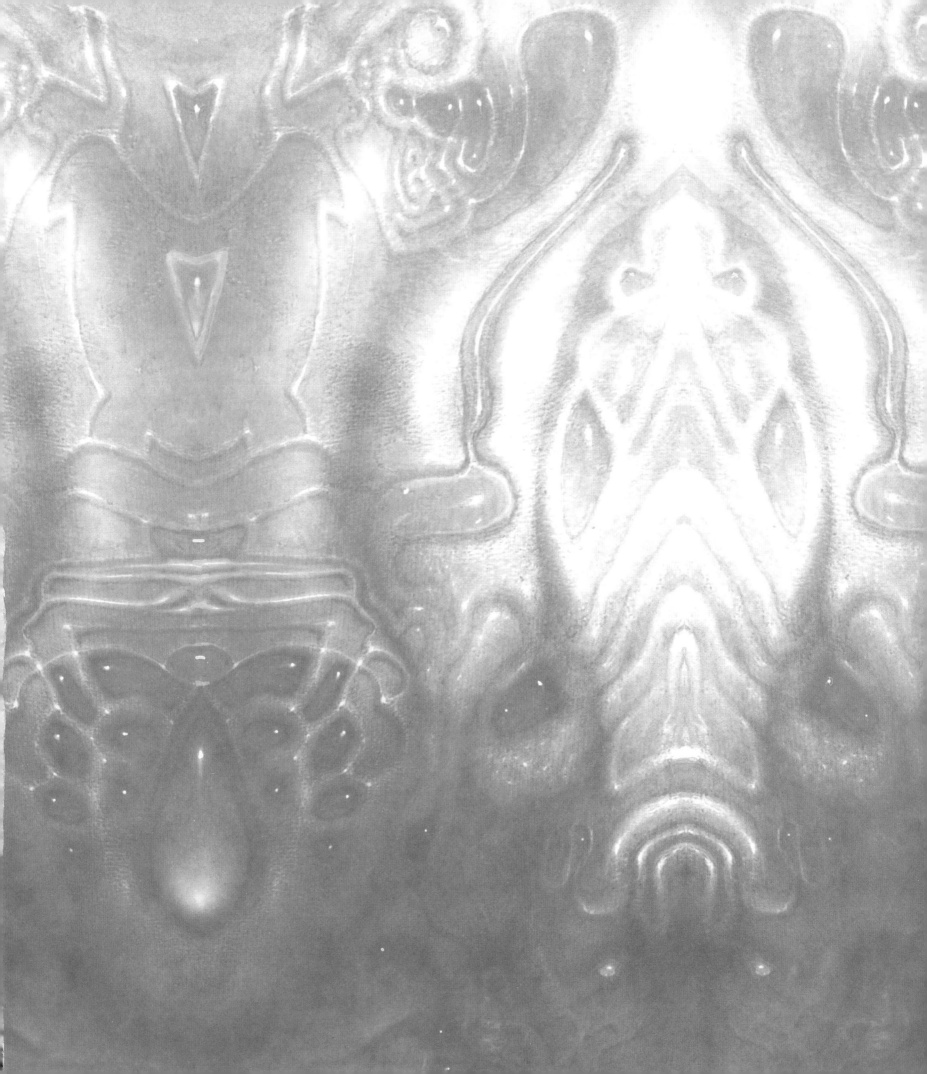

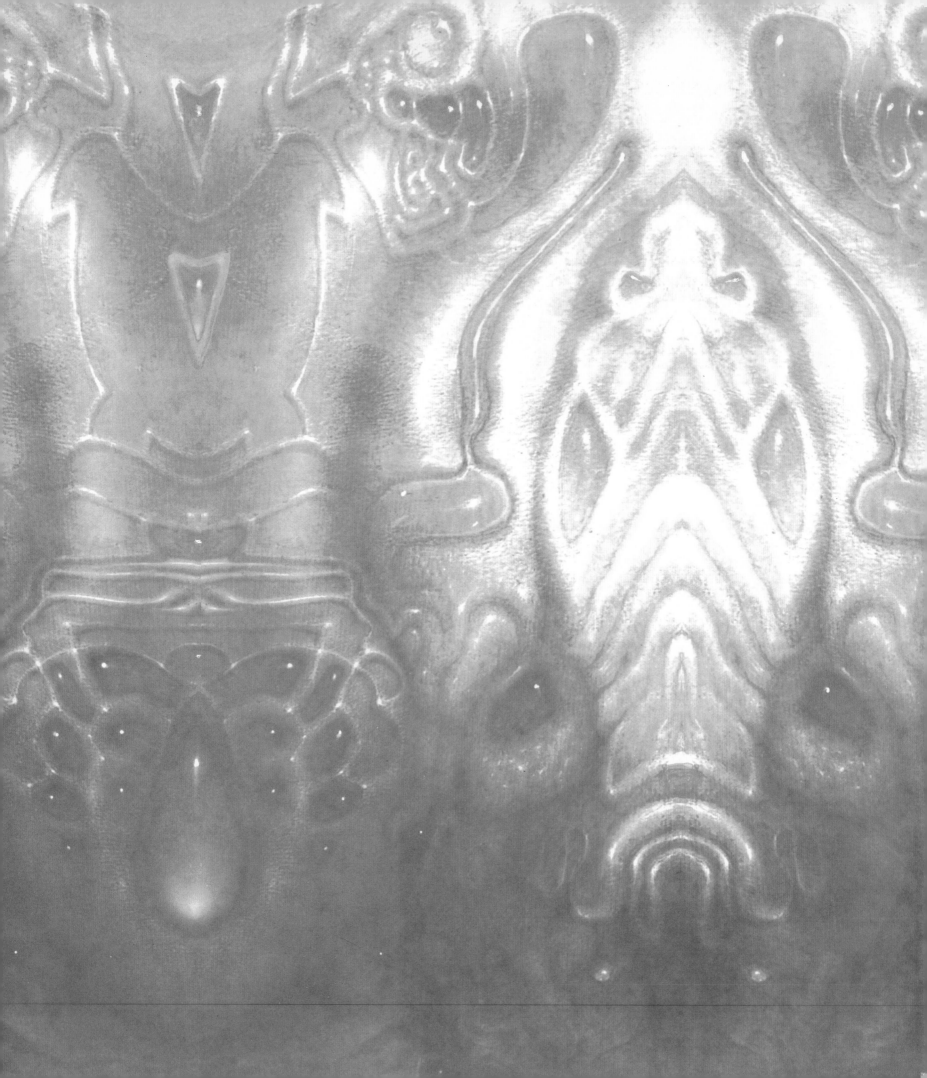